Pictures and Visuality in Early Modern China

Craig Clunas

Princeton University Press
Princeton, New Jersey

Originally published in Great Britain by Reaktion Books Ltd
11 Rathbone Place, London W1P 1DE, UK

First published in 1997

Published in the United States of America and Canada
in 1997 by Princeton University Press,
41 William Street, Princeton, New Jersey 08540

Designed by Humphrey Stone
Jacket designed by Ron Costley

Photoset by Wilmaset Ltd, Wirral
Printed and bound in Great Britain by Biddles Ltd,
Guildford and King's Lynn

Library of Congress Cataloging-in-Publication Data

Clunas, Craig.
 Pictures and visuality in early modern China / Craig Clunas.
 p. cm.
 Includes bibliographical references and index.
 ISBN 0-691-05761-3 (cloth: alk. paper)
 1. Art, Chinese—Ming-Ch'ing dynasties, 1368–1912. 2. Visual
communication—China—Psychological aspects. I. Title.
N7343.5.C6 1997
709'.51—dc21 97-22449

10 9 8 7 6 5 4 3 2 1

Pictures and Visuality in
Early Modern China

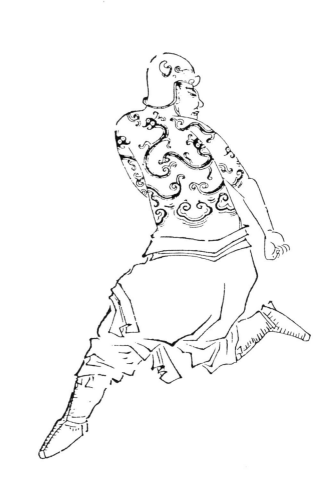

Contents

Acknowledgements

The writing of this book was helped immeasurably by a spell as a Fellow at the Getty Center for the History of Art and the Humanities in the spring of 1996, and I am very grateful to all the Getty staff and Fellows for their help in innumerable technical and scholarly matters. I would particularly like to acknowledge the help of Joanna Roche. For the supply of specific ideas, encouragement and materials it is also a pleasure to thank: Maggie Bickford, Timothy Brook, Michela Bussotti, Sören Edgren, Stanislaus Fung, Sue Gold of the Wellcome Institute, Jonathan Hay, Paul Holdengräber, Ladislav Kesner, Michael Lackner, Stephen Little, Joseph McDermott, Robert Nelson, Jessica Rawson, Susan Stewart, Miriam Wattles, Evelyn Welch, Verity Wilson, the Far Eastern Department of the Victoria and Albert Museum and the Library of the University of Sussex, especially Jennie Marshman. Many other colleagues and friends not named also provided stimulation, criticism and support, and I hope they will consider themselves sincerely thanked, although not implicated in any mistakes of fact or interpretation the book may contain.

1 Introduction

Lately, some large claims have been made for pictures. For some, 'representation itself is at stake', in a situation where works of art 'have engendered rather than merely reflected political, social and cultural meanings'.[1] This approach has called for a history of images, as opposed to a history of art, a form of historical enquiry which would not start from an *a priori* privileging of certain works as masterpieces, but would range more widely across the entire 'field of cultural production'. These claims come to a large extent from within the discipline of art history. In the crudest sense they are made by those whose primary professional identification depends on their employment as teachers of a subject of that name. They have the necessary effect of making art history seem like an important, even an essential, field of enquiry at a time when its credentials are challenged from both within and without. They recuperate its importance on new and ambitious grounds. These claims are not uncongenial to me, since my pay-cheque too derives from an equivalent source, even if in practice what such approaches have often involved is the summoning of new images to explain the traditional objects of study. But recently too, pictures have seemed too important to leave to art historians. There have been moves from those whose self-definition is as 'historians' pure and simple, for whom images have come to seem a legitimate field of enquiry.[2]

The present book is conceived under an awareness of both these tendencies. It looks at elements of the body of visual material manufactured in the China of the Ming Dynasty (1368–1644) and tries to pose a number of questions: how was this body of material conceived, manufactured and appropriated for use? Did it in fact engender rather than merely reflect social, cultural and political meanings, and if so, how? Is it possible to construct a frame of reference that will encompass types of objects (for example, painting on paper and on porcelain) which have historically been held apart, or discussed if at all only under the heading of 'influences'? Can we find ways of discussing the pictorial that do not collapse into assumptions about the 'importance' of certain representations as 'art'? What were the issues surrounding pictorial representation at the

time? What did it mean in Ming Dynasty China to 'look at a picture'? These questions may not be fully answered to the satisfaction of all readers, but they are at least posed in a manner designed to draw historians of China into a consideration of the visual, and historians and art historians of other parts of the world into perhaps a very necessary re-consideration of some of the certainties surrounding their own objects of study. The term 'early modern China' in the title of this book is thus a deliberate provocation, above all a provocation to those who continue to ground accounts of European exceptionalism over the last 500 years on a secure foundation of ignoring all other histories. For early modernity in its European sense is rarely invoked except as an inevitable if implicit prelude to modernity proper, and while the boundaries between them may be a subject of debate, there is rarely any discomfort with the geographical specificity of the category. Whether the 'early modern' began in 1400 or 1492 or 1700 is debated with more intensity than the silently accepted proposition that it is essentially a European phenomenon. *Where* modernity was seems less of a problem than *when* it was.

 This is a book about pictures in China at a particular period in the past. It is not just about painting. One strand of the received wisdom is that much of Chinese art, sometimes defined rather narrowly as painting, reached a point 'beyond representation' at an early date, discarding an early attachment to mimesis in favour of a self-referential attention to painting in and of itself. This is indeed the theoretical position adopted by most of the canonical artists and theorists (and it is a distinctiveness of the Chinese situation that they are frequently one and the same people) since the eleventh century. It is an account that has considerable strengths, not least those of taking seriously statements from within Chinese culture. It is a necessary and salutary corrective to European accounts that view the discarding of mimesis as one of the central pillars of Modernism, to be made to realise that claims of this kind were being made in China many centuries before Paul Cézanne. But the aim of the present study is definitely not to position art in China as somehow 'really' winning the race to be 'modern' with that of Europe, a race in which China is perceived as showing great early promise only to fade in the crucial closing stages. Instead it is my aim to cast doubt on the very existence of that single, global race to the modern. Rather this book seeks to deal with some of that vast body of Chinese picture-making and picture-viewing practices for which representation remained a central issue, indeed the principal justification for picture making at all. Some of these engagements fall within the Chinese discourse of 'painting' as historically constructed and presently sustained. Many of them do not. All need to be considered as part of a specific historical visuality, Hal Foster's 'sight as social fact',[3] although I have

done no more than indicate in Chapter 4 some of the directions such an enquiry would have to take.

This book might be seen broadly as part of the project described by Ivan Gaskell as 'historical retrieval (the attempt to interpret visual material as it might have been when it was first made, whether by the maker, his [*sic*] contemporaries, or both)'. The historicist pitfalls of such an approach are well spelled-out by the same author.[4] But it aims to stand also as an intervention in any account of pictures, above all of those which continue to see the necessity for explanations of the difference between 'art' and 'Chinese art', 'history' and 'Chinese history'. To this end, I have tried to make the work accessible to the reader with no prior knowledge of the material, citing English-language studies to the widest possible extent. I have not cited all of the extensive body of work on the art and culture of the Ming Dynasty which I have necessarily engaged with in the writing of this book, and I hope for the understanding of those who will be aware just how many elisions and skimpings there are, only partially compensated for in the notes.

Performances and Erasures

The absolute difference between 'painting' and 'Chinese painting' is one of the points of origin of Western art history. It is part of what makes that art history possible. From the first systematic European description of the field by Joachim von Sandrart in the seventeenth century, that difference has been expressed as often as not as a lack.[5] This is equally true whether the object of the discourse is 'China' or 'painting'. Matteo Ricci (1552–1610), the Jesuit missionary who more than anyone else created the possibilities of writing about China in the West in the generation before Sandrart, saw Chinese painting as 'without any liveliness' (*senza nessuna vivezza*), while for a China expert of a later generation, John Barrow writing in 1804, the grounds of criticism were essentially the same:

With regard to painting, they can be considered in no other light than as miserable daubers, being unable to pencil out a correct outline of many objects, to give body to the same by the application of proper lights and shadows, and to lay on the nice shades of colour, so as to resemble the tints of nature.[6]

Such statements could be multiplied without any great difficulty, and are obviously part of the larger project of self-definition with regard to Asia which is one of the major themes of European history in the second half of the second millennium of the Common Era.

The twentieth-century discourse of Chinese painting in Western literature largely eschews such crude put-downs. A specialist literature

developed, and growing professionalization made historians of Western art slightly less willing to pronounce. When Chinese painting is mentioned in a work such as Kenneth Clark's *Landscape into Art* (written in 1949), it appears as mere elegant grace-notes of erudition, the other as ostensive ornament to the 'main' story.[7] However, acts of comparison continue to be carried out, almost all of which are predicated on the preexistence of difference, in which the author finds their task in the explanation of that difference which has already been taken for granted. Sometimes these acts of comparison are still carried out with a very blunt instrument, as in the ecological determinism with which John Onians sites the absolute difference between unitary Western and Chinese traditions in the differing neuropsychology of Greeks 'brought up surrounded by white cliffs and rocks of hard angular limestone and marble', while by contrast 'All who lived in China would have had brains whose visual cortex was attuned to soft tones, curving shapes and an omnipresence of water, in the earth and in the air'.[8] In recent art-historical writing, the much better informed and more nuanced act of comparison, which has had the widest circulation and enjoyed the widest citation, is that made by Norman Bryson in his influential *Vision and Painting: The Logic of the Gaze* (1983). In addressing right at the beginning of this study Bryson's now-famous juxtaposition of 'performative' and 'erasive' modes of brushwork, the intention is not to critique this work as a whole, but rather to argue that the uses made of 'Chinese painting' in recent theory can, without the conscious intention of the author, act to reaffirm and revalorize attitudes to and deployments of that material which have long roots in the past, and imply a long reach into the future. Bryson writes:

If China and Europe possess the two most ancient traditions of representational painting, the traditions nevertheless bifurcate, *from the beginning* [my emphasis], at the point of deixis. Painting in China is predicated on the acknowledgement and indeed the cultivation of deictic markers. . . . Chinese painting has *always* [my emphasis] selected forms that permit a maximum of integrity and visibility to the constitutive strokes of the brush. . . . The work of production is constantly displayed in the wake of its traces; in this tradition the body of labour is on constant display, just as it is judged in terms which, in the West, would apply only to a *performing* art.

The useful category 'deictic' is borrowed by Bryson from linguistics, where it covers utterances which contain information on the 'locus of utterance', which draw attention to the place and act of uttering. He argues that 'Western painting is predicated on *the disavowal of deictic reference* [my emphasis], on the disappearance of the body as site of the image; and this twice over: for the painter, and for the viewing subject'. He further goes on to argue the 'erasive' nature of the Western tradition of oil painting:

The pigment must equally obey a second erasive imperative, and cover its own tracks: whereas with ink-painting everything that is marked on the surface remains visible, save for those preliminaries or errors that are not considered part of the image, with oil even the whites and the ground-colours are opaque: stroke conceals canvas, as stroke conceals stroke.[9]

The comparison once drawn, the terms once set, the one Chinese and one Japanese picture illustrated, this 'other' tradition of representation can be allowed to drift back over the horizon in order to allow the discussion of 'Vision' and 'Painting' to continue.

Yet no objects of comparison present themselves innocently. One might on the contrary advance a tendentious argument that around 1650 the entities 'Chinese painting' and 'Western painting' were characterized by a number of similarities. This is particularly so if we choose to privilege the reception of painting, rather than its creation. Although a concern with the latter has been widespread of late, it has not sufficiently been realized that doing so must undermine the perceived exceptionalism of both entities, the exceptionalism on which practices of teaching, writing, hiring and examining are predicated in the modern academy. In Rome, Nanjing, Yangzhou and Amsterdam in 1650 a contemporary painting was often a discrete physical entity. It could be, and was, moved about. Whatever transactions brought it about, which might involve money, it was in both cultures equally a potential commodity, enmeshed in market relations. Its path through those market relationships, and the value which would be put on it in the commodity context, depended principally on its acceptance as the authentic work of a single, named artist. Who a picture was by determined its monetary value. This, more than subject-matter or the social status of any originary patron, was the defining criterion of value. Hence both China and Europe were obsessively concerned with questions of authenticity and connoisseurship, which the wide prevalence of faking and the passing of false pictorial goods rendered only prudent. In both Rome and Suzhou, knowledge about and the private ownership of pictures were an important part of the cultural capital of individual male members of the élite. Connoisseurship was a practice of equal theoretical and practical importance to the maintenance of high status.

My point is not to substitute these similitudes for the differences that have hitherto seemed so obvious, so natural as to need only indication, rather than explanation. But it *is* to assault the obviousness of those differences, to draw attention to and cast doubt on the claims of *total* difference or incommensurability between pictorializing practices in China on the one hand and Holland, or Scotland, or Sicily, or Poland or the other numerous specific sites which attain their common Western identity through the exclusion of an Eastern 'other'. For one critique that could

surely be mounted against Bryson's enterprise is that, for all his sensitive-
ness to 'difference', the comparison of the two totalized terms still
implicitly sees 'Western painting' as that which stands in need of explana-
tion. Such a critique is voiced by Homi Bhabha:

The site of cultural difference can become the mere phantom of a dire disciplin-
ary struggle, in which it has no space or power [his examples include
Montesquieu on Turkey, Barthes on Japan, Kristeva's China] . . . part of a strat-
egy of containment where the Other text is forever the exegetical horizon of
difference, never the active agent of articulation. The Other is cited, quoted,
framed, illuminated, encased in the shot/reverse-shot strategy of a serial en-
lightenment. However impeccably the content of an 'other' culture may be
known, however anti-ethnocentrically it is represented, it is its *location* as the
closure of grand theories, the demand that, in analytical terms, it be always the
good body of knowledge, the docile body of difference, that reproduces a rela-
tion of domination, and is the most serious indictment of the institutional
powers of critical theory.[10]

Without for a moment questioning the anti-ethnocentric credentials of
Bryson's project, it is hard not to sense the sting of Bhabha's criticism,
just as it is hard not to feel its minatory force on projects such as this
book too. How can 'Chinese painting' be treated in comparative frame-
work, in such a manner that demands for its 'docility', its domesticity as
the 'good body of knowledge' are no longer even tactitly raised?[11] To put
my answer before the reader at once, and without any justification at this
stage, I would answer that nothing less than the abolition of 'Chinese
painting' as the sole object of study will suffice.

It would be foolish to 'blame' any modern scholar of art history within
the Western tradition for a somehow insufficient deployment of 'Chinese
painting', when they have to derive their understanding of its essential
qualities from the consensus of opinion among the founding fathers of
Western studies of Chinese art writing in many cases over 50 years ago;
Arthur Waley, Oswald Sirén, Alexander Soper. They in turn have derived
their understanding from a body of Chinese theoretical writing about the
making of representations in painted form, which stretches back many
centuries and which increasingly through those centuries foregrounds ex-
actly those concerns which Bryson, for example, has so accurately
identified; the cultivation of visible brushwork, the distrust of mere mim-
esis, the self-referentiality back to the moment of production of the work
of art, a moment somehow re-produced in the moment of viewing. These
issues are what the majority of Chinese texts on painting largely talk about.
These issues *are* to a large extent the discursive field of 'Chinese painting',
and I want to stress at the beginning that this is not some orientalist con-
fection put together outside China, but a coherent field of possibilities for

knowledge about the subject embodied in modern times in collections of source material like Yu Jianhua, *Zhongguo hualun leibian* (*A Categorised Compendium of Chinese Theories on Painting*, 1986) or Yu Anjian, *Hua shi congshu* (*Texts on the History of Painting*, 1982). They are designed to explain a work such as *Landscape in the Style of Ni Zan* by Shen Zhou (illus. 3), but not to deal (other then dismissively) with something like the *Lady in a Palace Garden* (illus. 28), which from the seventeenth century onwards was simply written out as 'not-art', at least as far as theoreticians were concerned. Yet it is arguable that *Lady in a Palace Garden* singularly fails to operate in the deictic manner demanded of Bryson's dichotomy, hiding the moment of its production behind erasive brushwork quite as effectively as a European painting of the same period. The aim is not to substitute it for *Landscape* as the object of 'Chinese painting', but rather to query the necessity for such totalizing definitions at all, however helpful they may be in defining certain historically specific European traditions as functionally equivalent to 'painting' *per se*.

Similarly, it is not the purpose of this book to question the empirical grounds of existing total accounts of 'Western painting' (although it should be noted in passing that the elision by Bryson of the Ancient Egyptian pictorial tradition to produce a neat binary West/East dichotomy might well be challenged today). A reading of Philip Sohm's work on the notion of *pittoresco* in seventeenth-century Italy is richly suggestive of a concern with the performative nature of brushwork within certain strands of European aesthetics. Arguments for and against visible brushstrokes in painting may have ultimately been settled *in theory* in favour of the position that *ars est celare artem* ('art lies in the concealment of art'), but any historian of Chinese painting would nevertheless find material to ponder in Sohm's confident (if typically parochial) conclusion that 'The Venetians were the first to explore, however tentatively, the modern proposition that a painting is nothing but paint'. The notion that style is most discernible where brushwork is most visible, an idea which according to Sohm was first voiced by Giulio Mancini, physician to Urban VIII in 1621, is certainly one with which the theoretically engaged of Mancini's Chinese contemporaries would have had no difficulty in concurring.[12]

However, one question to be posed in this book is this. What is the relationship between the discursive formation 'Chinese painting' and the surviving range of pictures from one period in Chinese history, the centuries falling broadly under the rule of the Ming Dynasty (1368–1644)? The aim is not to argue that Chinese painting is *really* like 'this', instead of like 'that'. Instead it is to take seriously the developing paradigm of 'visual culture' by examining one part of it, the total range of pictures found in the Ming world, and by examining alongside it the Ming world of looking, its

culture of visuality. An attempt will be made to engage with the contemporary theories of representation, with the Ming discourse of pictures, while at the same time being aware of the exclusions which it operates, the silences which are its conditions of possibility, the objects it does not want to talk about. It is a key part of my argument that painting derived a large part of its cultural authority from what it deliberately was not, from what it *did not do*.

This is not a book about the visual culture of the Ming. Although attracted by the paradigm of 'visual culture' I am aware that this is not truly what I am doing. I would stress that I am still dealing with only one part of visual culture, perhaps unfortunately the most studied bit. A true 'visual culture' of Ming Dynasty China would deal as well, for example, with clothes and buildings and with colour as a category (which are scarcely mentioned here), with the presentation of food and of self, and would engage fully with the visuality operative in the theatre and in street festivals, in ephemera such as lanterns and processional floats, which feature only tangentially in this book. I emphasize this point because I am conscious that the sleight-of-hand whereby the old objects of art-historical study are reborn as 'visual culture' merely by calling them so must not be allowed to naturalize itself.

Recent studies of Chinese painting in Europe and America have been dominated by a discontent with the very picture of a single coherent 'Chinese painting', which Bryson derives from the scholars of an older generation. Particularly as regards the sociology of artistic production, there has been a concentrated assault on the model of 'good' scholar-amateur artists and 'inferior' professionals, an assault contained in works such as James Cahill's *The Painter's Practice* and Richard Barnhart's recuperation of Ming court art in the exhibition catalogue, *Painters of the Great Ming*.[13] Such an assault cannot but undermine the grounds on which the 'performative' model stands, since it is becoming increasingly clear that a concern with the 'traces of the brush' is in Chinese theory an essentially *social* discourse, predicated on the élite status of the artist, on the possession of certain types of cultural capital and generally on certain levels of economic capital too.[14] Only now are scholars challenging the formulations of Chinese painting theory, with its insistence on the consonance of the status of a representation with that of the person producing that representation. Old boundaries of amateur/professional, which it must be stressed are not inventions of Western orientalism but which are firmly inscribed within the Chinese written record of painting as a social practice, are now being questioned as never before.

Nevertheless, it remains the case that the work of Cahill, Barnhart and others remains focused on 'painting' as the unit of analysis, even if on a

somewhat broadened definition of the kinds of painting to be looked at. Any attempt to move towards the possibility of engaging with 'visual culture' will only fail if it refuses to acknowledge the privileged status accorded within Ming culture to certain modes and technologies of representation, and to take seriously that privileged status. However, it is also the case that an engagement beyond 'painting' will be necessary to a historical enquiry of the type rightly demanded by readers of this book. For the Ming world was full of pictures; pictures on walls, on paper and on silk, printed pictures in books and printed pictures pasted on the doors of homes at New Year, pictures on the paper used for correspondence and for business contracts, pictures on the bowls out of which wealthy people ate and on the screens with which they marked important festivals and rites of passage, pictures painted on ceramics and carved in lacquer, pictures embroidered in silk and woven into the clothes they wore. The excellent work that has been done by so many scholars on the rich textual record of aesthetic theory in China will only go so far, will explain only a very small portion of the pictorial representations which survive on actual objects of the Ming period.

The distinction, operative in the modern museum and in the art market with regard to objects manufactured in Ming China, between 'fine' or 'high art' and 'decorative art', is by no means a purely Western invention. On the contrary, it is explicit in the Chinese writing of the period covered by this book, where it enjoys the same status as a ranking device that it holds world-wide today. However this does not mean that it was operative in all aspects of Ming culture at all points equally. Accepting the privileged status of painting within Ming aesthetic theory does not have to mean privileging that theory in all subsequent writing. As we shall see, other discourses, such as that of the gift, might provide alternative ways of structuring an understanding of representations. Bryson's account, however, retains the assumption that the painting validated in élite theory forms a norm of picturing practice towards which all other picturing must of necessity aspire, and that a book illustration, for example can only be seen as a failed painting. Indeed, he goes further, banishing all representations found on porcelain, or lacquer, or textiles, to a realm of insignificant darkness. In a vitriolic excursus against art journals such as *Apollo* he writes:

Emphasis on the technical autonomy of craft processes serves only to prolong theorisation of the image as manufacture, as commodity, and for as long as it is understood as *that*, the inter-communication of painting with social formation across the sign is obscured by a mystificatory economism making no distinction between painting and the other 'fine arts' – furniture, porcelain, glass, clock-making, all the manufactured goods whose trade not only sponsors the art journals, but [also] constructs as a unified category and as a single object of

knowledge processes involving the sign and processes not involving the sign, under the general and impoverished heading of Connoisseurship.[15]

This desire to preserve 'the sign' from contamination can only be read as an attempt to recuperate the distinction between the fine and decorative arts on a semiotic ground, and must cast a certain amount of doubt on the aim announced earlier in the same work to found a materialist art history on 'the recovery or retrieval of evidence left behind by previous interaction of the image with discourse...'.[16] For the collapse of 'the image' into a simple correspondence with the category 'painting' ignores the presence of representations beyond those painted on paper or silk and validated by centuries of élite critical discourse. It is with this larger body of 'pictures on things', *as well* as with that special pictorial practice carved out as 'painting', that this study seeks to concern itself.

Mimesis and Istoria

If *Lady in a Palace Garden* (illus. 28) presents a problem in terms of what 'Chinese painting' is meant to look like, then *Divinities of Nature* (illus. 1) does the same to an even greater extent. Another topos inherited from the explicit programmes of Chinese aesthetic theorists, modulated by art history in the first half of this century, is that manner of representing is more important than the thing represented. Bryson's reference to the preferred subject-matter of painting in China – foliage, bamboo, boulder and mountain formations, fur, feathers, reeds, branches, mist and water – is in fact a catalogue of the most theoretically prestigious types of subject-matter, derived quite accurately from the mainstream of Chinese art-historical writing.[17] It is a model that cannot cope quite so well with religious representation, in which the accurate delineation of the forms of deities, often of fantastical appearance as here, is of central concern to the person who paid for the picture and the person who executed it. It is a model that takes as normative for all Chinese picturing at all times the critical positions to be found in art *theory* from the poet Su Shi (1037–1101) to Dong Qichang (1555–1636) and on into the present day, in which mimetic representation is relegated to a decidedly lower status. Within this model, it is well known that *xing si*, 'likeness in form', was a lowly value in the hierarchy of painting criticism from the late Ming onwards, and that Su Shi criticized as childish anyone who judged painting on the basis of faithfulness to the thing represented.[18] This is the view of Chinese painting as essentially going 'beyond representation' by the fourteenth century at the latest, accelerating past mimesis to a concern with the self-referential painterly sign, to an 'art-historical art' where pictures are signifiers purely of other pictures made and yet to be made.[19]

18

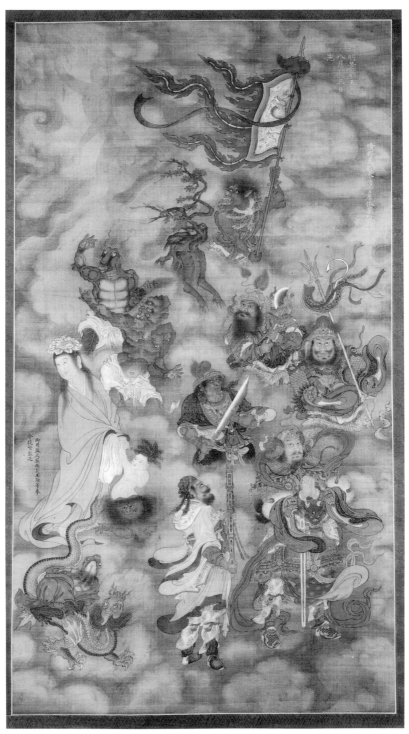

1 Anon, *Divinities of Nature*, 15th century. Musee Guimet, Paris. Part of a set of paintings for the Buddhist 'water and land' ritual for the salvation of the dead.

2 Anon, *Landscape*, ink and colours on silk, 16th–early 17th century. Kupferstich-Kabinett, Statliche Kunstsammlung Dresden. A 'workshop' painting of low standing, preserved by its early export to Europe.

Such theoretical positions are strong in their ability to explicate and historicize the canon of Chinese painting over the past millenium. They are not always as successful in accounting for all the pictures we have surviving from the Ming period, and not even for all of the paintings we have, leaving aside the much larger body of graphic work and of pictures in media other than painting on paper and silk. Many of the members of this huge art-historical underclass are anonymous, as is *Divinites of Nature* (illus. 1), but so too is *Landscape* (illus. 2), a fortuitously preserved survivor from a body of ephemeral, work-shop pictures which must have been produced in enormous quantities in an empire whose population in the sixteenth century had reached 150 million. The mainstream of Chinese art-historical

3 Shen Zhou (1427–
1509), *Landscape in the
Style of Ni Zan*, dated
1484, ink on paper.
Nelson Gallery-
Atkins Museum,
Kansas City.

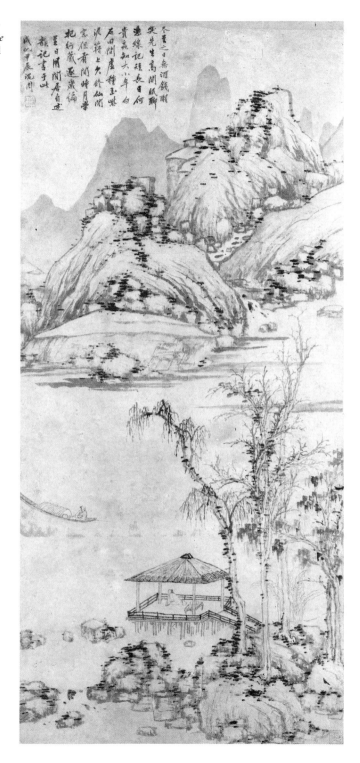

theory is good at explaining why these two pictures have been excluded from the canon, but is less helpful in explaining why they were made at all. The connections of an anonymous and mass-produced workshop painting like *Landscape* may be less visibly with other paintings, particularly less with those like *Landscape in the Style of Ni Zan* (illus. 3), produced by a famous élite artist working within a full consciousness of the hegemonic theoretical model, and more with something like the lacquered wood tray (illus. 33), where function and purpose are an essential part of understanding the impulse which brought it into being. Nor has the model historically coped very well until quite recently with the painting *Copy of Dai Jin's Xie An at East Mountain* (illus. 29), despite the fact that like *Landscape in the Style of Ni Zan* it is by Shen Zhou (1427–1509), one of the most revered of all scholar-amateur masters. For not only is it highly coloured in a manner little associated with artists of Shen's class, but also it is a copy of work, not by a revered old master enshrined within the amateur canon (as is illus. 3) but by an almost contemporary professional painter associated with the imperial court. Finally, it is not in any sense a self-referential piece, but one which 'tells a story', that of the fourth-century grandee Xie An (320–85). In doing so it is perhaps closer to a lacquer box like that shown in illus. 36, which also shows well-known figures from the remote if historical past. Both scroll and box are very much 'within representation', even if that still implies a distinctive Chinese epistemology and economy of representation.

Indeed there is considerable textual evidence from the Ming period itself that mimetic representation was not quite as discredited in the practices of the audiences for pictures as élite theorists of painting would insist, particularly in the earlier centuries. By and large theorists only attack a position which a significant number of people adhere to. Writing in the first half of the sixteenth century, Yang Shen (1488–1559) quotes with pitying contempt the widely held view that 'When a scene is beautiful, people say it is like a painting (*si hua*), and when a painting is excellent people say it is like reality (*si zhen*).[20] This was clearly a literary commonplace among the educated, since Yang's contemporary Lang Ying (1487–c.1566) says the same thing in almost exactly identical wording, under the heading 'True and False Landscape':

It has often amused me that people, when they see a fine painting, say, 'It is almost a real landscape', and when they see a real landscape say, 'It is just like a painting'. This shows they don't know what is real and what is false.[21]

One-hundred years later, Wang Keyu (b.1587) was still complaining, 'When vulgar people discuss painting they know nothing of the spiritual subtleties of brush method and spirit consonance (*bi fa qi yun*), but first

point out the form likeness; form likenesses are the viewpoint of the vulgar. ... When people nowadays look at paintings they mostly grasp the form likenesses, not realising that form likeness was the least important thing for the men of antiquity...'.[22] A term such as *ru hua*, 'picture-like', might have a very long and complex lineage within the specialized discourses of literary and artistic theory.[23] However, the vulgar, perhaps not all of whom were children, eunuchs or other marginalized groups, would persist in looking at pictures with quite the wrong set of expectations, questions and demands, asking what it was a picture 'of', asking what it 'meant'. Any account of 'visual culture' will have to take this silenced segment of the Ming population, and their engagements with the pictorial, into serious consideration besides the better informed, the vociferous, the theoretically *au courant* who have had such a good hearing up to now.

In writing what follows, I have taken to heart Donald Preziosi's critique of the

panoptic, anamorphic apparatus of the discipline [which] with its built-in instrumentalism, exhorts the art historian to construct the text of history so as to render it internally consistent and coherent. This exhortation extends to the larger chronological picture as much as to the individual vita or to the individual artwork. Ambiguity, internal coherence, or contradiction are to be gradually eliminated as the historian or critic comes to elaborate hypotheses that can account for and render mutually coherent the greatest number of elements in the work, in the life, or in the period.[24]

The following text is therefore more of a set of linked essays than a single thesis. This seems appropriate in that my principal target is reductionist accounts, of whatever period or source, which seek to narrow the field of study to manageable proportions simply by leaving the inconvenient majority of pictures out of account. The aim is to stimulate the discovery and explication of other excluded bodies of material to which I am undoubtedly blind, not to define the grounds on which a 'better' total account of Chinese pictures in the Ming period might be defended. Accordingly, Chapter 2 tries to provide the reader with some sense of the multitude of types of engagement with pictures available in Ming China. It looks first at the decline of the public format of mural painting and the parallel expansion of pictures in printed form. Certain types of lacquered object and ceramic are then studied as examples of how context of use and iconography of decoration were mutually determined. Chapter 3 deals with some types of representation of the world of humanity and of the terrestrial sphere, two terms out of the Triad of 'Heaven, Earth, Humanity' which provided a structure for much of Ming categorizing. In Chapter 4 the focus is on the categories to which pictures were themselves subjected,

the terms which differentiated 'pictures', from 'painting' and both from 'images', and the terms which organized viewing, looking and appreciating as cultural practices. In Chapter 5 a case-study is made of one late Ming imaginary collection of paintings, in the form of the woodblock prints making up 'Master Gu's Pictorial Album'. Chapter 6 deals with restrictions on the image, the fear on the part of élite writers of obscene or inappropriate images and what their role in the derangement of the good society might be. The final chapter looks briefly at the crystallization in the decades after 1600 of 'painting' as a discursive field now more fully separated than ever before from the wider body of pictures, focusing on the question of the attempted introduction of European canons of representation as a way of returning to the question of whether the Ming world of pictures comprised an epistemologically grounded totality of absolute difference with contemporary practices at the other end of the Eurasian landmass. These chapters leave many topics uncovered, and serve in many ways to indicate the research which remains to be done. One of these topics concerns the nature of the Chinese 'élite', which is invoked frequently in these pages in a lax manner that will cause social historians considerable unease. The nature and composition of this élite (the older Western term 'gentry' is falling into disfavour) is the subject of sophisticated and prolonged debate, which makes one thing above all clear; that the élite of the early Ming and the élite of the late Ming were different. The latter was more likely to be urban in its central concerns, was geographically more diffuse, stood a statistically worse chance of passing the all-important examinations (the quotas for which remained static as the population increased), and enjoyed a different relationship to the central organs of the state. Much remains to be uncovered about the cultural life of this élite, particularly about exactly which cultural practices *granted* status as opposed to simply marked status, which was obtained through other means. The precise alchemy by which cultural capital, economic and social capital were transmuted into one another is still a long way beyond our current understanding. This book aims to stand as a contribution, from one very precise angle, to complicating that understanding.

2 Positions of the Pictorial

The decline of the mural

The seventeenth-century collection of artists' biographies and anecdotes about painting entitled *Wu sheng shi shi* ('History of Poems Without Sounds') contains a famous anecdote about the artist Shen Zhou (1427–1509), by that time an acme of the scholar-amateur ideal in art. If, as Shen's modern biographer has shown, it is unlikely to be true, it is nevertheless extremely revealing about how the production and consumption of pictorial representation had come to be understood by the very end of the Ming Dynasty.[1] The story tells how Shen, a prominent local worthy with extensive estates outside the city of Suzhou, who was on social terms with many leading intellectual and political figures of the day despite his lack of formal degree or official rank, was summoned by a magistrate ignorant of his true status to execute a painting on the wall of a government building.

Later there was a certain Governor Cao, who having newly completed the construction of an Investigation Bureau, wished to ornament with painting its columns and walls, and so summoned together artisan painters. Someone secretly entered the gentleman's [i.e. Shen's] name in order to humiliate him. He was issued with a summons on paper, and said to the messenger, 'Having no fears for my old mother, but remaining in that place I will execute the painting day and night, not daring to lag behind the others'. Someone said to him, 'But this is a menial labour service, which you could be excused by visiting one of your noble friends'. The gentleman said, 'It is right to carry out the service, and is no insult, but would not seeking to be excused through one's noble friends be an insult!' He then went discreetly, completed the work before the others and returned home without seeing Governor Cao.[2]

Only when a number of other grandees, and Cao's political superiors, ask after Shen Zhou does the culturally-challenged governor realize what he has done, and hasten to apologize.

For the seventeenth-century reader of this little tale of exemplary modesty and official gaucherie the insult was two-fold. You did not 'summon' a Shen Zhou as if he were a hireling artisan. A whole machinery of reciprocity and sociability had to be set in motion to get a painting out of a member of the élite, however renowned his artistic talents.[3] But above all you did not

summon a Shen Zhou to paint a *wall*. Gentlemen did not do walls.

It had not ever been thus. In the Tang Dynasty (618–906) one of the main glories of the imperial capital had been the lavish mural decoration of its Buddhist and Daoist temples, and of the palaces of its aristocracy, executed by all the great painters of the day, men whose names continued to resonate through the history of Chinese painting as it was constructed in the Ming. The same was true of the great painters of the Song (960–1279) and Yuan (1279–1368) Dynasties, and it was equally so of artists who were understood in the Ming as being on the virtuous side of the professional–artisan/scholar amateur chasm. Some of this work could still be seen. It was possible in the seventeenth century to see at Hangzhou murals that were accepted as being by Guanxiu (832–912), by Li Gonglin (*c.*1049–1106) and even by Wang Meng (*c.*1308–85), one of the 'four great masters of the Yuan' (itself a category constructed in the later sixteenth century).[4] The seventeenth-century poet, artist and ultimately Catholic priest Wu Li (1632–1718) believed he had seen murals by the great Zhao Mengfu (1254–1322), an artist who stood very firmly in Ming art-historical writing in the lineage of the scholar artists.[5] Even so the critical and connoisseurly tradition had turned decisively against mural painting by the beginning of the Ming period.[6] When the physician and artist Wang Lü (*c.*1332–*c.*1395) climbed Mount Hua in 1381, he noted in one of the temples there that 'The walls were covered with landscape paintings in the tradition of the Fan Kuan school of painting; however the painter had not succeeded in transforming this influence into a personal experience'.[7] 'Personal experience', not the coverage of walls, was what theoreticians of the image like Wang now expected to see.

None of these early mural masterpieces survives today. More to the point, they were not being replaced in the Ming by large numbers of works from the brushes of the major contemporary artists, the names who enjoyed equivalent fame with Wang Meng and Zhao Mengfu in the fifteenth, sixteenth and seventeenth centuries. There were a few murals produced by Ming artists of renown. A sixteenth-century critic cited by Richard Barnhart speaks with awe of the gigantic figural murals painted on the walls of a Nanjing temple by Wu Wei (1459–1506), in which 'The walls were over twenty feet wide and more than forty feet high! The figures, objects mountains, rocks and trees truly spread irresistibly from earth to heaven!' However, significantly, by the 1570s 'the walls were in complete ruins; nowadays not even the corridors are there'.[8] And Wu Wei is an artist who broke all the rules, a *déclassé* son of a good family who worked as a court professional and died of drink, a personal, professional and stylistic eccentric. Painting walls is just the kind of thing, the text seems to say, that such a man *would* do.

Such wall painting as was commissioned in the Ming often had connections to the imperial court and imperial policy. In 1370, the founding Ming emperor had re-ordered the tutelary gods who presided over each administrative unit of the empire, commanding that the shrines in which they were worshipped be decorated with landscape painting, presumably signifying the territories in which they held supernatural sway. These landscapes were painted over earlier murals of the underworld, to emphasize the new terrestrial role of the city gods in the reconstructed Ming imperial order.[9] Large and elaborate schemes of mural decoration were produced in the early part of the Ming period in the vicinity of the two imperial capitals, often related to programmes of religious patronage sponsored by members of the imperial court. One of the most splendid of these to survive was executed in Beijing's Fahai ('Ocean of the Law') Temple between 1439 and 1443 (illus. 30), and was paid for by the pious eunuch Li Tong (d.1453). Although named members of the group of professional painters in attendance at court are known to have worked on some now-lost murals in other temples, the Fahai Temple murals carry no inscriptions or signatures (although the names of the men who painted them are listed separately on nearby stele – none has a reputation that has survived to the present).[10] Away from the court, those who did murals were increasingly poorly documented or anonymous artisans. We know nothing about Gao Tingli, from Changle, who decorated the Daoist cult site of the Xu brothers in Fujian in 1411, apart from his name fortuitously contained in a poem commemorating his (lost) work.[11] And the Sun Zaizi who according to the critic He Liangjun (1506–73) reworked the murals at the Feilaifeng Temple in Hangzhou is scarcely in the same league of fame as Wang Meng, their original creator in the fourteenth century.[12] The artisan who in 1551 inscribed a fragment of wall painting now in the Museum of Fine Arts, Boston (illus. 4), did not append his name at all.

The Boston fragment comes almost certainly from Shaanxi Province, far to the north and west of the cultural centres of the empire in the lower valley of the Yangtze River. By 1551, the élite of those centres had largely lost interest in murals altogether, even if in more remote areas they continued occasionally to be commissioned.[13] 'Secular' mural painting such as landscape was now little practised, and certainly not in the decoration of the élite mansion. By the early seventeenth century the writer Wen Zhenheng (1585–1645) could explicitly state that even if the greatest ancient painters of the canon were still to be active, 'nothing can be as good as plain white walls'.[14] The great revival in the patronage of Buddhism that took place in the later part of the sixteenth century and continued into the seventeenth led new temples to be built and old ones refurbished, new bells and statuary to be cast and gilded at great expense;

4 Fragment of a mural, *The Infant Buddha and Mahaprajapati*, said to have come from the Huayan Temple, Yicheng, Shaanxi province, dated 1551. Boston Museum of Fine Arts.

new wall paintings are almost never mentioned in the inscriptions commemorating these acts of élite piety.[15] European Jesuit observers of the Ming scene, for whom the temples of what they deemed to be idolatrous cults were a focus of concern and recording, scarcely mention wall painting, in marked contrast with the attention they give to sculpture. The loss of interest was not in the themes of religion that murals had largely embodied, but in the very form of such paintings. Such a change must indicate some shift in the culture of visuality on the part of the educated, For the early Qing Dynasty writer Pu Songling (1640–1715) the murals of a temple were not a familiar part of everyday life, but a dangerous and illusory phantasmal realm, a near-fatal boundary between seeing and being.[16]

Much early religious wall painting was expected not to be looked at, but to *do* something. As Paul Katz has shown with regard to one of the best-preserved and consequently best-studies of such programmes, that of the fourteenth-century Yonglegong in Shanxi province, murals in a Daoist or Buddhist temple were not there for decoration nor simply to inspire devo-

tion on the part of the worshipper.[17] Rather they were themselves an essential part of the rituals performed in those spaces. It was their iconography, not their style or the fame of the artist who painted them, that was from the point of religious practice absolutely central to their function. They were pictures that were *for* something (as, for example, *Divinities of Nature*, illus. 1), pictures placed on permanent view in public spaces and carrying shared public meanings. It was this that was to make them increasingly problematic in the eyes of the élite by at the very latest the seventeenth century, even if the piety of that élite was undimmed.

The plenitude of pictures

The decline in élite interaction with public pictorial formats in the Ming Dynasty cannot be put down to simple iconophobia. For at precisely the same time that this was happening, the private space of the book was exploding with a quantity of pictures greater than at any previous time since the invention of printing almost 1,000 years previously (illus. 5–9). These pictures range from the arcane figurings of technical treatises on philosophy (illus. 5) to the elaborate and beautiful, full-page illustrations for luxury editions of works of fiction and drama (illus. 8). It is these latter pictures that have formed the centre of the category of 'Chinese book illustration' since it was constructed earlier in this century by scholars such as Zheng Zhenduo (1898–1958).[18] They have continued to form the focus of scholarly attention, both within China and abroad, and to form the bulk of the material which those without regular and immediate access to a large library of Ming editions must use in a study of the subject.[19] Yet illustrations, broadly categorized, are much more widely distributed across the Ming world of print than this concentration of attention would suggest, whether it be the portrait of the author found in the collected works of individuals (illus. 43), or the diagrams setting out a new method of land surveying found in the writings of the stern reforming official Hai Rui (1513–87).[20] Any account of visuality at this time will have to engage with the complete spread of such figures, maps, plans, charts and author portraits, alongside the better studied aspects of the subject.

Printing was invented in China, a fact so well known as scarcely to need repeating. It is a fact that has been well known in Europe since the sixteenth century, receiving its earliest acknowledgement in English in 1614, when in his *History of the World* Sir Walter Raleigh noted, 'But from the eastern world it was that John Guthenberg, a German, brought the device of printing...'.[21] However the continued and repeated refusal to acknowledge the implications of this fact on the part of almost all discussions of the impact of the technology on early modern Europe is startling. This

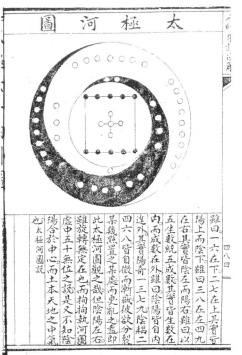

5 *Top left* Woodblock print, 'The River Diagram of the Supreme Ulitimate', from Lai Zhide, *Illustrated Explanation of the Classic of Changes Annotated by Mr Lai (Yi jing Lai zhu tu jie)*, 1599.

6 *Top right* Woodblock print, from the drama *The West Chamber*, 1498 Beijing Yue Family edition

7 *Below* Woodblock print, from the novel *The Romance of the Three Kingdoms*, Shuangfengtang 1592 edition British Library. At this late date the format of picture-above-text was a sign of a cheaper product.

8 *Left* Woodblock print, from the drama *The Lute*, 1597 Xin'an Wanhuxuan edition. Typical of the lavish full-page illustrations of the best quality Ming books.

9 *Right* Woodblock print, from *Water Margin Leaves*, designed by Chen Hongshou (1598–1652). Designs for a set of playing cards used in popular gambling games, illustrated with characters from a novel of heroic banditry.

refusal is classically laid out in Elizabeth L. Eisenstein's *The Printing Revolution in Early Modern Europe* (1983), an abridgement of her even more suggestively titled magnum opus, *The Printing Press as an Agent of Change: Communications and Cultural Transformations in Early Modern Europe* of 1979. She writes, 'Occasional glimpses of possible comparative perspectives are offered, but only to bring out the significance of certain features which seem to be particular to western Christendom'.[22] Bhabha's 'docile body of knowledge' could scarcely be made more explicit. And what are these 'singular features' discernible in the sixteenth- and seventeenth-century European setting which she sets out uniquely to document? They include the following: 'The fact that identical images, maps and diagrams could be viewed simultaneously by scattered readers constituted a kind of communications revolution in itself'; 'That the printed book made

possible new forms of interplay between [letters, numbers and pictures . . .] is perhaps even more significant than the changes undergone by picture, number or letter alone'; and 'Printing encouraged forms of combinatory activity which were social as well as intellectual. It changed relationships between men of learning as well as between systems of ideas'.[23] These views, though controversial in detail, have become commonplaces of historical debate, with all sides of the argument accepting that printing, and most particularly its characteristics of plurality and reproducibility, changed *something*. Citing Eisenstein as well as Marshall McLuhan and Walter Ong, Martin Jay's marvellously subtle and complex account of the discourse of visuality in European history can still conclude that 'the mechanical reproduction of actual images' had a major impact in a situation where 'the dawn of the modern era was accompanied by the vigorous privileging of vision'.[24] And within literary history, Bertrand Bronson has argued that is the dissociation between reader and writer, most noticeably from the eighteenth century in Europe, which is one of the enabling conditions of modern forms of communication.[25] Yet all these arguments for a perceived (even if unarticulated) European exceptionalism can only operate by ignoring the fact that in contemporary China texts and images were being, and what is more *had been* for centuries, reproduced mechanically and disseminated by a highly commercialized printing and publishing industry to an audience spread across the entire empire, and differentiated by status, by education and by gender in complex if as yet little-understood ways. The earliest illustrated editions of the classic Confucian texts dated from the twelfth century, and this was several centuries after the first Buddhist text to be produced in this way.[26] If the mere fact of the technology changed things, if the mere fact that 'identical images, maps and diagrams could be viewed simultaneously by scattered readers constituted a kind of communications revolution in itself', then that revolution had happened in China a couple of hundred years before Gutenberg. The decision to omit this inconvenient fact, and to frame the question of 'printing revolutions' as one affecting Europe alone, is excusable only as a defensive act which has already committed itself to protecting the given of European 'modernity' at almost any cost. Again, the point is *not* to argue that China 'got there first', but to cast doubt on the unilinear and exclusionary nature of the arguments deployed for the single destination of modernity.

In Ming China itself the effects of printing, ancient though they might be, were still the occasional subject of comment from members of the élite. Writing most probably in the 1550s, Lang Ying (1487–c.1566) traced the origins of the technology (correctly) to the Tang period (618–906). He saw the long years of peace and prosperity under the Ming as being uniquely favourable to the publishing of books, but saw the commercial

expansion of those years as being ultimately corrosive of standards, as publishers struggled with one another for advantage in an unregulated environment of competition. He blamed in particular the publishers of Fujian Province, who ruined everything they brought out, in a disaster for 'this culture of ours' equivalent to the burning of the books by the famous tyrant emperor of antiquity Qin Shihuangdi (r.221–210 BCE).[27]

Yet Lang's complaint was about textual corruption, and he makes no mention of the role of pictures in books. These were also the subject of criticism at this time, as when one commentator writes:

Nowadays the moneygrubbers in publishing houses make up novels and other kinds of writing...; their books and illustrations are copied by farmers, plain labourers and merchants. Every family possesses such writings and pictures, which ignorant women are particularly crazy about. Publishers then compiled *Women's Historical Chronicles* for this market, and even slandered ancient worthies in plays for mundane entertainments. Officials neglect to prohibit such things; educated gentlemen view them as normal. Some writers wish to criticise this social evil, but write plays to express their views and thus encourage the evil instead. Insincere writers compose plays as a pastime; their works, such as the *West Chamber* and the *Blue-cloud Steed*, have exerted such a widespread influence that no-one has been able to stop this trend.[28]

But even this is essentially a complaint about the corruption of manners, of which the chief symptom is the drama itself, the illustrated editions of such plays merely compounding the insult to propriety rather than causing it. What is in fact striking is how very *little* is written by the élite about book illustration at this period, given its prevalence in texts of all kinds and aimed at all kinds of audiences. The upper class writers of the Ming have left us more on the techniques and style of manufacturing carved lacquer than they have on the pictures in books. The wave of writing on luxury material culture, which began in the 1590s and which embodies a fascination with the world of goods in all their physicality and specificity, hardly mentions books. As objects of connoisseurship, the only books mentioned by a writer like Wen Zhenheng (1585–1645) in his 'Treatise on Superfluous Things' are Song antiquarian editions of standard historical, philosophical and belle-lettristic works; he lists as most desirable Song editions of the *Han shu, Hou Han shu, Zuo zhuan, Guo yu*, the works of Laozi and Zhuangzi, *Shi ji, Wen xuan* and works of the philosophers (*zhu zi*). In his second category of desirability are 'poetry and essays by famous writers, miscellaneous records and Buddhist and Daoist books'.[29] Wen might have been living in the late Ming 'golden age' of book illustration, the age which saw the development of colour printing in works such as *Cheng shi mo yuan* ('Master Cheng's Garden of Ink Cakes', 1606) and *Shi zhu zhai hua pu* ('Painting Album of the Ten Bamboo Studio', 1619–33), but he shows a

singular unwillingness to acknowledge it.[30] It is very rare to find a statement like that made by his older contemporary Xie Zhaozhe (1567–1624) in which he complains, 'As for books like the "Water Margin", "West Chamber" and "The Lute", the "Ink Cake Album" (*Fang shi mo pu*, 1588) and the "Ink Cake Garden", they involve the prolonged concentration of numerous souls, the exhaustion of effort over minute details, the cunning of heaven and the art of man, all vainly to amuse the eyes and ears with marvels. What a shame!'[31] The rarity lies in the fact that Xie is complaining not about the content of books but about the book as a luxury artefact, and one whose luxuriousness and excess lies partly at least in the sheer fact of illustration. Even the involvement, towards the end of the Ming Dynasty, of highly regarded artists such as Chen Hongshou (1585–1652, illus. 9, 35) did not generate an equivalent critical literature on this aspect of their work, compared with what was written about them as painters.

Such comments can perhaps be put down to élite snobbery, but it is also noticeable when one looks at the titles of Ming books how rarely, rather than how often, the presence of illustration is signalled in the work's title. There are something short of 10,000 works in the (far from definitive) *Mingdai banke zonglu* ('Bibliography of Ming Editions') compiled in the early 1980s by Du Xinfu.[32] Of these, I calculate that just under 200 advertise in their titles alone that they are illustrated. This advertisement can however take two very different forms. One is where the fact of illustration is integral to the title, such as the case of the famous encyclopaedia *San cai tu hui* ('Pictorial Compendium of the Three Powers', illus. 38, 49), or the collection of stories about distinguished examination successes of the early Ming, *Zhuangyuan tu kao* ('Illustrated Study of the Palace Optimes', 1607 and 1609). Such titles are in fact extremely rare. Just over seventy fall into this category of 'illustrated explanation' (*tu jie*) or 'illustrated discourses' (*tu shuo*), including for example the 'Illustrated Explanation of the Classic of Change Annotated by Mr Lai' (*Yi jing Lai zhu tu jie*, 1599; illus. 5). By contrast, the majority of the 200 are those, often with very long titles, that employ such formulae as *chu xiang*, *xiao xiang*, 'illustrated' or *quan xiang*, 'fully illustrated', usually in conjunction with other formulae meaning 'newly published' (*xin ke*, *xin xi*, *xin qie*), 'revised (*chong xiu*) or 'annotated' (*yin zhu*). These are by and large works of drama or fiction, where the 'core' title of the work bears no mention of pictures, and indeed where pictures are in no way essential, but where I think we are entitled to see illustrations as part of the marketing strategy of a commercial publisher. There is little point in describing something as 'illustrated' if that does not add to its allure in the marketplace. However, many more books contain illustrations and do not draw attention to the fact, whether through an integral or a core title.[33]

This lack of interest could be put down to two possible reasons, both of which will bear a certain amount of scrutiny. Possibly the very presence of illustrations in books seemed vulgar and beneath the notice of such arbiters as Wen Zhenheng, associated as they were with those sections of the public for whom the text was insufficient. Or possibly pictures in books were just too common, in the sense of widespread, to be worth noticing; it was something only to be expected that books of all sorts had pictures in them. Perhaps a certain purchase could be gained on this problem by looking at one actual library, and the cataloguing practices of its owner. The sixteenth century saw a marked increase in the publication of private library catalogues, which would if systematically analysed cast more light on the size and composition of the holdings of books in certain élite families.[34] One such owner, Gao Ru (active mid-sixteenth century) came from a hereditary military family, and was not a holder of any degree i.e. he was not a member of the highest reaches of the élite. However he did have a considerable library, which he catalogued himself in a text republished this century from a sole copy of *c.*1550 preserved in Japan.[35] This is of some importance in the study of Ming fiction and drama, since Gao, unlike his grander contemporaries, had no compunction about including such works in his bibliography, under the broad heading of 'History'. He also recorded the titles of books in a form that pays special attention to the presence of illustrations, and his annotations of individual volumes make mention of pictures on a few notable occasions. Although it is not possible to link his titles to surviving editions in most cases, what is clear is that he possessed works in almost all the traditional bibliographic categories where he thought it worth mentioning the pictures. In the 'Classics' section he had illustrated works on the 'Classic of Change' (possibly akin to illus. 5), the 'Classic of Poetry' and the 'Classic of History'. He had illustrated works on the ethnic groups of the south-west, and on geography. Occasionally he is more specific: a geographic text entitled *Dong guan di li tu* discusses '273 places, with 40 illustrations'.[36] He remarks of *Da Ming yu di zhi zhang tu* that 'The Territory of the world is divided into seventeen pictures, each supplied with textual explanation', implying that in this work at least he sees the illustrations as having primacy over the text, while their value is confirmed with regard to a work on border defences, the *Jiu bian tu lun*, where the strengths and weaknesses of the borders, the topography of fortresses and the lie of the land 'could not be seen without the pictures'.[37] (Clearly these pictures are what we would now choose to call 'maps', a distinction which will be discussed in more detail below.) Gao Ru occasionally notes the presence of pictures in works whose title gives no indication of the fact, works which include a morality book designed 'to explain the Four Principles of the diligent and frugal, rich and

noble, proud and luxurious, and poor and base. There are also illustrated explanations (*tu shuo*)'.[38] The mere fact of the presence of illustrations is noteworthy to Gao in recording titles like a supposedly Song treatise on inkstone designs (he says 'There are twenty-three pictures') while a famous pharmacopoeia elicits the comment, 'The pictures resemble their forms, the explanations record their uses'.[39] This interest in pictures as 're-cording the form' of plants is clearly removed to a considerable degree from the misprision of 'form likeness' found in aesthetic theorists concerned solely with painting, and begins to suggest a broader spread of attitudes to representation in the sixteenth century than those theorists would care to admit to. The enormous quantities of pictures in circulation via the medium of printing may have sharpened such contradictions, and pushed the issue of representation to a head.

The Japanese historian Denda Akira has calculated that some sixty separate editions of the romantic drama 'The West Chamber' were published in the Ming period, of which over thirty carried pictures (illus. 6, 32). Citing him Wu Hung goes on to point out that almost all of this thirty are late sixteenth-early seventeenth century in date.[40] This is very roughly the same proportion (i.e. about half) of illustrated-to-unillustrated editions which Anne E. McLaren found over the same time-span for the epic novel, 'Romance of the Three Kingdoms'.[41] In terms of quantity, this was the high point of the output of the Ming printing industry, concentrated in several centres and addressing somewhat different markets in terms of quality. The earliest illustrated editions of fiction and drama in the fourteenth century had been distinguished by a format in which the pictures ran along the top of the text, a formula still employed in the earliest as well as one of the finest editions of 'The West Chamber', that published in Beijing in 1498 (illus. 6). It has been calculated that the 150 pictures it contains would make a scroll 2–3 feet long if joined together, making it presumably expensive to produce. The publisher's colophon explicitly addresses the book to the context of the solitary, male reader, able to deploy leisure practices not available to the majority, when it says, 'This large character edition offers a combination of narrative and pictures, so that one may amuse his mind when he is staying in a hotel, travelling in a boat, wandering around, or sitting idle'.[42] It has been convincingly argued that 'the combination of narrative and pictures' in the earliest printed texts has its origins not in élite forms of the hand scroll, but in the use of such scrolls in picture-storytelling, oral performances where the reciter pointed to pictures to support the telling of the story (often a religious one).[43] Nearly a century after the 1498 'West Chamber', an edition of the classic historical novel 'Romance of the Three Kingdoms', published in 1592 by the Shuangfengtang of the Yu family in Jianyang,

Fujian Province, retains this format but with considerably more crudely drawn illustrations and less elegantly cut characters (illus. 7).[44] There is an immediate visual disparity between this small cartouche of two charging warriors and an almost exactly contemporary edition of 'The Lute', brought out in Hangzhou by a publisher employing some of the most famous block-cutters of the day to produce full-page illustrations rich in sumptuous detail (illus. 8).[45] Such disparity raises the question of the nature of the market for illustrated books: who saw them?; who purchased them (not necessarily the same question)?; and how did audiences conceptualize what they saw? In particular, were texts and pictures juxtaposed on the same page understood differently from full-page illustrations where the text was physically more remote, possibly even involving the act of turning the page before it could be engaged with? McLaren has stressed the difference between what she identifies as 'pictorial' editions of this picture-above, text-below type, and those 'complex editions' where extensive commmentary suggests a better-educated target audience for the 'same' work of fiction. Where her 'pictorial' editions have commentary at all, it is often of a very basic explicatory type, assuming low levels of cultural literacy on the part of the putative reader. Yet she also shows that such 'cruder' editions were circulating in élite households, citing the case of Chen Qitai (1567–1641), who at age ten borrowed such a book from his uncle, to his mother's annoyance. His defence was that he had *not* been looking at the pictures, suggesting that even a ten-year old was socialized into a sense of the somewhat low-class nature of such supports to the understanding.[46] We have as yet no fully effective history of *reading* as a practice in Chinese history, let alone one subtle enough to take account of the presence or absence of all the types of pictures which might be found in a whole range of books.[47] There has been little done as yet (McLaren's work is a very important exception, as is that of Katherine Carlitz) to match the sophistication of Roger Chartier's work on reading in early modern Europe, or of Eamon Duffy's sensitive discussion of the role of sacred pictures in the (much more limited) range of books circulating in the very different visual economy of fifteenth-century England, where the mere presence of illustration served to confirm the sacred status of the books that contained them, and where evidence exists of the personalized addition of pictures (printed and hand produced) to books.[48]

It would be helpful to know more about who owned books of any kind in the Ming period. Timothy Brook has pointed out the generally small size of such early to mid-Ming libraries as we have any reliable data for, at least before the middle of the sixteenth century and the expansion of commercial printing.[49] However by the later Ming libraries of 10,000 *juan* (the 'chapters' which made up the traditional unit of book size)

were more common. By 1562 the disgraced Grand Secretary Yan Song, whose property in that year was confiscated by the state, owned seventy-one titles deemed worthy of accession to the imperial library (mostly manuscripts and Song and Yuan fine editions), as well as 5,852 volumes (*tao*) of classics, histories and belles-lettres, and 841 volumes of Buddhist and Daoist scriptures.[50] This would seem to set some sort of upper limit on private holdings of books. Much more typical perhaps were the four titles found in the grave of a minor landowner of the early sixteenth century, all simple and widely circulated works of practical instruction. None of the four is illustrated.[51] Twelve illustrated books, one the text of a southern-style drama and the others belonging to the genre called *shuo chang ci hua* ('tales for recitation and singing'), have been found in the grave, dating to the Wanli period (1573–1627), of a Mrs Xuan, wife of a member of the official classes.[52] Given the alacrity with which male moralists associate a liking for drama and fiction with women, it is tempting to read too much into this find, which makes Mrs Xuan almost the only securely documented owner of illustrated works of this kind in the entire Ming period. As will be argued below, this temptation should be resisted.

If contemporary commentators had little to say about the pictures in books the internal evidence of the books themselves offers very little more. Much of what they do say is framed within a discourse of popularization, of reaching a wide audience, often with some necessary but not immediately entertaining moral message. Occasionally this involved using pictures to reach the totally illiterate, an aim invoked by the *Sheng yu tu jie* ('Illustrated Explanation of the Sacred Edict') of 1587, which aimed at the broadest possible exposure of normative imperial moral maxims through their interpretation in pictures (illus. 16).[53] However pictures in books are just as likely to be advanced by publishers as an additional pleasure for the already literate, something giving the edition a market edge over competitors, or making potentially dull content more palatable. The idea of visual pleasure, of the desire to look, is to the fore here. It is the stated aim of the illustrations to Lü Kun's 'Female Exemplars' (*Gui fan*) of 1591, which with its focus on women and the quarters they inhabit has an extra voyeuristic dimension for the male reader.[54] Visioning as intellectual pleasure is invoked in a far-fetched rationale for pictures throughout the book in the Preface to the 1637 technological work *Tian gong kai wu*, 'The Creations of Heaven and Man' (illus. 15):

Yet, while the best rice is cooking in the palace kitchens, perchance one of the princes would wish to know what farming implements look like: or, while the officers of the Imperial wardrobe are cutting out suits of brocade, another of the princes might wonder about the techniques of silk weaving. At such times a

volume of drawings that depict these tools and techniques will indeed be treasured as a thing of great value.[55]

The reader is by implication a person of great standing, too grand to know about practical matters but agreeably intellectually curious all the same, and likely to benefit from pictures as well as from words. Note that the fictional context of looking at these pictures is the fairyland of the palace, not the world of the élite mansion, with which the reader might more feasibly be familiar.

This rhetoric of dissemination invokes a very ancient and didactic view of the image as source of information about reality and as exemplar to be emulated. Pleasure, the desire to look, is not invoked in Ming texts except negatively, as a licentious act to be censured and avoided. The topos in Ming pornographic fiction whereby the viewing of erotic images infallibly produces a desire to imitate the actions depicted (and it is a topos in which men show pictures *to* women, always the more mimetically captured in Ming male constructions of visuality) operates on the same terrain which led the halls of ancient and modern emperors to be hung with the images of great men, whose deeds could inspire their successors. Both are predicated on an attitude to mimesis which is very different from that operating in the world of élite painting, of an image like that in illus. 3.

By the late Ming, however, the world of painting was already imbricated in that of the book, particularly in the persons of artists like Chen Hongshou (illus. 9, 35). Chen was only one of a number of artists with reputations in the world of painting who, in the later sixteenth and early seventeenth centuries, were involved in the production of designs for book illustrations. One of the first was Ding Yunpeng (1547–*c*.1628), who was responsible for some of the pictures in 'Master Fang's Manual of Ink Cakes' of 1588.[56] The court artist Gu Bing was the impresario of the extraordinary 'imaginary collection' contained in 'Master Gu's Pictorial Album' of 1603 (illus. 74–6, see p. 141). Later on in the 1640s, Xiao Yuncong (1596–1673) worked on illustrations to albums of topographical prints and of at least one work of classical poetry. Chen himself had a hand in at least five books, among them the set of designs for playing cards, decorated with characters from the great vernacular novel of romantic outlawry and issued in 1640 as *Shui hu yezi*, 'Water Margin Leaves' (illus. 9).[57] Chen worked with one of the most prolific cutters of blocks for luxury editions at this time, one Xiang Nanzhou, whose signature appears on more then ten surviving editions of drama or fiction. This signing of illustrations by the block cutters (the most prominent of whom were the Huang family from Huizhou, active in all the major publishing centres) is an innovation of the later sixteenth century, and parallels to an extent the increased use of

signatures on other luxury products such as jades, lacquers and certain types of ceramics at the same time.[58] Taken together with the involvement of painters, it might be seen as a sign of a rise not only in the status of the artisan, but also of the rise of the illustrated book to an object of élite concern, even despite the silence of arbiters like Wen Zhenheng.

The situation may in fact be much more complex than that. Anne Burkus-Chasson has shown how very hard it is to pin down the range of pictorial practices in which Chen Hongshou was involved through the use of such blunt critical instruments as 'amateur' or 'professional' (or in their emic late Ming forms 'elegant' and 'vulgar').[59] She unpicks the complex circumstances surrounding his hanging scroll 'Lady Xuanwenjun Giving Instruction in the Classics' (illus. 35), produced in 1638 not only as part of the network of élite and familial obligation to celebrate the birthday of the painter's aunt, but also to allow space for subtle and personal interventions on questions of political engagement and personal retreat. Yet at the same time he was involved with the purely commercial world of literary publishing through projects such as the 'Water Margin Leaves'. Her analysis demonstrates that by the 1640s for someone like Chen, 'amateur' and 'professional' were social roles to be negotiated, masks to be slipped on and off almost at will, rather than fixed and inescapable social markers.

Thus to debate whether pictures in books in sixteenth–seventeenth-century China represent a 'popularization' of élite taste, its penetration by the visual signs of the non-literate, or by contrast whether they represent a 'trickle-down' effect of élite ways of seeing, may simply be to pose the question wrongly. The very notion of a polar opposition between 'popular' and 'élite' culture in Europe at the same time has been the subject of a sustained critique by Chartier. He has argued against the notion 'that it is possible to establish exclusive relationships between specific cultural forms and particular social groups', but by contrast has claimed:

One notion has proved useful to an understanding of these phenomena: appropriation. It has enabled me to avoid identifying various cultural levels merely on the basis of a description of the objects, beliefs or acts presumed to have been proper to each group. . . . A retrospective sociology has long held that unequal distribution of material objects is the prime criterion of cultural differentiation. Here, this theory yields to an approach that concentrates on differentiated uses and plural appropriations of the same goods, the same ideas, and the same actions. A perspective of this sort does not ignore differences – even socially rooted differences – but it does shift the place in which this identification takes place. It is less interested in describing an entire body of materials in social terms . . .; it instead aims at a description of the practices that made for differing and strongly characteristic uses of the cultural materials that circulated within a given society.[60]

Chartier's central idea of 'appropriation' has been usefully deployed within the historical context of late Ming China by Katherine Carlitz, in her discussion of the illustrated editions of biographical compendia on the lives of idealized role models for women.[61] It is important to the present study too in suggesting a way of going beyond attempts to associate *this* kind of object or representation with *that* kind of person, or to say 'this type of picture is popular, that type of lacquer box is in scholar's taste'. Chartier sees his project as one that attempts to 'close the false debate between . . . the objectivity of structures and . . . the subjectivity of representations'. In attempting to map some of the broader contours of the visual in Ming China, this guiding principle of refusal to pin down individual objects and the representations they bear on the basis of the perceived social status of their owners, makers or consumers may enable a more historically grounded picture to emerge. We cannot say, 'This sort of picture was meaningful to that sort of person'. Things were never so simple.

Iconic circuits

This complexity is made manifest in the relationship between figural representation in painting, in printing and on objects, exemplified by an inlaid lacquer box (see illus. 10). It was manufactured probably towards the end of the fifteenth–first half of the sixteenth centuries, and is decorated using the technique of inlaying pieces of mother of pearl against a black lacquer ground, over a wooden core. The practices of the art market and of Western scholarship, for which iconography has traditionally been of much less importance than dating, have until very recently tended to describe the subject of pieces such as this as 'a sage, with attendant, sitting on a terrace outside a pavilion, watching a bird in flight'.[62] However, the figure depicted is not any generalized 'sage' or 'scholar' but rather a representation of a particular figure from the past, the famous poet and recluse Lin Bu (967–1028 CE). This is established by a number of prominent visual clues. There is the distinctive head cloth of the recluse, very different from the winged hat of the Ming official élite (see, for example, illus. 26). Above all there is the coincidence of cranes and the blossom of the flowering plum, *Prunus mume*, for it is with these above all that the figure of Lin Bu is associated. He is forever linked to the tag that he 'took the plum to wife and the cranes as his children'. Interest in him seems to have been on the rise in élite circles at the point when the box was made: his grave at Hangzhou's West Lake, despoiled under the Mongol Yuan Dynasty, was restored in 1457–64, while new structures alluding to his life there were erected on the shores of the lake several times in the first half of the sixteenth century.[63] As a poet with a major reputation, he

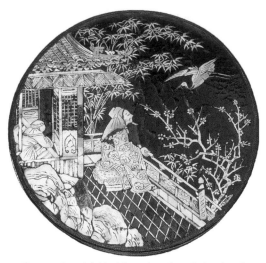

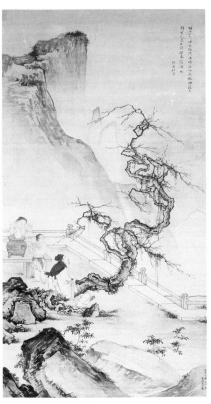

10 Lacquer box, inlaid with mother of pearl, showing the Song dynasty poet Lin Bu, *c.*1500. Victoria and Albert Museum.

11 Du Jin (active *c.*1465–1505), *Playing the Qin under a Plum Tree*, ink and colours on silk. Shanghai Museum. This painting of the poet Lin Bu relates closely to the same subject seen on the decorated lacquer box in illus. 10.

would seem to be firmly associated with the 'high' literary culture of the educated. He had a presence too as a subject in painting (illus. 11), represented a number of times by professional artists patronized by the upper classes, painters such as Du Jin, whose hanging scroll, 'The Poet Lin Bu Walking in the Moonlight' has been studied by Stephen Little.[64] Little points out that traces of Lin's calligraphy were highly prized by Shen Zhou, who owned the album in which they were preserved. This cannot be taken, however, to mean that a box like that shown in illus. 10 is an unproblematic part of the visual culture of the élite, simply by virtue of its subject-matter. The identification of the figure on the box as Lin Bu is done in a manner much more thumpingly obvious than that in the painting, and certainly more so than might have been necessary within the allusive poetic culture of a Shen Zhou. Even more problematic for the élite was the very status of figural representation, which was losing esteem *within painting* to a considerable degree at this period. For just as gentlemen did not do walls, gentlemen by and large did not do figures in the early sixteenth century, increasingly they were the domain of professional painters (however well-regarded at the time) like Du Jin. Ming

objects are covered in figural representation at precisely the point when Ming aesthetic *theory* confined them to a distinctly inferior status.

No figure in the literary past had a higher status than the poet, theorist of aesthetics, philosopher and statesman Su Shi, also known as Su Dongpo (1037–1101). His pronouncements on painting as something that went 'beyond representation' (the province as he saw it of children and other inferior intellects) achieved near-canonical status in the Ming, and were repeated extensively. Had his theories actually achieved universal normative status (as is sometimes suggested in the historiography of Chinese painting), then we would be even more at a loss to explain something like the representations of the man himself, whether in printed (illus. 12) or painted (illus. 13) form. The painting is the earlier object, being by Zhang Lu, a painter active in the early part of the sixteenth century who was by that century's end the object of an almost unrivalled quantity of critical invective as the creator of 'wild and heterodox' pictures.[65] The scroll shows the triumphant return of the great statesman to the Hanlin Academy, following a period of banishment at the hands of political opponents, preceded by the lanterns sent by his patron the Dowager Empress, and surrounded by a crowd of well-wishers and attendants. This is a famous moment in Chinese history, one known to every literate person.

One of the mechanisms whereby such stories became known was that of the illustrated encyclopaedias of Chinese culture, and anthologies of prose and verse, published in considerable quantities as the sixteenth century progressed. These gave access to elements of the high tradition to anyone who could read to almost any degree, and are part of the broader 'commoditization of knowledge' which is one of the distinctive features of the age. Illus. 12 shows the same subject as the Zhang Lu painting, the return of Su Shi from exile, although in a greatly abbreviated form. It comes from an anthology entitled 'The Orthodox Lineage of Classical Prose' (*Gu wen zheng zong*), published in Anhui in 1593.[66] Its sixteen chapters of extracts from the most admired writers of the past are each headed by a full-page illustration showing one literary hero in a characteristic pose, flanked by a couplet descriptive of the scene. Lin Bu with his cranes and flowering plum, Su Shi with his lanterns and palace attendants, these are both examples of the kind of trope described by Wai-kam Ho as complying with the important notion of *yue ding su cheng*, 'established by consensus and perfected by tradition'. These are literary and/or visual tropes, whereby the image of Lin Bu is enough to conjure up for the educated an entire corpus of allusions to reclusion and purity of disengagement from the grubby world, while Su Shi always stands for the righteous but wronged official whose ultimate vindication is secure.

12 Woodblock print showing the scholar and politician Su Dongpo, from *The Orthodox Transmission of Antique Prose (Gu wen zheng zong)*, 1593 Anhui Zhengshaozhai edition

13 Zhang Lu (*c.*1490–*c.*1563), *Su Dongpo returning to the Hanlin Academy* (detail), ink and colours on paper. The Jingyuanzhai Collection (University Art Museum, Berkeley).

Once the authority of these icons is established through the sociocultural process of *yueh-ting su-ch'eng*, the mere mention of the name of the person or place, if manipulated skilfully and structured effectively, will immediately induce an irresistible lyrical empathy with the implied space and time, united by the human drama.[67]

An assumption is being made here about the homogeneity of the audience to which imagery was addressed. The fact that irresistible lyrical empathy was the subject of commerce in books and luxury goods tends rather to undermine the image of Ming culture as one operating solely on the basis of exquisitely subtle hints and allusions. The very obviousness of the references on the box and in the book suggests forcefully that there were customers and conditions of viewing when what was wanted in the way of references to the past was clear and above all obvious mimetic association.

These associations could well exist in paintings too, paintings of a kind which were so low on the scale of élite esteem that they do not register at all, and indeed survive as physical objects only by occasional acts of chance, usually the circumstance of export from China at the time of their manufacture, or their reattribution in the art market to more prestigious artists. These were the workshop manufactured paintings that did not even bother with the most basic apparatus of élite art, the signatures and colophons, but instead went into the world of commerce purely as pictures. An example would be the very rare one preserved since before 1596 at Schloss Ambras near Innsbruck as part of an archducal *Kunstkammer* (illus. 34).[68] This, together with another example fortuitously preserved in Europe (illus. 2) are the remnants of a once flourishing pictorial industry, manufacturing images using the technical resources also employed in élite art (both are in fact on silk), but in a form which appears largely unaware of the strictures of élite theory. Indeed élite theory, and in particular its counter-representational rhetoric, only begins to make some kind of sense when we consider that it operated in a climate of picture-making that was in the main entirely '*within* representation', satisfying customers who required images for reasons very different from those proposed by the theorists whose views had come to seem normative by the present century.

The Ambras picture, which clearly shows a single male accompanied towards a palace by an escort, who bear lanterns in front of him, may well not be the generalized 'Palace Scene with Female Orchestra' of modern cataloguing, but a very precise reference to the return of Su Shi. Whatever it is, it is clearly the same scene as that on a carved lacquer panel now in the Tokyo National Museum (illus. 14), and formerly part of a table screen. Indeed the iconographical congruence between illus. 12–14 and 34, all of

which I would argue do show the same subject, suggests a type of common pictorial engagement across a range of media, from painting by a prominent artist (Zhang Lu was successful in his own time, if vilified later), through anonymous paintings to books to luxury craft objects. There would be very little point in attempting to rank these four representations of the same theme on a hierarchical basis, from 'élite' to 'popular', as Chartier has shown. Nor does it make very much sense to attempt in traditional art-historical terms to trace 'influences' from one medium to another, assuming either the priority of painting or the converse, its dependence on themes from the crafts. As with the Lin Bu box and the Lin Bu painting, it might in fact be more fruitful to explore the notion of the 'iconic circuit', an economy of representations in which images of a certain kind circulated between different media in which pictures were involved. Carlo Ginzburg's use of this term with regard to sixteenth-century Europe differentiates two iconic circuits:

one public, widespread and socially undifferentiated, and the other, private, circumscribed and socially elevated. The first contained statues, frescoes, canvases and panels of large dimensions - objects exhibited in churches and public places, accessible to all. The latter consisted of the above, as well as paintings and panels of small dimensions, gems and medals preserved in the homes of an élite of lords, prelates, nobles and in some cases merchants. To be sure, this is a simplistic distinction, warped, moreover, by the growing diffusion of printing: it suffices to mention the widespread circulation of sacred images in commonplace settings. Nevertheless the identification of two iconic circuits, one public, the other private, seems useful, at least in a preliminary evaluation, for the question of erotic images that interests us here.[69]

The dichotomy public/private may well be one that provides little interpretative leverage in the Ming period, based as it is on parochially European notions of space and public culture, but I would argue that it is worthwhile at least attempting to appropriate the idea of the 'iconic circuit', and in particular the notion of exchange and movement, the circulation of images for which it provides a metaphor. It may provide, for example, a much better mechanism than 'style' for interpreting the visible difference between two pictures by the same artist which both copy other artists (illus. 29 and 3). The first, *Copy of Dai Jin's 'Xie An at East Mountain'*, occupies something of the same position as Zhang Lu's picture of Su Shi: a real historical figure is painted in a setting and is involved in social relationships that allude to a large corpus of literary and historical material external to the representation itself. If they do not 'tell a story' they instantiate stories that exist to be told. The *Landscape in the Style of Ni Zan* (illus. 3) could be seen as inhabiting a different 'iconic circuit', in the sense that it signifies *only* the other work of art, the much

14 Carved lacquer panel from a table screen decorated with the theme of Su Dongpo's return, 16th century. Tokyo National Museum.

admired style of one of the 'Four Great Masters of the Yuan'. This, the 'art-historical art' identified as the distinctive and distinguishing essence of Chinese painting in the kind of accounts on which Bryson has drawn, would in this reading no longer stand for 'Chinese painting' but merely one circuit among several. Quite how many is hard to say, and to attempt to circumscribe them would be to miss the point – it is the fluidity of the concept which is its attraction. It would, for example, be premature to impose categories like 'secular' and 'sacred' as grounds for distinguishing between the palace lady (illus. 28) and the nature deities (see illus. 1). Clearly there are interchanges between circuits, if only because the same people (like Shen Zhou) were involved in the consumption and production of images which might find themselves circulated within and between more than one visual arena. But another advantage of this notion to any sort of enquiry based broadly on a 'visual culture' paradigm is that it side-steps the painting/not-painting division and allows an engagement with the pictorial in whatever physical forms it is produced and however it is viewed and consumed.

It is a central proposition of this book that the period from 1400 to 1700 in China saw the two circuits potentially represented by, very crudely, the referential picture and the self-referential picture (illus. 29 and 3), grow more estranged as the period went on, and as the latter, now identified as 'scholar painting', assumed a hegemonic position within élite culture. This deprived the former of discursive force, until pictures with stories in them became both unthinkable and unwritten about, especially if they were by artists configured as part of the now normative writing of art history. One of the most important effects of the enormous work of recuperation undertaken by Richard Barnhart and collaborators on the body of non-'scholar' painting, is the recovery of the lost subject-matters of many Ming paintings. He has shown how a considerable body of pictures (eleven examples are cited), which reside in museum collections with titles such as *Winter Landscape*, are in fact representations of a story known as 'Yuan An Sleeps Through the Snow', in which a moral paragon of the later Han Dynasty puts his own concerns below the public weal.[70]

The rediscovery of the theme makes sense of the existence of the pictures, since they evoke notions of service which the political and cultured élite saw as embodied in their own persons. A picture of Yuan An thus was an extremely appropriate gift for anyone in government service, just as the return of Su Shi to the Hanlin stood for triumph over political enemies and Lin Bu stood for the delights of private life (whether enforced or not). The oblivion of these subjects, which were in the years around 1500 still part of the repertoire of impeccably 'scholarly' artists like Wen Zhengming (1470–1559), is part of the larger obscuring of the narrational

in Chinese élite visual culture, which goes hand in hand with the decline in continuously present pictorial formats like wall-painting, in favour of the more intimate pictures contained in scrolls, books and luxury objects.

The circulation of images

If images did indeed 'circulate', and if the idea of 'visual economy' is to be more than an attractive metaphor, it is necessary to spend some time thinking about the material practices which enabled them to do so. Not all types of picture appeared in all types of medium. Nor was there anything as convenient as a simple 'fine arts'/'decorative arts' split, whereby subjects appearing in painting formed one realm and those appearing on textiles or lacquer or ceramics formed another. As we have seen, the 'Su Shi returns to the Hanlin' story appears in painted form, in books and on lacquer. The technology of printing is obviously one way in which pictures could be multiplied, and it was clearly the single most important, but it was not the only one. Another, much older technology that may in fact have given rise to printing in the past was that of engraving text and pictures on stone, and allowing rubbings to be taken from that stone which could then be disseminated much more widely. This was the major way in which samples of the élite art of calligraphy were circulated, but it was also used for pictures in certain specific contexts (illus. 16). One of these was pictorial biographies of Confucius, which have been recently studied in detail by Julia K. Murray.[71] She points out that this subject, despite its importance to the élite, was not treated by any famous artist of the Ming period, but instead exists only in a number of printed and engraved forms.

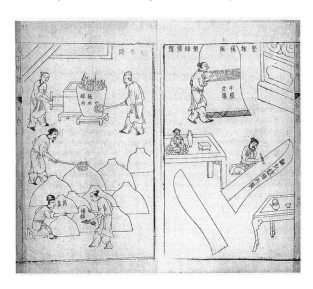

15 Woodblock print illustrating techniques of bell-founding, from *The Creations of Heaven and Man (Tian gong kai wu)*, 1637. Bibliothèque nationale de France, Paris.

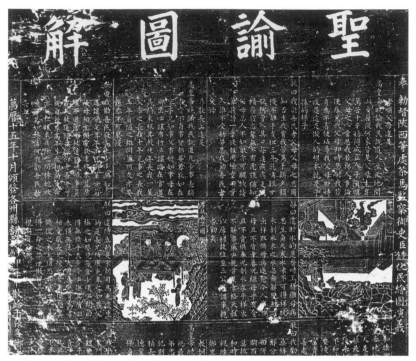

16 Stone rubbing, *Illustrated Explanation of the Sacred Edict*, dated 1587, showing state-sponsored ideals of decorous behaviour. Field Museum of Natural History.

She also shows that such a pictorial biography of the Sage was an innovation of the Ming period, appearing first in the fifteenth century in both book and stone forms, the two being in the first instance intimately related. These pictures did indeed circulate through a number of reproductive processes, with painted pictures by anonymous painters being subsequently transferred to stone, from which rubbings were made, which in turn were repainted and transferred onto woodblocks for printing. These representations of Confucius' life multiplied rapidly in the sixteenth century. In 1592 a set of stones displaying the biography was installed in the Temple of Confucius at Qufu, the birthplace of the Sage in Shandong Province. It is worth stressing again that no purely *technological* explanation will account for this phenomenon: none of the practices involved was new, rather they were extremely old. It was the scale of their deployment, and presumably their reception by audiences in changed social and intellectual circumstances, that was the novelty. It is also worth noting the use of stones rather than wall paintings as away of rendering permanent the biography of the cult figure of a site (in an equivalent fourteenth-century case, murals were used extensively).[72] This may be partly to do with the

archaising associations and the aura of permanence surrounding texts and images 'cut in stone', but it may also have to do with a consciousness of the dissemination of pictures as a desirable possibility. The 1592 'Record of the Hall of the Pictures of the Sage' explicitly states that, '[One] can respectfully regard them and have an audience with them, or take rubbings and transmit them',[73] making it clear that visitors of a certain standing would be allowed to take versions of the biography away with them (the precise details, as for example whether visitors took their own rubbings with their own materials, had servants take them, or purchased them from the custodians of the shrine, remain unclear).

At the level of actual workshop practice, the techniques for ensuring the reproducibility of pictures are much more obscure, and rely in the absence of any written evidence on surviving objects themselves. That workshops used pattern books is clear. This was so in the field of painting as well as of other types of manufactures. Two surviving hanging scroll-on-silk versions of the 'Yuan An Sleeps through the Snow' story are 'similar enough to allow the possibility that they were done from the same cartoon, design or stencil'.[74] A lacquer tray from the early sixteenth century (illus. 33) showing the summer departure of hopeful participants in the examinations for the *jinshi* degree exists in two identical versions now in London and Osaka, making it impossible that they were not manufactured in the same workshop using some sort of pattern, whether painted or printed.[75] It is only sensible practice that a workshop, rather than creating every picture from scratch, would retain some sort of pattern book of the most popular subjects, and indeed examples of these patterns or cartoons (in Chinese *fen ben* or *pu zi*) from the later seventeenth century and on into the Qing period are known to have survived.[76] It seems more likely that these costly objects were manufactured on commission, rather than completely speculatively, giving a putative pattern book a role also in a customer's process of choosing the sort of object desired for purchase. However, competition between workshops may be one factor in reducing the number of widely circulated printed collections of patterns, which are in fact extremely rare. Apart from the published catalogues of ink-cake designs mentioned above, almost the only surviving Ming or early Qing printed pattern book for any sort of craft is the *Jian xia ji*, 'Collection of Scissored Clouds' (illus. 19) which exists in a unique copy. Some doubt surrounds the actual utility of this work too, and it has on the contrary been argued that, 'It is likely that very limited editions of works of this quality were produced for an élite audience, and it may be presumed that other artisans published similar books, which have not survived to this day'.[77] It may well be that what we are seeing here is an élite appropriation of an artisanal form, akin to the re-writing by scholars of the specialized

17 Wine jar, porcelain painted in underglaze blue with design of boys playing, Jiajing reign period (1522–66). Victoria and Albert Museum, London.

18 Porcelain jar painted in enamels with the exemplary story of the 'Five Sons of Yanshan', 1500–50, Victoria and Albert Museum, London.

19 Colour woodblock print of an embroidery design showing boys playing, from the pattern book *Jian xia ji*, mid-17th century. Private Collection.

mnemonic verses on which craftsmen relied for technical information.[78] The subject depicted, often referred to as 'The Hundred Boys', shows male children engaged in a number of carnivalesque activities, the most significant of which (in the bottom-left corner) shows them burlesquing the triumphal procession of the *zhuangyuan*, the top candidate in the highest level *jinshi* exam. This was such a widely dispersed subject through a range of crafts (illus. 17) that it is very unlikely a weaving or ceramics workshop actually needed to purchase a book showing them how it was to be represented. A combination of now-lost drawings and all-important verbal formulae is the much more likely origin of this subject on a porcelain jar of this type.

The idea of pictorial subjects having verbal referents as well as visual ones is made clearer if we consider what is a rare subject on a Ming object, a small mid-sixteenth-century ceramic jar painted in enamels with the story of 'The Five Sons of Yanshan' (illus. 18) Dou Yanshan, an obscure grandee of the tenth century, is renowned largely for having five

sons who all rose to high office, and who are shown on the other side of the jar processing in their official robes to pay their respects to their father.[79] This is a relatively rare theme in purely visual terms, not known to me on other Ming objects, and certainly not surviving in painted form, although it may once have formed part of the repertoire of the sort of workshop responsible for *Palace Scene with Female Orchestra* (illus. 34). However, the subject could not be better known, appearing as it does in the elementary 'Three Character Classic' (*San zi jing*), the rhyming primer used to teach children in the Ming to read, and which they memorized as an introduction to cosmology, ethics and history:

Dou Yanshan,
Had the right plan,
Taught his five sons,
Each became a great man.

The purposes to which such an object might have been put will be explored below, but for the present it is necessary to remark that we will only advance our understanding of the role of pictures in Ming society if we pay attention to the form in which they appear. This is not just a ceramic, but a particular kind of ceramic, enamelled in a distinctive and temporally specific palette with a subject not seen on other objects. The same kind of enamelled jar is the only object known to me carry a scene from one of the best-known (and most heavily illustrated) novels of the Ming period, *Xi you ji*, 'The Journey to the West', also known by the

20 Porcelain bowl with moulded decoration of exemplary figures from history, 1500–50. University of Sussex.

English title 'Monkey'. A full mapping of the visual culture of the period would thus have to take account of a great number of variables, down to quite striking levels of differentiation. To take another example, there is a group of green-glazed porcelain bowls, made in the sixteenth century in Zhejiang Province in the style of ceramic ware known after the site of one of the kilns as 'Longquan', which is impressed (not a very common technique) with figurative scenes from the drama (illus. 20). The use of wooden moulds to make reproducible pictures in clay is yet one further technique to be taken into consideration, but not one which was widely spread throughout the ceramic industry, in contrast with the more costly technique of hand-painting. Why should this be? What coming together of producers, techniques, practises of commissioning and ownership, and consumption bought this group of objects into being, and caused them to cease to be made? We are still a very long way from being able to answer such questions.

Pictures on things and pictures of things

A wide range of Ming objects had pictures on them, pictures which in some cases were shared with the world of printing and of books. However pictures *of* things within those books have a much more fugitive status, and it is worth pausing to consider the absence from certain Ming books of pictures, in contexts where the contents would seem to render them not only useful, but also almost obligatory. Most striking is the absence of pictures from the literature of material culture produced from the 1590s, texts such as *Zun sheng ba jian*, 'Eight Discourses in the Art of Living' by Gao Lian, and *Zhang wu zhi*, 'Treatise on Superfluous Things', by Wen Zhenheng.[80] These are texts that pay close and serious attention to the world of manufactured goods, specifying materials, decoration, even dimensions, but which by and large eschew illustration, despite the purely technical ease with which they could have been included. 'Eight Discourses' it is true does contain a small number of illustrations, including instructions for life-prolonging exercises and a plan for the packing of travelling picnic hampers, but the sections on things are notably, with the single exception of inkstone designs, un-pictorial. 'Treatise on Superfluous Things' contains no pictures at all. Given the work's dependence on a socially structured-discourse of the 'elegant' and the 'vulgar', this would seem to lend force to the notion that pictures are of themselves 'vulgar' (and indeed Wen Zhenheng makes this explicit at one point as we shall see). However, his 'Treatise' is a work of 1615–20, and one with a very specific agenda, which cannot of itself be taken as normative for the entire period. Things could be represented in books, things such as the clothing

21 Bottle painted in underglaze blue with scene from the drama *The West Chamber*, 1620–40. Vctoria and Albert Museum, London.

and sacrificial vessels of the philosopher Wang Gen (1483–1541), contained in an edition of his collected works published in 1631.[81]

When by the seventeenth century things were represented in a context acceptable to the élite, the epistemological status of those representations did indeed often go beyond the mimetic. Compare two artefacts of the mid-seventeenth century, both of which are decorated with scenes from the ever popular drama 'The West Chamber' (illus. 21, 32). The first is a ceramic vase painted in underglaze blue, of a type extremely common at the time, and for which there was clearly an extensive market, even if we do not know quite how that market was structured, or indeed what sort of customers comprised it.[82] The scene shown is related quite directly to illustrated texts of the play. It is a picture on a thing. Much more complex is the printed picture *of a picture* on a thing shown in one of the illustrations from one of the great luxury books of the age, the colour printed edition of the text produced in 1640 by Min Qiji (illus. 32).[83] The twenty pictures, one for each act of the play, have been described by Wu Hung as 'the most amazing collection of metapictures from traditional China'.[84] What

makes them so astonishing is their representation of twenty types of arte-
fact or performance (puppet shows, scroll paintings, bronze vessels, fans
and as here lanterns) in a manner which queries with a sort of playful im-
placability the security of any kind of representational stability. A printed
picture of a lantern of a picture of play contains so many layers of referen-
tiality that it undercuts the possibility of saying '*this* is a picture of *that*'
with any sort of certainty. Such indeterminacy was now what advanced
aesthetic theory of the period held to be both desirable and normative.
However, it is the very rarity of this type of representation in anything
other than certain modes of élite painting which is perhaps just as telling.
The Min Qiji album is indeed amazing, amazing as some kinds of seven-
teenth-century painting are amazing, but it is also very much by itself,
outnumbered and surrounded by a world of pictures whose consumers
continued to feel much more comfortable with pictures which remained
quite firmly 'within representation'.

Objects and occasions

If close attention needs to be paid to variables of format and materials in
looking at the deployment of pictures in Ming culture, then one other
much more complex variable needs to be given even greater attention, de-
spite its intractability to traditionally art-historical forms of analysis. This is
the factor of occasion, of time. The physical mobility of the objects dis-
cussed here was not accidental, it was on the contrary central to their
ability to constitute meaning, by appearing in certain contexts at certain
times. It is a central thesis of this book that, in understanding the use of pic-
tures in the Ming period, *when* they were seen was as important as what
they depicted. This was just as true of paintings as it was of other kinds of
objects. Perhaps the best-known example of this is the sets of representa-
tions of 'door-gods' displayed at the New Year in the Ming period (as
today) in painted or printed form.[85] The 'Treatise on Superfluous Things'
is only making explicit existing élite forms of knowledge when it lists the
precise circumstances and times of the year when certain types and subjects
of painting could elegantly be displayed. If anything, such distinctions may
have been *more* important in the 1620s than they had been earlier, in that by
the late Ming anxieties over the collapse of hierarchies of cultural and
economic capital into one another increased the importance attached to
manner of possessing over the sheer fact of possession.

 Robert H. van Gulik long ago translated in full Wen Zhenheng's 'Calen-
dar for the displaying of scrolls', describing them as 'representative for
those prevailing in literary circles during the later part of the dynasty'.[86]
The key concept here is 'appropriate':

At the New Year it is Song paintings of the God of Happiness which are appropriate, together with the images of famous sages of antiquity; around the 15th of the First Month [pictures of] viewing lanterns and puppet shows are appropriate. In the First and Second Months spring excursions, ladies, flowering plum, apricot, camellia, orchids, peach and plum are appropriate. On the 3rd day of the Third Month a Song painting of the dark warrior is appropriate. Around the Qingming Festival peonies and tree peonies are appropriate; on the 8th day of the Fourth Month Song and Yuan Dynasty paintings of the Buddha and Song embroidered Buddhist images are appropriate

The list continues with equivalent precision through the twelve months of the year. Occasional anecdotal evidence suggests that such prescriptions, or personal variants of them were in fact adhered to, as when one writer notes how his friend Xu Lin would bring out a hanging scroll of the Thunder Gods by the painter Du Jin, 'on the day of the Dragon-Boat Festival, or on the 15th of the 7th month'.[87] There are also equivalent prescriptions in Wen's *Treatise* for events which are not fixed:

As for occasions like moving house, then there are pictures like 'Immortal Ge Moves his Dwelling', and for birthdays there are academy paintings such as the Star of Longevity, and the Royal Mother of the West. When praying for good weather there are such paintings as the Lord of the East, when praying for rain there are antique paintings of the divine dragon of wind and rain, or of the spring thunder stirring the insects. At the beginning of spring there are pictures of the god Donghuang Taiyi; all of these should be hung according to season, to manifest the succession of seasonal festivals.[88]

A passage like this, as well as suggesting that even such an aesthetically aware commentator as Wen Zhenheng was not indifferent to subject-matter, and that indeed he retained a considerable awareness of the apotropaic and performative aspects of picture making, also helps us to make sense of a picture which shows the literary incident of a culture hero of the past moving house (see illus. 29), making it an appropriate gift for a friend or acquaintance faced with such an event themselves.

Indeed it is the fact of exchange, the relationships of mutuality and reciprocity in which a very high proportion of surviving Ming objects were enmeshed, which enables us to get a handle on the whole question of the circulation of images. Pictures, whether on silk scrolls or lacquer boxes, circulated not in some metaphorical sense but literally. A large proportion of surviving Ming pictures existed to be *given* as gifts (even if originally purchased from their makers by the donor), and very often as we shall see they were given back. Many of the most famous pictures of the period bear inscriptions telling us of their presentation by the painter to a friend, relative, colleague or other social peer. Members of the élite without reputation as painters would still occasionally attempt to produce a picture

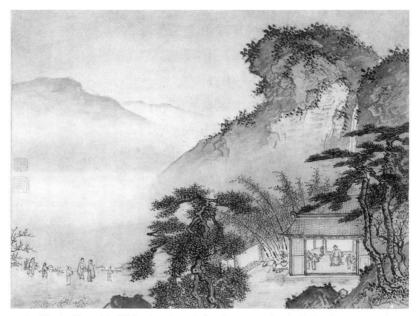

22 Dai Jin (1388–1462), *Wishes for a Long Life in Retirement*, first half of 15th century, Palace Museum, Beijing.

23 Carved lacquer tray depicting the type of inter-elite visiting in which such a tray was used for the presentation of gifts, early 15th century, The British Museum.

if it was designed to be given as a gift to a patron or relative.[89] Modern anthropological theories of the gift (all of which are in some sense indebted to Marcel Mauss) fit very comfortably with the Ming evidence, where presentations were clearly made to embody physically relationships which already existed, as much as to create those relationships.[90] What was crucial was that no relationship was ever perfectly equal, it always existed in a situation of status or power imbalance, which it acted to acknowledge. Taking 'the gift' as an analytical category, no matter how crude, is a useful way of cutting across fine art/decorative art distinctions with regard to Ming objects. Thus there is a clear congruence of purpose between the uses to be made by a donor of a painting like Dai Jin's 'Wishes for Long Life in Retirement' (illus. 22) and a lacquer plate of a date rather earlier in the fifteenth century (illus. 23), which shows a similar scene of élite visiting, in addition to being formally rather close in compositional terms. The fact that the painting is titled in so specific a way helps us to read the previously generic scene on the dish, and alerts us to be aware of 'retirement' as one of the life-events requiring commemoration through the transference of objects such as paintings and lacquer ware across the course of the Ming period.

Birthdays were another such a life-event, as Wen Zhenheng confirms (illus. 24). These were certainly the occasion for gifts of paintings with appropriately congratulatory themes. When executed by artists who formed

24. Carved lacquer box depicting immortals celebrating the birthday of the deified Lao Jun, early 15th century. Aberdeen Art Gallery. Such boxes were used for the conveyance of birthday gifts.

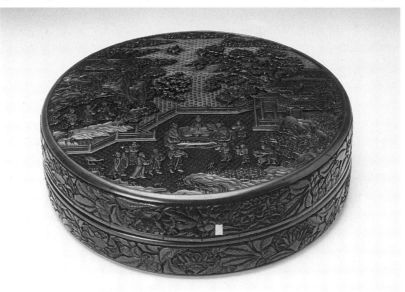

part of the canon of great painters at the time and subsequently, these are often very well documented, and have been discussed by scholars.[91] Ellen Johnston Laing has uncovered a number of instances in which the professional master Qiu Ying (*c.*1494–*c.*1552) created scrolls for specific birthdays.[92] His enormously expensive scroll of antique palaces, created for the birthday of the mother of one of his patrons is now lost, although his portrait of another of his patrons, Xiang Yuanqi (1500–72) may also have been painted for a birthday, given that the setting of the portrait in the arcadian 'Peach Blossom Spring' conveyed just such anniversary associations (illus. 64).[93] The *biji*, or 'note-form writings', of Ming authors often contain accounts of the commissioning of works of art for family birthdays, sometimes from artists with great reputations such as Qiu Ying or Chen Hongshou (illus. 35), but just as frequently from local artists who find no place in the standard books today. Thus Zhang Dafu (1554–1630) ordered a version of the birthday feast of the Royal Mother of the West for his grandmother's sixtieth birthday from a painter named Zhang Huan, while Gui Youguang (1507–71) records being asked by a wealthy merchant to provide the inscription explaining the iconography of a painting of the same subject ordered for his mother's birthday. Gui responded with the desired flourishing of his erudition, and the citing of recondite sources, but made no mention of the artist, who was not in this instance deemed to be of any consequence.[94] Similarly anonymous is a painting of the Three Stars, the deities of Happiness, Emolument and Longevity (illus. 25), one of the most popular of such birthday themes and the most frequently depicted in a variety of other sculptural and graphic forms as well as in painting.[95]

Objects of other kinds were made specifically for birthdays right through the Ming period. The most spectacular, and quite possibly the most expensive, are lacquered wood screens decorated in the technique known in Chinese as *kuan cai*, 'incised colours', and often in English by the erroneous name 'Coromandel' (illus. 31). These screens were to become much more common towards the end of the seventeenth century, when they seem to have become almost the standard retirement gift at a certain level of the bureaucracy (the gold carriage clock of the early Qing), but they were a novelty in the late Ming, the *kuan cai* technique itself being attested for the first time in a treatise on lacquering published in 1625.[96] This lavish twelve-panel example shows a variety of deities arriving for the birthday celebrations of the cosmic hierarch Lao Jun, in a style which must have also existed in scroll format, although at a much more modest cost, unless the most expensive of painters was commissioned. What is almost certainly the same subject appears on a very much earlier lacquer object, a box of carved red lacquer dating from some 200 years previously

25 Anon, *The Three Star Gods*, 16th
century. Ink on silk, Freer Gallery of
Art, Washington, DC. Another artistic
subject with connotations of birthday
wishes.

26 *(Opposite)* Lacquer box, inlaid with
mother of pearl, showing the triumphant
return of a successful examination
candidate, dated 1537. Victoria and
Albert Museum, London.

(illus. 24), suggesting a considerable continuity of iconography for birth-
day objects across a period when the advanced aesthetic theory in which
'painting' was situated underwent considerable changes.

The relationship of the box format to gifts and gift giving in the Ming
was a very close one. As far as preliminary research suggests, it was not the
box but its contents that formed the gift, which might be either very valu-
able in itself (ingots of silver) or relatively modest (fruit, cakes or sweets).
Fruit was deemed to be a particularly 'elegant' gift, particularly if grown
on one's own land, and the discourse of gardens in the Ming is richly
shot through with awareness of this role that fruit might play. (The most
famous gift in China's cultural history was probably the oranges given by
the great calligrapher Wang Xizhi and commemorated in his 'Offering Or-
anges Letter'.[97]) The role of the box, like wrapping paper at Christmas,
was to turn a commodity into a gift. This was such an everyday part of
Ming social life that it is scarcely mentioned in written sources. One
author mentions as an aside how, when passing the headquarters of the
Military Commandant of Nanjing, he found the road in front of the
grandee's office blocked by the 'food boxes' (*shi he*) offered by prominent

families of the city.[98] The fiction of the Ming period is a bit more forth-coming about the etiquette involved. The novel *Jin Ping Mei*, known in English variously as 'The Golden Lotus' or 'The Plum in the Golden Vase', which dates in its earliest published recension from 1618 or shortly after, reveals the all-important fact that once the presents they contained had been inspected the elaborate boxes were *sent back*, containing a small return present or a tip for the servants who had brought them.[99] They thus remained the property of one owner, who might use just such a laquer box on the occasion of another birthday.

A less specific but equally congratulatory subject is shown on the box dated 1537 (sec illus. 26). This is the triumphant return of the *zhuangyuan*, the first-placed graduate in the highest of the three examination grades. An umbrella of state over his head, his diploma born before him by govern-ment lictors in distinctive conical hats, he dreams of the joy with which his family will receive the news. A *zhuangyuan* in the family was an almost impossible dream, since only one scholar every three years would achieve this dizzying pinnacle, and the immediate empire-wide fame which came in its wake. But like the fabulously expensive sports cars and

27 Porcelain wine jar painted in enamels with the four scholarly pursuits of painting, calligraphy, chess and music, 1522–66. Victoria and Albert Museum, London.

aeroplanes that decorate the birthday cards thought suitable for boys of a certain age, the aspirations and good wishes which the subject contains are more important than the specific goal alluded to. Like the tray which encodes the same wishes for examination success (illus. 33), the box may be less directly tied to the occasion of actually setting out for the examinations than it is to some event in a male's life (perhaps the formal 'coming of age' of a teenage boy, the beginning of his formal education, the hiring of a new tutor) for which congratulations would be appropriate. When the point of an object was in its mobility, its transference from donor to receiver, we cannot read off it a fixed meaning as it sits motionless in a museum case now.

Just how much of the iconography on surviving Ming objects (or in surviving Ming painting for that matter) is congratulatory is impossible to calculate. But the notion of the expensive and reusable container for something that might of itself be of little value is perhaps applicable not only to lacquer boxes but also to containers of other materials, such as ceramics. The good wishes suggested by the 'Five Sons of Yanshan' jar (illus. 18) now seem obvious, but the same context may fit something like the much larger jar for wine shown in illus. 27, and dating from around the same

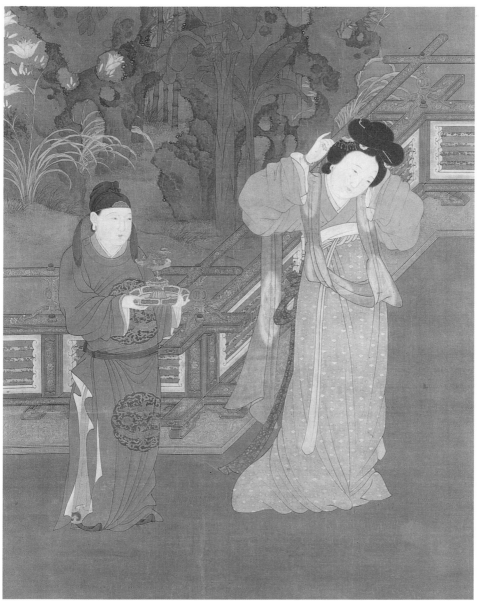

28 Anon, *Lady in a Palace Garden*, ink and colours on paper, 16th–early 17th century. Liaoning Palace Museum.

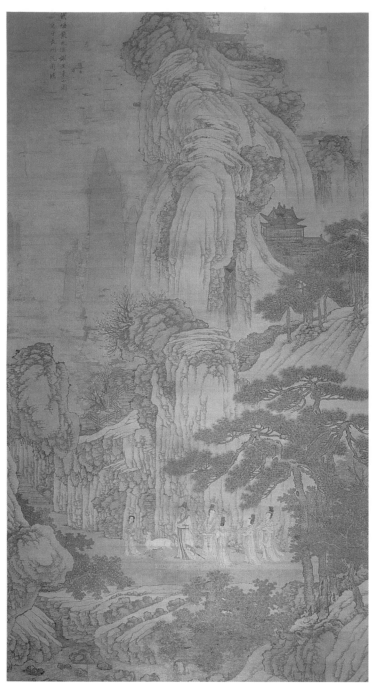

29 Shen Zhou (1427–1509), *Copy of Dai Jin's Xie An at East Mountain*, ink and colours on silk, dated 1480. Mr and Mrs Wan-go H.C. Weng.

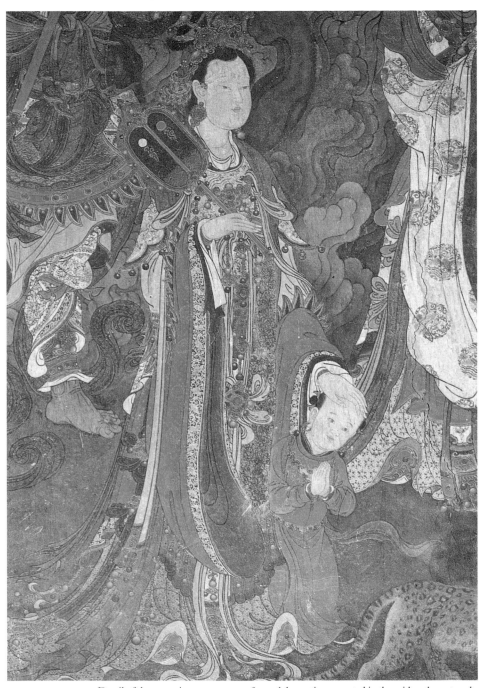

30 Detail of the extensive programme of mural decoration executed in the mid-15th century by artists of the Ming court workshops at the Fahai monastery just outside Beijing.

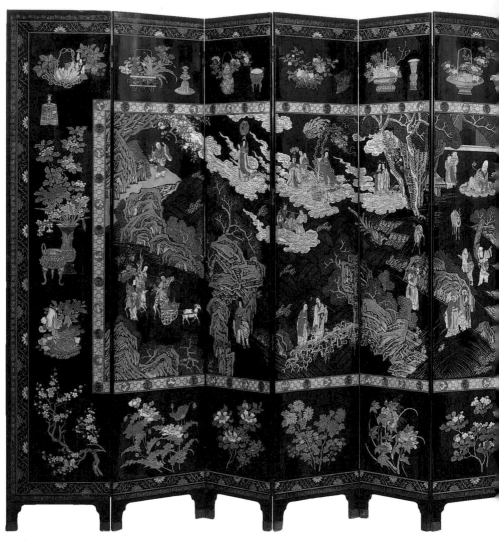

31 Incised lacquer screen decorated with the birthday celebrations of the Queen Mother of the West, early 17th century. Victoria and Albert Museum, London.

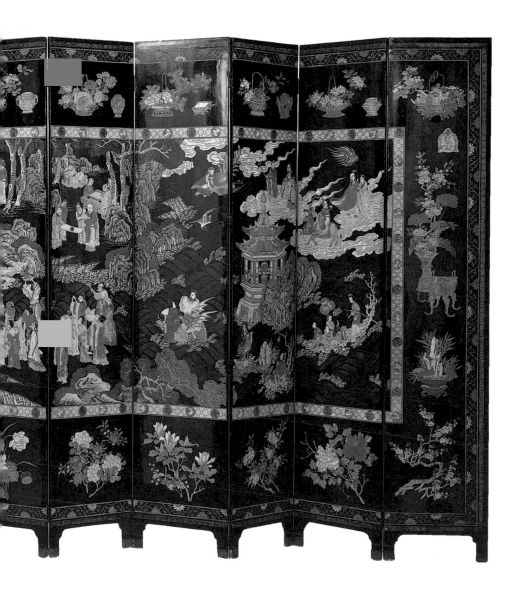

32 Colour woodblock print, from the drama *The West Chamber*, 1640, Museum of East Asian Art, Cologne.

33 Lacquer tray, inlaid with mother of pearl, showing candidates setting out for the examinations, *c.* 1500. Victoria and Albert Museum, London.

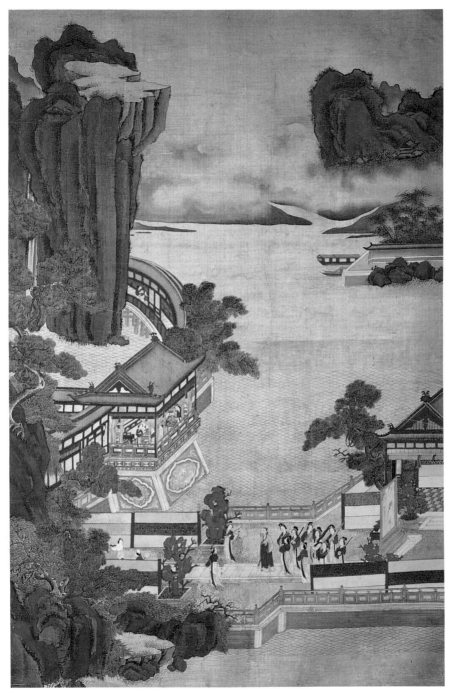

34 Anon, *Palace Scene with Female Orchestra*, 16th century, ink and colours on silk. Schloss Ambras, Innsbruck. Probably another version of the Su Dongpo story, and a rare survival of a large-scale workshop painting.

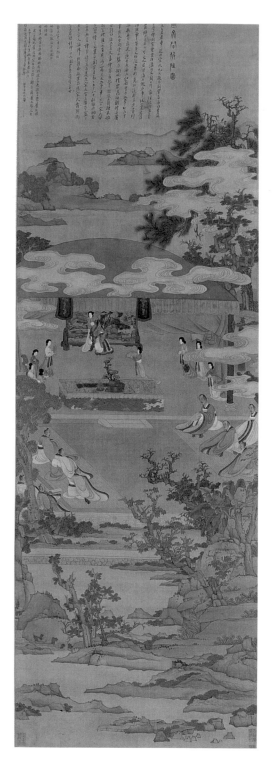

35 Chen Hongshou (1598–1652), *Lady Xuanwenjun Giving Instruction in the Classics*, dated 1638, ink and colour on silk. Cleveland Museum of Art.

period. The figures on it are a group known as the 'Eighteen Scholars', advisors to the admired ruler of the Tang Dynasty, Taizong (r.627–49). As a piece of iconography, 'established by consensus and perfected by tradition' this subject had its semi-mythical origins in painting of the Tang period itself, and continued to be painted in scroll form in the Ming, often as here showing the eighteen engaged in the four traditional gentlemanly pursuits of music, chess, calligraphy and painting. At least five lacquer boxes with the subject are known, so closely alike that they confirm the use of workshop patterns.[100] If as seems almost certain the boxes are for gifts then the ceramic jar may well be too, its allusion to high bureaucratic office being an aspiration shared between those for whom it was a realistic possibility and those for whom it remained at the level of fantastical wish-fulfilment.

If it is hard (or even pointless) to attempt to associate pictures on objects of this kind with a specific social stratum, it becomes even harder when we consider objects related to another life-event common to almost all above the subsistence level in the Ming, that of marriage. In the decades between about 1550 and 1620, there came into being a group of objects, in the form of lacquer boxes in various techniques, specifically designed for use in the ceremonies surrounding this event, and which are not exactly paralleled by objects produced either before or after (illus. 36, 65).[101] They are of distinctive proportions, not matched by other types of box, and are usually divided into three registers of decoration, readable when the box is held with the long side vertical, i.e. like a hanging scroll. The painted example in illus. 65, dated to 1600, carries three scenes from top to bottom, namely the ancient emperor Yao seeking the horoscope of his putative son-in-law and successor Shun from Shun's irascible father Gu Sou, 'The Blind Elder'; Li Yuan, future founder of the Tang Dynasty, winning his bride's hand in marriage by hitting the eye of peacock painted on a screen in an archery contest; and two ancient paragons of conjugal respect, Liang Hong and Meng Guang, treating one another with ideal distance, as she raises a tray to her husband in the gesture befitting an honoured guest. The carved box in illus. 36 shows Yao and Gu Sou at the top, and the archery scene at the bottom, with in the middle the presentation of a pair of geese, a part of the ritual of wedding prescribed by the 'Family Rituals' of Zhu Xi (though here the allusion is likely to be to some more precise story I have failed to recognize).[102] All of these scenes have their locus in the most respectable and canonical of texts, generally in standard dynastic histories and other writings that formed the matter of the élite male education, one available to women in occasional cases only. However, these stories had other, more purely visual presences in the wider culture. The archery story, for example, appears in an illustrated encyclopaedia of the Chongzhen period (1628–44), entitled *Wu duo yun*, or 'Five Clumps of

36 Carved lacquer box showing scenes associated with marriage, and probably for the exchange of horoscopes or wedding gifts between bride's and groom's families, early 17th century. Victoria and Albert Museum, London.

37 Woodblock print, from the encyclopaedia *Five Clumps of Cloud (Wu duo yun)*, 1628–43 Cuncheng-tang edition The scene shows the founder of the Tang dynasty winning his bride's hand in an archery competition, also seen on the boxes in illus. 36 and 65.

Cloud' (illus. 37). This text in four *juan* has one full page illustration at the head of each chapter, and was produced by an Anhui publishing operation which had to its credit a number of popular educational works.[103] Pictures of these scenes were therefore circulating in printed form, and available to those who had not worked their way through the history of the Tang Dynasty. Even more importantly, stories such as that of 'Firing at the Screen and Hitting the Eye' existed in the Ming in dramatic form; they were plays or extracts of plays, hence potentially available to all, even beyond the boundaries of literacy. Collections of play extracts were published in the Ming, conveniently arranging them by the occasions on which they might appropriately be performed; 'Birthday Congratulations', 'The Birth of a Son', 'Weddings'. The objects we have are not so neatly categorized, but if we start to put them into similar groupings they too seem to fall in with such life events, some (illus. 24, 25, 31, 64) being for birthdays, others (illus. 18, 26, 33) potentially celebrating the birth of sons, who might rise to the lustre of the great men portrayed on the gift containers they essentially are.

Weddings, birthdays, the birth of sons were all events celebrated in the élite mansion as in the homes of all above the barest subsistence level. Objects appropriate to these celebrations were therefore necessary at all levels of society, and not surprisingly it is the most expensive and luxurious examples of such objects, in materials such as carved lacquer and enamelled porcelain, which survive. No single understanding of an event like a wedding can realistically be posited for the Ming period. With the family as a locus of very unequal relations of power, structured along lines of age and gender, it is highly unlikely that a box like that shown in illus. 36 carried a single uncontested meaning for all who saw it displayed, or carried through the streets as part of the ceremonies which it made possible. Similarly, when the procession of the *zhuangyuan*, the very summit of élite academic and political culture, was being widely portrayed on lacquer boxes, ceramics and textiles, often in a form in which it is being burlesqued by children, and when a lavish performance of such a procession was annually staged in the city of Songjiang purely as spectacle, it becomes impossible to allot objects and representations to realms of the 'élite' or the 'popular' on the grounds of subject-matter alone.[104] This is not necessarily the same as refusing a distinction between different modes of visuality on grounds of class or gender, but it relocates any such fissures in the realm of 'how to look' rather than 'what to look at'. This necessarily speculative area of enquiry will be taken up again in Chapter 4.

3 Representing the Triad

Few structuring devices within Ming discourse had as much capacity as the triadic relationship of heaven, earth and man (*tian di ren*), the 'Three Powers', which gave their name to one of the great encyclopaedias of the Ming, *San cai tu hui*, 'Pictorial Compendium of the Three Powers' of 1607. The following chapter will use the three terms of this arrangement as a way of looking at a range of pictures produced in the period, as a way of cutting across some of the other types of classification (painting/printing; art/not-art) which might be privileged in some other types of analysis. The categories used here are *not* meant to imply some deeper or more satisfactory level of engagement, but it is hoped by forming groupings of things not always juxtaposed that the contingent and enabling status of some of the more familiar types of categorization operating within the pictorial economy of the Ming may become less opaque.

Heaven

Although very early cosmographical writings in China contain the often-repeated formula that 'Heaven is round and Earth is square' (a distinction observed in the respective shapes of the altars at which the emperors of the Ming worshipped these powers in some of the most solemn ceremonies of the state ritual calendar), the possibilities for representing Heaven are distinctly limited. The fifteenth-century scholar Qiu Jun (1421–95), whose thorough-going critique of the representation both of transcendent cosmic powers and of the great human teachers of the past has been explicated by Deborah Sommer, refused to allow that Heaven *had* an appearance, any more than it had a sound or a smell.[1] His views were not eccentric, but were widespread, and lead in the decades after to his death to a wide-ranging removal of figurative imagery of deities from centres of the state cult. One scholarly opinion of the sixteenth century quoted below (see p. 104) is quite explicit that 'Seeking the Way through figures is to restrict the Way to those figures', where the congruence between the Way (*dao*) and Heaven (*tian*) was a common trope of learned discussion. It is

very striking that the three sections into which 'The Pictorial Compendium of the Three Powers' are divided are of very unequal length, and that although Heaven takes primacy in the order of presentation it is very much the shortest of the three. What *San cai tu hui* actually contains under this heading is a certain amount of material on the 'patterns of heaven' (*tian wen*, which in modern Chinese means 'astronomy'), in the forms of star charts and the like, plus a certain amount of the type of cosmological diagram represented by illus. 5, to be discussed in Chapter 4.

Earth

The possibilities for representing earth, the second of the Three Powers were much greater, even if more disparate, more various and even conflicted. The prestige of some of these representations within art history has made many of the others almost impossible to see, but the attempt must nevertheless be made. Two representations of land taken from the encyclopaedia *San cai tu hui* (illus. 38 and 39) bear very little resemblance to the more familiar and better-studied type of image (see illus. 3), and both are drawn from the books section on *di li*, 'the principles of the earth', a word which has come in modern Chinese to mean 'geography'. One of a number of representations of field patterns (illus. 38), in this case 'chequerboard fields' (*qu tian*), is discussed in terms of the mathematical measuring of a large rectangle into smaller ones for the intensive cultivation of crops. Another (illus. 39) shows a range of *xue*, or 'lairs', the central concept within the science of geomancy, the study of those favourable locations for graves and houses that would insure that beneficent chthonic influences would flow to the inhabitants of those spots.[2] The two very different representations are nevertheless bound together in a number of ways beyond their common presence in the category 'principles of the earth'. Behind both lies the presence of another structuring concept important to the Ming élite, that of 'number' (*shu*), which led back to the most prestigious of the canonical texts, the 'Book of Change', or *Yi jing*. Number allowed the operation of agronomy, and the imperial state with its material base in the taxation of land, while also allowing the complex calculations which made geomancy an operative practice , rather than merely an unchallengeable given on the landscape. Both images are also, in purely formal terms, linked by the point-of-view, the subject position which they create, one of a purely vertical perspective. The looker looks crucially down from a height, straight down on field system or lair alike.

The same is true of many of the Ming representations of landscape which now fall within the category 'map', such as a rare survival of what almost certainly was once a much larger class of objects, large-scale

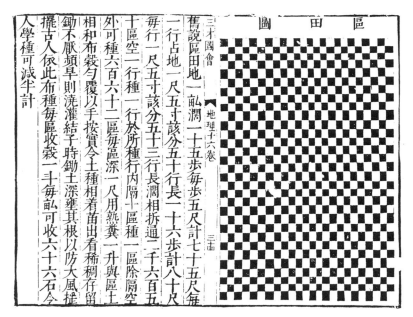

38 Field pattern, from the encyclopaedia *The Pictorial Compendium of the Three Powers,*
1607.

39 Geomantic lairs, from the encyclopaedia *The Pictorial Compendium of the Three Powers,*
1607.

40 Woodblock printed and hand-coloured wall map, *Map of Advantageous Terrain Past and Present*, dated 1555. Archivo General de Indias, Seville.

decorative maps used in interior display (illus. 40). Printed in 1555 and hand-coloured, it is a picture of the whole of China, showing administrative divisions of the past as well as present, and copiously annotated with historical information, making it of value in antiquarian and classical studies.[3] The often- (indeed over-) remarked interest of the Chinese élite in the maps brought to China around the very end of the sixteenth century by the Jesuit missionaries rested solidly on a long engagement with maps and map-making on the part of that élite. When Matteo Ricci describes the response of visitors to a map of the universe hung on the wall of the Catholic mission at Zhaoqing, or when he claims that the emperor ordered some of his maps made into screens 'for pleasant decoration', he is attesting to the fact that maps were a regular part of the Ming upper classes culture, *not* that they were some stunning novelty.[4] This can be backed

up with even a quite casual glance at the writings of Ming bureaucrats and scholars. The official Gui Youguang (1501–71) is a good example of a Ming writer whose works contain numerous references to what we would now call maps, mixed in with occasional notices of what we would now call paintings. He provides a historical and textual 'Explanation [*shuo*] of a Picture of the Three Rivers', and a 'Colophon after the Illustrated Gazetteer of the Capital City in the Hongwu Reign', which the text makes clear is a long handscroll of the topography of Nanjing which he saw in the house of one Wu Zhongyong.[5] Indeed it is very hard, not to say pointless, to draw a clear distinction between topographical painting and map-making in China at this period. Gui also provides texts for pictures of the property of individual friends and acquaintances, and a 'Record of a Picture of the Mountains of Wu', produced by an anonymous artist for a group of gentleman to present to a popular magistrate of Wu county (half of the city of Suzhou) to remind him of his time in office there.[6]

The non-separability of maps from other forms of representation of land throughout Chinese history has recently been argued very cogently by Cordell D.K. Yee, who suggests that 'what is now considered to be cartography participated in the same "economy" of representation as poetry and painting', and he pushes home this concept of an 'artistic economy' with a discussion of the common technologies of production, the shared attention to a variable viewpoint which typically mixes the planimetric and the pictorial, arguing finally that 'in the field of the history of cartography, it is time to heal what might be called a dissociation of sensibility'.[7] I shall go on to argue that this dissociation of sensibility is a specific historic process, beginning in the late Ming, which was complete by the early eighteenth century, but which had not yet fully taken place at the beginning of the sixteenth century. Rather we should see something like illus. 40, which is now clearly a 'map', and illus. 43, which is equally now a 'painting' as being at two ends of a spectrum of representations which also encompassed ephemeral (in the sense of rarely surviving, not of 'unimportant') works. These include painted representations like the one executed in around 1560 by a military commander named Tan Jiuchou, and showing the entire coastline of the empire from south to north (illus. 41).[8] Such representations, along with the maps on which the land tax registers were based, were treated in the Ming as powerful state secrets, rigorously kept from the eyes of foreigners, like the unfortunate Koreans who were confined to quarters in 1522 after buying an illustrated administrative handbook of the empire very similar to that from which illus. 42 is taken.[9] They were also on occasion produced by men who we think of nowadays as 'painters', like Wen Boren, a member of the élite Wen family of Suzhou, who in 1561 produced a scroll of coastal defences prepared

41 *Above* Tan Jiuchou, section of a coastal map of Zhejiang province, *c.* 1560.

42 *Below* Woodblock print showing map of Zhejiang province, from the administrative handbook for officials *Huang Ming tian she ya man guanzhi daquan*, late 16th century, Bibliothèque nationale de France, Paris.

against the 'Japanese pirates' who were Tan Jiuchou's principal opponents.[10]

The power to represent space and place was one of the key attributes of élite status in the Ming, as it had been for centuries. When He Liangjun writes about how painting allows him to 'travel to the Five Peaks from my couch', he is invoking one of the oldest rationales for the act of representing land, that given by the fourth–fifth-century writer Zong Bing (375–443), who he quotes directly. (He was also interested in the technicalities of land representation for cadastral purposes, and writes elsewhere of the *tu ben*, 'picture booklets' which contained the maps of individual pieces of property.[11]) However he goes on in an immediately subsequent passage to restate a fundamentally mimetic role for such painting of the famous places of the world, which words alone, no matter how eloquent, can never fully capture. Pictures allow 'spiritual wandering' in the places they represent, and those places are conceived of as actually existing. Like the recovery of stories in what were once generalized scenes of 'scholars in the snow', the growing awareness of the topographical impulse in much Ming painting is a recent project of scholarship. Kathlyn Liscomb's monograph on Wang Lü's album of views of Mount Hua builds on the work of Richard Vinograd, who has demonstrated the importance of actual place in what he has felicitously called the 'landscape of property' in the fourteenth century, a type of landscape which I have argued previously continued into the Ming period.[12]

The importance of topographical representation to the artists of Suzhou in particular has been discussed thoroughly in the literature.[13] It gave rise to scrolls like that showing the much-pictured Tiger Hill to the north-west of Suzhou itself (illus. 43), a scene pictured by many members of the élite. But the example shown is by a professional artist who, despite the inscription's suggestion that he painted the picture purely for personal amusement, made it as a saleable work within the context of upper-class tourism, the consumption of space through movement which only the wealthy could aspire to engage in. And engage in it they did to an increasing extent as the Ming period progressed. The culture of travel and of movement was one of the most conspicuous parts of élite status, commemorated not only in the texts they themselves wrote about travel, but also in the pictures they created or commissioned as souvenirs of their experience, souvenirs which exist 'within the privatized view of the individual subject'.[14] These pictures, physical traces of personal experiences, also played a part in the consolidation of new types of personal identity in the early seventeenth century, identities expressed in the growing body of autobiographical and confessional literature which was another characteristic of the period.

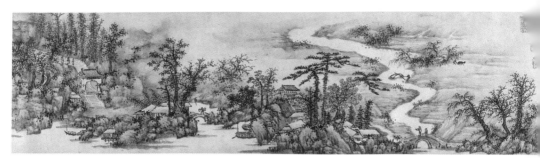

43 Xie Shichen (1488–after 1588), *Scenery of Tiger Hill* (detail), dated 1536, ink and colour on paper. Boston Museum of Fine Arts.

By the end of the sixteenth century these representations of places visited in reality or imagination were as likely to exist in printed as in painted form. In fact, the vagaries of preservation mean that we still have today the printed versions, whereas the cheaper end of the tourist souvenir painting market, which must once have existed on an analogy with pictures like illus. 2, has largely vanished. It is not surprising that Hangzhou, the city which along with Suzhou was the chief objective of upper-class tourism, should be the most likely place of publication of two of the most striking collections of touristic images, the *Hai nei qi guan*, 'Striking Views within the Seas' of 1610 (illus. 44), and the *Hu shan sheng gai*, 'Conspectus of Sights of the Lakes and Hills' (illus. 66). The first text, the product of a publisher named Yang Erzeng who had a range of titles to his credit, has been described as the first of the genre of Ming travel books 'to have been luxuriously illustrated, with landscapes and scenes of social life that might capture a traveller's attention'.[15] What is important is that the collection of places the book contains is precisely that, a collection, not a practical guide to getting around the empire. The same is true of the very much rarer *Hu shan sheng gai*, a work whose title alludes to at least one other book of collected views, the *Ming shan sheng gai* of 1628–44.[16] The 'Conspectus of Sights of the Lakes and Hills', preserved in a partial unique copy in the Bibliothèque nationale, Paris (a later reprint is in the Central Library, Beij-

44 Woodblock print, from *Newly Compiled Striking Views within the Seas*, 1610. Gest Oriental Library, Princeton.

ing), is of particular importance because it is printed in colour, in a luxurious and time-consuming technique which almost certainly made it more expensive to produce than the cheaper of the painted souvenirs of Hangzhou's West Lake which it seeks to replace.[17] In addition to views of the sites around the lake, it provides by its liberal use of figures models of deportment for the tourist to aspire to, as the ideal tourists it portrays point out to one another points of literary or historical interest, gesturing with hands or fans. They portray a manner of being in a place that might perhaps be thought of as one 'iconic circuit', restricted by class and gender. The prestige associated with certain types of renditions of the land could thus be argued to be bound up with élite male constructions of the self as above all possessors, those who were at ease in the spaces they traversed so freely (illus. 45).

At least one image of those contained in the *Hai nei qi guan* shows an urban setting, and although such images are excluded from later canons of the representation of place, they do exist in Ming painting. An anonymous topographical scroll in Beijing (illus. 67) bears a colophon dated 1609 and represents the urban scene to an élite gaze, revelling in the detail of shops and stalls and customers in the same way that certain texts of the period delight in the details of the city's fabric and occupants (perhaps it too is a tourist souvenir of a kind). Such scrolls may once have been

45 Woodblock print, from *Huancui tang yuan jing tu*, illustrating the garden of Wang Tingna, *c*.1610. Gest Oriental Library, Princeton.

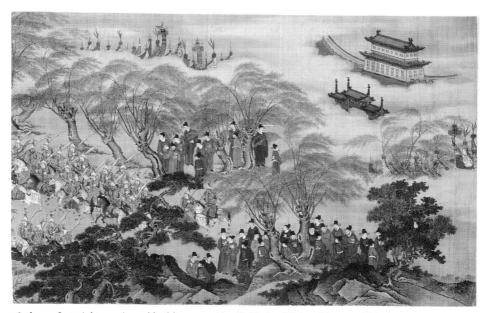

46 Anon, *Imperial procession*, mid-16th century (detail). National Palace Museum, Taipei.

more common than is suggested by their exclusion from canons of taste, and they exist as an important if little-studied type of image, their only major analogies being the massively detailed scrolls showing imperial entertainments and processions (illus. 46), which similarly lie outside the boundaries of approved subject-matter in painting criticism, and have been correspondingly ignored also until very recently. That the élite wished to see the city in certain of its aspects helps to make sense of a much-discussed but continuously enigmatic picture, Zhou Chen's scroll of 'Beggars and Street Characters', dated 1516 (illus. 47). In discussing

47 Zhou Chen, *Beggars and Street Characters* (detail), dated 1516, ink and light colour on paper. Cleveland Museum of Art.

48 Anon, *Street Scenes in a Time of Peace* (detail), 15th–16th century, ink and colour on paper. Chicago Art Institute.

this work, James Cahill has explained its seeming uniqueness on the grounds of subsequent collectors' distaste for images of this kind, many more of which must once have existed.[18] Although not strictly speaking comparable, the range of such images of the lower orders once available is perhaps exemplified by a scroll in the Chicago Art Institute (illus. 48), which shows a range of street occupations taking place against an empty ground, a space which is no place, just like that against which Zhou Chen's procession of grotesque and distorted human forms is pinned like specimens on a piece of blank paper. What they share in addition to this

blank background is the fact that both display the ugly bodies of the poor, distinguished by their relative nudity and above all by their lack of verticality. The poor bend forward whether burdened by disease and want or stooped in toil over their tools, in contrast with figures who are both decently clothed and dominatingly erect in posture (see illus. 66). I shall have occasion to discuss later at least one piece of evidence for the presence of the carnavelesque, the transgressive and the distorted in representations of the human figure, with regard to pictures of foreigners, but here it is the poor who are the Other of the looking subject, subjects which by virtue of their power to look are defined as élite. The absence of public representations of the élite, except in very special circumstances, can be seen here as leading to a situation where it is those who are looked at who are forced to accept the inferiority which such literal objectivity implies.

Man

As the dictionary entry 'man; mankind' for the Chinese term *ren* suggests, there is no doubt the term carries an implication of 'male' as the default position of humanity, and in fact the equation *ren* = male was largely normative in Ming pictorial usage. The faces used as the ground for the sections on physiognomy in *San cai tu hui* are almost all the faces of men

49 Pages of physiognomies, from the encyclopaedia *The Pictorial Compendium of the Three Powers*, 1607.

(illus. 49), and the issue of looking on the faces of women *by* men was a highly controversial one in a culture where women were strictly enclosed. In mid-seventeenth-century Taiwan, a wave of resistance to Dutch colonial rule was set off when a forcible search of peasant's houses by Dutch troops brought respectable women and strange men literally face-to-face.[19] Real women's faces were looked on by physiognomers and doctors, among others, but the representation of the female face was a different matter.

The importance of physiognomy at all levels of Chinese society was considerable, indeed it was almost certainly more widely diffused than was the comparable science of geomancy with regard to the earth. Physiognomy tied the individual to the cosmos, for example through connections it made between facial features and the five sacred marchmounts of the earth, and through the importance attached to numerological categories, particularly the sacred number nine. The system of physiognomy still practised today, though its roots were ancient and various, appears to have become crystallized in the early Ming period, embodied in a text entitled *Shen xiang quan bian*, 'Complete Guide to Spirit Physiognomy', attributed to Yuan Chongzhe (1367–1458).[20] It was clearly closely imbricated with any attempt to represent the human face, whatever the purposes for which such representations were made.[21]

In her discussion of the place of physiognomic practice in portraiture, Mette Siggstedt has remarked, 'During Yuan and Ming, portraiture became very much an artisan genre, developing along its own lines, different from the mainstream of Chinese painting. The development of painting during this period was towards greater abstraction and a growing attention to the calligraphic quality of the brushwork, while there was little interest in colours and very little use of graded ink washes. The development of formal portraiture went contrary to this trend.'[22] Despite the problematic nature of the concept of 'the mainstream of Chinese painting', it is impossible to take issue with this analysis – almost all Ming portraits before *c*.1600 (when as we shall see there was a revival of interest in the subject on the part of aesthetic theory) are the product of anonymous artisan painters. However it may not be entirely safe to take the pronouncements of writers on *painting*, from which category portraiture was being gradually but forcefully excluded, as equivalent to statements about the importance of portraiture to the Ming élite as a whole, or about their willingness to engage with portraiture as commissioners of work or commentators in their broader writings.

One very particular use of portraiture was in the rites of the ancestral cult (illus. 50), and indeed to Western curators and auction houses most formal portraits are referred to in everyday usage as 'ancestor portraits'.[23]

50 Ancestor portrait of man and wife, 16th century. National Gallery, Prague.

The canonical status of such representations in the ancestor cult during the Ming period was shaky but venerable; they were by no means essential but they were tolerated by most commentators. The normative 'Family Rituals' of the Song Dynasty author Zhu Xi makes a distinction on gender lines, saying

This [the making of portraits] is all right for men who had portraits made while alive. But what about women who during their lifetimes lived deep in the women's quarters and never went out except in a closed carriage with a veil over

their faces! How can one have a painter, after their deaths, go right into the se-
cluded room, uncover their faces, take up a brush, and copy their likenesses?
This is a gross violation of ritual.

One Ming commentator finessed this objection with the response that it
was acceptable as long as the portrait of a woman was only seen by those
members of the family (including the males) who had seen her in life.[24]
Qiu Jun, in his attack on the use of cult images in any context, quotes
Song Dynasty arguments against ancestor portraits, on the grounds that
if they deviate in the slightest degree from the appearance of the deceased
(as they almost invariably will), then the sacrifice will not reach the re-
quired destination.[25] These strictures and restrictions sharpen the
satirical edge of what is the most extensive description of the process of
making a ritual effigy-portrait in Ming literature, that found in Chapter
63 of the novel *Jin Ping Mei*, and illustrated in the woodblock picture ac-
companying the head of the chapter (illus. 51).[26] Li Ping'er, beloved
concubine of the wastrel hero Ximen Qing, has died young, and the incon-
solable Ximen summons a master painter, Master Han, and tells him, 'I
loved her so much, that I have to have a portrait (*ying xiangr*) to look at
and remember her by morning to night'. He proceeds without qualm to
send away the women of his own household, and to lead the painter plus
a crowd of his sycophants and boozing companions (unrelated to the dead
woman) to her corpse, where a discussion ensues on how to make her look
her best. The painter tells them not to worry, as he has observed her in life

51 Woodblock print, from chapter 63 of
the novel *Jin Ping Mei*, Chongzhen edition.
Men study a portrait of the hero's recently
deceased wife.

when the famous beauty went to make offerings at a local temple. He is ordered to make two pictures, one full length and one half-length, at which offerings will be made in the course of the funeral service, and is promised a bolt of satin and ten ounces of silver as payment (a fairly lavish sum). Quickly, the artist dashes off the half-length portrait, which is what the men are examining and praising (see illus. 51). It is described significantly as 'a picture of a beauty' (*mei ren tu*), using the term for generalized, non-specific images of more or less erotic content which were one of the staple manners in which Ming women were presented to the Ming male gaze (e.g. in illus. 28). Only then is it submitted to the judgement of the women in the family, the servant who brings it instructing them:

'Father says that you should all take a look at this image of the Sixth Lady, and see how its painted. If there's anything not right, just say so and he'll have it changed.' Yueniang said, 'And turn her into a spirit to trouble us all! We don't even know where she's gone off to in the afterlife, and we're doing her image, painting her like I don't know what!'

The principal wife, Yueniang, is not just piqued at the favour shown to a rival even in death, but troubled by the impropriety of a husband, rather than a child as the true ritual heir, commissioning such a portrait. However she is engaged enough to join in the detailed critiquing of the likeness, and expresses surprise at the accuracy on the part of an artist who has only seen the corpse for a moment, until she is told of the artist's ogling of her late 'sister' on the visit to the temple. The ladies convey to the artist, through a servant, their impression that the lips are too flat and the eyebrows not curved enough, whereupon he immediately amends his version, to be finally approved, not by Ximen Qing but by his neighbour and relative by marriage Big-guy Qiao, with the words, 'it just lacks a mouthful of breath'.

This slightly squalid episode opens out a number of issues about representing the face in Ming culture, as it piles impropriety on impropriety to damning results. Indeed it would be hard to find a more telling instance in which the interpretative framework of the 'gaze', used to such effect in the critique of Western visuality, might bear on Ming visuality also. The dead woman gazed on by a gaggle of unrelated men, including a painter who has already voyeuristically enjoyed her in a public place, the confusion of the ritual with the transgressively erotic in the very commissioning of the portrait, the excessive payment to the painter as testimony to Ximen Qing's disordered appetites for looking as for everything else, the cloistered women who can comment on the accuracy of the representation but who cannot give the final approval, which is instead casually abrogated to another unrelated male – all these elements build up for the educated male

Ming readers of the novel a powerful scene of vision misused and abused, of the wrong people looking the wrong way at the wrong things.

Ladislav Kesner, in his discussion of this passage, draws attention to the importance attached to likeness by at least some of the viewers of the effigy portrait. However he does not remark on the association between correct mimesis and women, something which as we have seen surfaces elsewhere in Ming discussions of the pictorial. There were good ritual reasons for insisting on the importance of mimesis in portraits to be used in ancestral rites – an inaccurate representation could mean that the offerings were going, not to one's deceased parent, but to someone totally unrelated, a truly horrible impiety. However issues of public display may well have interfered with this aim at least occasionally, if the authors of fiction are to be believed. Satire is not a description of what happened, but it has no bite if the behaviour being criticized is utterly beyond the belief of the putative readership. Another novel, dating from the very end of the Ming period, contains a description of the process of creating an 'ancestor portrait' which shows how ritual and display might be in tension. The novel is *Xing shi yin yuan zhuan*, 'Tale of a Marriage to Awaken the World', whose dissolute central character Chao Yuan is arranging in Chapter 18 to have a likeness made of his deceased father (so far is he more proper than Ximen Qing).[27] He summons a master painter (*hua shi*), and orders him to paint his father in the insignia of a high official, insignia to which he was in no way entitled in his lifetime, and including a golden crown such as no-one ever wore. The painter protests, and Chao Yuan bets him the pig that forms the centrepiece of the ritual sacrifices, against the free execution of the painting, that the hat *does* exist and that it was worn by the deceased in his lifetime. A compromise is reached, and the painter offers a three-for-the-price-of-one deal; one portrait in court dress, one in everyday formal dress and one in casual dress, at a price of twenty-five ounces of silver. The painter then produces a draft, which is felt by a crowd of instant critics to be 'rather a likeness'. The painter ripostes that at least he had seen the late Mr Chao in his lifetime, 'otherwise it wouldn't even be that like him'. But Chao Yuan interjects, 'Never mind whether it's like him or not, just paint a white complexioned, stout, proper and impressive guy with a three foot long black beard. As long as this painting looks good (*hao kan*), who cares if it's a likeness !' After his scruples about complaints from other relatives are brushed aside, the painter draws on his repertoire of deity figures and produces three versions of the God of Literature, Wenchang dijun, in the three agreed forms of costume.

What has been painted here is the 'social body' of the deceased, the ritually more important facial features being set aside in favour of lavish accoutrements. But the point of the passage may be to draw attention to

the fact that in better-conducted households the question of resemblance was indeed paramount. However Chao Yuan's tasteless concerns for status do remind us that these ritual effigy-portraits were displayed in public and quasi-public contexts. Again we are faced with portraits where the principal concern is how they will be received by an audience, and the passage opens up the whole area of portraits designed not as operative parts of ritual but as part of a visual culture of display. Away from the theorizing about painting, the writing of the Ming upper classes suggests that this concern was quite active.

Portraits were as often commemorative as they were ritual objects, to be retained within the family and shown to later generations as well as to visitors outside the family. Lang Ying describes seeing in Hangzhou a 'genealogy image' (*pu xiang*) of a Song Dynasty empress, whose face he describes in physiognomic terms, and who is portrayed in mourning for the patriotic hero-general Yue Fei. This was in the home of her descendants, as was a similar portrait of another empress in the garb of a Buddhist nun.[28] An album of such genealogy images, belonging to the Yao family, is in the Shanghai Museum (illus. 52–5), and other examples of this format are also known in Western collections.[29] The album is anonymous, but each sitter is portrayed in the relevant costume appropriate to rank, and with a caption identifying their place in the generational hierarchy and their name. Published editions of genealogies with similar portrait collections also exist from the Ming.[30] These are portraits of ancestors but not 'ancestor portraits' in the ritual sense of the term. A few famous examples of portraits of this type exist, such as the one of Shen Zhou in the Palace Museum, Beijing (illus. 56), which was inscribed by the sitter in his lifetime, in terms which elegantly disavow the effectiveness of physiognomic prognostication for a man who is now in his eightieth year.[31] An inscription by Gui Youguang on a portrait of the statesman Ye Sheng (1420–74), which must have been preserved for at least a century, makes it clear that what the writer is describing is a picture designed to commemorate the deeds of a great man, and to allow the later generations to know what he looked like, as if this was a desirable outcome of itself. He is not dealing with anything of ritual significance, not an image used in Ye Sheng's funeral obsequies. A similar prose piece by Lang Ying entitled 'Eulogy of a Painted Image' stresses that the point of the picture is to call to mind the features and the deeds of a long-gone person.[32]

It is impossible to know how many of the Ming élite had themselves represented in this way, or how common 'genealogy portraits' actually were. Writing in the fifteenth century, Yang Shen repeats as a commonplace the opinion that no-one under the age of thirty should ever have their portrait painted, as to do so would rob the sitter of vitality (*jing shen*).[33] However it is

九世鳳翔號惺初
八世鍾號吳山
松溪公配沈孺人像
吳山公元配王宜人像

52–55 Anon, Some of the *Members of the Yao Family* (top left, Yao Fengchi; top right, Yao Zhong; bottom left, Madame Shen (mother of Yao Fengchi), and bottom right, Madame Wang (wife of Yao Zhong). 16th century, ink and colours on silk. Shanghai Museum.

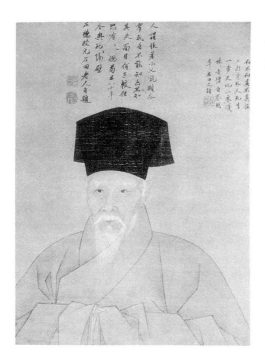

56 Anon, *Portrait of Shen Zhou at Age Eighty*, dated 1506, ink and colour on silk. Palace Museum, Beijing. The inscriptions are by the subject.

possible to posit an interest in the physical appearance of the great of the past and present which is separate from any such religious or ritual scruples, but is based instead on sheer curiosity to gaze upon the features of the famous. The word *xiang* or 'image' is the one consistently used for any sort of portraiture, a word as we shall see with particularly dense connections to some of the most complex theoretical positions about representation, positions rooted firmly in the 'Book of Change' (see pp. 102-5). Thus Gui Youguang provided a 'Colophon on the Images of the Seventy-two Disciples of Confucius', in which questions of pictorial style are not mentioned at all, eschewed in favour of a discussion of the content which makes it clear these are new images, not some antique set.[34] The creation of such sets of (clearly imaginary) portraits of the great may not have been only an occasional act. Zhang Dafu records the making in 1593-4 of a set of over fifty images of 'posthumous images of former sages' in album form, commissioned by an unnamed patron from an artist named Wang Minhui of Xin'an of Anhui Province.[35] These are not ancient worthies, but political and literary figures of the Song–Ming periods, coming down to the nearly contemporary, and including a portrait of Gui Youguang, who had died only some twenty years previously. The commemoration of the facial features of famous men was a continuing interest of the wider élite, as when Lang Ying records seeing a single-sheet woodblock print of a self-portrait dated 1094 by the great Song writer Su Shi

(incidentally an important piece of evidence for the existence of such prints, and for the fact that the élite noticed them).[36] Such images of the great were known to have been produced in the Song period itself, but essentially for ritual and commemorative purposes, rather than as objects of curiosity. We even have a piece of evidence for the Ming court in the reign of the Jiajing Emperor (1522–66), a man not usually noted as an avid collector, seeking out the image of a famous figure of the past. With regard to one Mo Yueding, a 'lofty scholar of the Yuan Dynasty', we are told that in the Jiajing reign 'the court sent envoys to Suzhou to acquire specimens of his calligraphy, and also obtained his portrait', which the text goes on to describe in some detail.[37] As anonymous works, portraits are hard to manage within the discourse of Ming painting criticism, centred as it is around the concepts of genuine/false works by named masters of the past and present. But that does not mean that portraits of the great were not in at least some cases avidly collected, and it seems likely that further investigation in *biji* writing would turn up more cases in which they were the objects of attention. The collecting of portraits might seem analogous to the upper class Ming appetite for gossip about the lifestyles and personal habits of the rich and famous. The *biji* literature is full of such anecdotes, of how the great painter Wen Zhengming had very smelly feet, what he normally had for lunch, of how grand secretary Xie Qian (1449–1531), described as a 'silly old fool', frittered away his retirement playing cards with his grand-daughters for cakes and fruit. All these examples are from the *Si you zhai cong shuo* of He Liangjun, one of the richest sources of such gossip, but far from the only one.[38] A fascination with portraits went along this interest, and was fed as early as the fifteenth century by published books containing collected portraits of the great, among the first of these being the *Li dai gu ren xiang zan*, 'Images and Eulogies of the People of Antiquity through the Dynasties', of 1498.[39] Such printed collections continued to be produced throughout the Ming, as did painted albums of portraits of the great, like the famous album of 'Eminent Men of Zhejiang Province' now in the Nanjing Museum.[40]

One of the major ways in which the features of the élite were conveyed to their peer group was through the medium of frontispiece portraits to their collected writings (illus. 57). This was how one knew whether a writer was fat or thin, heavily bearded or smooth-cheeked, with prominent or small ears. The example shown, from the collected works of the philosopher Wang Gen (1483–1541), is a typical example that can stand for many; though published many years after his death (it comes from an edition of 1631) it conveys an accepted image of his appearance, perhaps rather on a par with certain types of formal portraiture then current in other parts of the world, most particularly England, where sets of monarch's portraits were used to decorate aristocratic houses. In late Ming China too, some

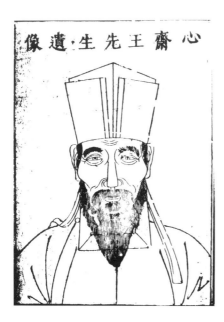

心齋王先生·遺像

57 Woodblock print, posthumous portrait of the philosopher Wang Gen (1483–1541), from *The Collected Works of Wang Gen*, 1631 edition.

images of past and not-so-past rulers were at least a peripheral part of the visual culture available to the literate, and this in spite of legal strictures against the representation of members of the ruling house in any form. It is a commonplace of introductory teaching that the imperial image was not used in the same public sense in Ming China as it was in sixteenth-century Europe: the ruler's visage did not appear on the coinage for example, and such portraits as do survive of the Ming emperors were created within the palace for ritual purposes and remained there down to the present century.[41] One of the most common complaints of moralists against the drama was that it represented on stage the rulers of the past, this in itself being an impropriety. It therefore comes as something of a shock to realise that there was in no way an absolute enforced taboo on the representation of rulers, even those of the ruling dynasty. The encyclopaedia *San cai tu hui* contains extensive illustrations of historic rulers, down to and including the Jiajing Emperor of the Ming Dynasty (r.1522–66). The three figures shown in illus. 58 are: (top right) the founding emperor of the Dynasty Taizu, or Zhu Yuanzhang; (top left) Chengzu, or Zhu Di (r.1403–24 as the Yongle Emperor); and (bottom right) Shizong, or Zhu Houzhao (r.1522–66 as the Jiajing Emperor). Clearly the images are dictated by the conventions of imperial portraiture, but a distinctive cast of features of the three emperors has been attempted by the block cutters, regardless of how 'accurate' such portraits may be. People to an extent 'knew' what Ming emperors had looked like, just as they knew from other parts of the encyclopaedia how other great political and cultural figures had looked in their lifetimes.

98

If indeed there was a consistent and continuous interest in looking at and collecting portraits of the famous throughout the sixteenth century, it helps us to put in context the 'revival' of portraiture which has been observed as one of the features of the decades after about 1600, when named artists again turned their attention to the features of their contemporaries.[42] Artists like Zeng Jing (1564–1647) and Huang Cunwu, the painter of 'A Noble Gathering at Green Woods' (illus. 59) were only in this reading re-appropriating portraiture and re-investing it with the discourse of painting, producing what were often group portraits, records of gatherings actual and imagined.

Excursus on sculpted images

Painting and printing were not the only ways in which the human form could be represented in the Ming. There was also sculpture. So little literature exists on Chinese sculpture after the Song period that it seems worth including in this context just a few pieces of the evidence for the

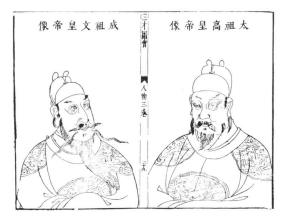

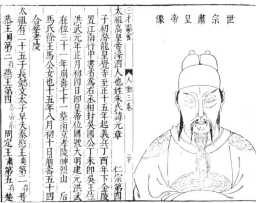

58 Emperors of the Ming dynasty, from the encyclopaedia *The Pictorial Compendium of the Three Powers*, 1607. The most recent emperor portrayed is the Jiajing emperor (r.1522–66).

élite awareness of sculpture, and the tentative beginnings of a connoisseurship of the sculpted image. Lang Ying, for example, describes seeing effigy sculptures of Song date, rather than painted portraits, in aristocratic homes as well as in temples in his native Hangzhou. He also describes a visit with a friend for the purposes of connoisseurly enjoyment (*jian shang*) of the Buddhist sculptures of Hangzhou's Zhengding Temple, and his dating of the pieces to the Song Dynasty on the basis of votive deposits recovered from inside the images.[43] But this is a very rare mention of such attitudes. Sculptures were generally more involved in doing things than in being appreciated as visual spectacle. And their mimetic accuracy was often assumed; the same author adduces the large size of sculptures in temples as proof of his contention that 'there were giants on the earth in those days'. Sculptures, along with the giant bones occasionally dug up, and the huge robe of King Wu of Yue preserved in a certain temple, prove that 'the forms (*xing*) of ancient and modern people are not the same.[44]

It was in sculpted not painted form that the first Ming emperor chose to represent the rulers of previous dynasties, from remotest antiquity down to his immediate predecessors of the Mongol Yuan, allowing Lang Ying to record one of his most piquant anecdotes, entitled 'The Weeping Statue of Khubilai Khan':

When Taizu possessed the empire, he established a temple in order to sacrifice to rulers through history. From Fuxi downwards, the images were all easily made. Only the face of Yuan Shizu [Khubilai] was several times stained with the tracks of tears. The sculptors (*su gong*) restored it repeatedly, but overnight the same thing happened. When Taizu heard of this he visited the temple and pointed his finger, saying 'Stupid Tartar ! It was a piece of luck that you barbarians managed to enter and rule China, and now you've been driven out. You were rulers for a generation, and now the Mandate of Heaven has returned to me, and I possess the empire. I didn't massacre your descendants, only chased them back to the north, and my attentions to a defeated dynasty are an act of mercy. What have you got to complain about? So stop snivelling!' The next day the sculptors reported that there were no more tears on Shizu's face.[45]

This mini-short story (the emperor even speaks in colloquial Chinese in it) recalls numerous stories in Chinese literature, particularly found in seventeenth-century collections like *Liao zhai zhi yi*, which probe the edges of reality, test the effectiveness of mimesis, but which all trade in the very strong links, indeed the identity, between the representation and the represented. They depend on attitudes that are definitely not those of aesthetic theory's distrust of 'form likeness', but where the statue rather *is* the defeated emperor.

Such identifications could have a negative side. Sculpture in fact lay at

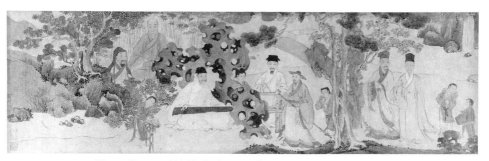

59 Huang Cunwu, *A Noble Gathering in Green Woods*, early 17th century. An undated group portrait of some of the major cultural figures of the late Ming, including the painter Dong Qichang (1555–1636). Minneapolis Institute of Arts.

the heart of the major state interventions into Ming debates on representation, as when the founding emperor of the dynasty had decreed the destruction of all images of the tutelary City Gods throughout the empire, and the removal of images of Confucius and other teachers from the Imperial University.[46] However, it was only in the 1530s that images of Confucius were definitively banished, to be replaced by tablets bearing his titles alone. In this instance the power of the imperial state decisively backed the word against the image, in a manner which set it in parallel with trends towards the rejection of mimesis among the wider élite. Although tastes in painting were diverging at this point between the court workshops and the wealthy of the culturally dominant lower Yangtze region, on this perhaps more fundamental level there was a shared hostility to representing the ineffable, particularly in the all-too-solid form of sculpture.

4 Practices of Vision

Terms of the Image

The discussion so far, focusing as it has on *what* was looked at in the way of representations in Ming China, has avoided a number of crucial questions. Most centrally, it has avoided dealing with the contemporary understanding of representation as a discourse, and has strenuously sidestepped the issue of the terminology of representations, using words like 'picture', 'map', 'painting', as if there were Chinese terms whose semantic fields mapped immediately and unproblematically onto these pieces of modern English usage. It is time to remedy these very serious defects by looking at some of the words which lie behind these bland-seeming translations. I would stress at the outset of this attempt that it very consciously concentrates on Ming and early Qing Dynasty usage, that of the fourteenth–seventeenth centuries. The 'same' words may have been employed very differently at other times. However this was not the perception of Ming intellectuals themselves, who when they interested themselves (as they often did) in the 'origins' of contemporary phenomena like painting (*hua*), considered that the written forms with which they were familiar were in essence those that had been deployed in the past, all the way back to High Antiquity, the eras of the Xia, Shang and Zhou Dynasties (traditionally 2205–49 BCE), and back beyond them to the Sage Kings of the remotest past.

'Painting' is a term we shall come to, but there are other terms operating in the semantic area of 'representation' that were understood in the Ming to have both greater age and a wider compass. One of the most important of these was *xiang*, which I choose to follow Willard J. Peterson in translating here as 'figure'.[1] He demonstrates the centrality of this term to understanding the most prestigious commentary to the earliest and most important of the canonical texts, the *Yi jing*, or 'Book of Change'.[2] The 'figures' of which this commentary speaks, when it states that 'Being the *Change* is a matter of providing figures. ... Providing figures is a matter of resembling',[3] are the trigrams and hexagrams, those groups of three and six broken and unbroken lines (visible round the neck of the jar in illus. 18) which lie not only at the heart of the text's prognosticatory

aspects, but also of its cosmological explicatory force. For Ming readers of the text (and this included the entire body of the educated), the trigrams and hexagrams are therefore without doubt the primary representations, primary not only by virtue of their antiquity but also by virtue of their comprehensive power. Peterson explains:

Each of the sixty-four hexagrams has a name, most of which are words or terms referring to particular objects and activities which are involved in 'figuring' (*hsiang*) [= *xiang*] the situation revealed by the act of divination. The word *hsiang*, as used in the 'Commentary', is sometimes rendered into English as 'image', which connotes resemblance and implies an act of perception. *Hsiang* often is the object of the verb 'to observe' (*kuan*), which supports translating *hsiang* as image. However *hsiang* are independent of any human observer; they are 'out there', whether or not we look. . . .Therefore I find that the English word 'figure' comes closer to covering the meanings of *hsiang* in the 'Commentary'. A figure is an image or likeness, but it is also a form or shape, a design or config-uration or pattern, and a written symbol; 'to figure' is to represent as a symbol or image, but also to give or bring into shape. Taking *hsiang* as 'figure' also main-tains a distinction from *hsing*, translated conventionally as 'form'. *Hsing* is used of classes of physical objects as well as particular physical objects, often with an implication of 'that which is tangible'. *Hsiang* is used of classes of objects and particular physical objects . . ., as well as events . . ., and in the 'Commentary' has the added implication of 'that which is portentous for human conduct'. Both the form and the figure of a given thing are perceivable; it is the figure, according to the 'Commentary', which is especially meaningful.[4]

The text furthermore provides a theoretical justification of the inadequacy of the purely verbal in the realm of representation, by claiming (and attri-buting the words explicitly to Confucius himself); 'Sages set up figures [rather than rely on words] in order to bring out exhaustively what is thought'.[5] 'Figure' and 'form' remained live terms in Ming writing on visual forms of representation.[6] 'Form' in particular is a word with a very wide distribution, as when the sixteenth-century writer Lang Ying char-acterizes the *yang* principle as having no form, describes the geomantic configuration of a certain city as having the 'form of a sleeping ox', or says 'Snow is made when water congeals to take on a form'. He uses the word to mean 'representation' when he says 'Nowadays people make the forms of men and women in candy, which people take and eat; is this not near to eating people ?'[7] He uses it too in the context of painting criticism, when he writes of Shen Zhou, 'In his paintings of mountains and rocks, from the foot of their slopes to the top, the form (*xing*) and gesture (*shi*) of the greater and lesser arteries are piled together in the configuration of layers, yet without the attitude of sleekness.'[8]

However by the Ming period *xiang*, Peterson's 'figure', as seen in the previous chapter, had developed a very precise meaning, to do with repre-

sentations of the human form, principally the human visage. The older
and newer meanings, now represented by two different graphs, appear to-
gether in Lang Ying again, in his discussion of the four natural phenomena
of wind, thunder, rain and lightning, and the weird appearances by which
the deities of these forces are represented in temple sculptures. When he
says, 'thunder takes its image from the trigram *zhen* . . .' he employs the
older form of the graph without the element indicating a human being
(the 'man' radical: no. 9). However in discussing the 'images' of the deities
he uses the graph with the man radical.[9] It is this sense of *xiang* as 'image,
effigy, portrait' that is dominant in Ming writing, but the deeper sense of
'figure' is never wholly absent, and remains available for appropriation,
particularly in learned or more philosophically inflected writing on the
visual, as when Gui Youguang writes in the second half of the sixteenth
century, 'The Way of all under Heaven cannot be sought through figures.
Seeking the Way through figures is to restrict the Way to those fig-
ures . . .'.[10]

The etymology of *xiang* meant that macrocosmic perspectives were
never absent in considering images like those where conventions of social
role would seem to be foremost (see illus. 50, 56 and 57). This was true
largely through the association of *xiang*/figure with *xiang*/image. It was
true through another homophone as well, as we have already seen. Richard
Vinograd, the leading scholar of Ming–Qing portraiture sums up effec-
tively:

The standard Chinese character for 'portrait', read *xiang*, is homophonous with
the character for fortune-telling or fate reading. The character for 'portrait'
comprises a significant component for human being plus an element that
refers to the images, or heavenly patterns, that are manifested in earthly objects.
Thus the character might suggest that the portrait image reflects a heaven-
endowed appearance that can be interpreted in ways related to the process of
fate reading in physiognomic evaluation.[11]

In Ming usage, the term was generally circumscribed to images of the in-
dividual, generally of a named individual. Thus illus. 57 is actually labelled
as a *xiang*/image, and the same term can be safely attached to illus. 56,
which it so closely resembles. Illus. 28 might conceivably have been con-
ceptualized in the Ming under the title *Meiren xiang*, 'Image of a beauty',
but it is unlikely that illus. 13 would have been titled as a *xiang* of the Song
Dynasty scholar Su Dongpo, since what it represented is not the image of
the man in a physiognomic cosmological sense, but an incident from his
life, his triumphant return from exile. Another term would have been
used for that.

The term in question is *tu*, which the first dictionary to hand defines as
'A map; a picture; a diagram; a portrait', seemingly making it cover any

form of representation in visual form at all. Indeed its semantic range is such that no single English term seems appropriate. As a verb the graph can carry a range of meanings in the area of 'to hope, anticipate, plan, scheme'.[12] *All* of the images in this book are capable of being subsumed under this heading, signed pictures by prestigious artists like the Shen Zhou scroll (illus. 3), as much as anonymous maps or the scenes of examination success portrayed on lacquer boxes, the one-off textile as much as the mass-produced book. The standard way in which paintings are titled in the Ming period, as indeed now, is with a phrase which ends with the word *tu*. A hand scroll (see illus. 13) is titled in Chinese *Dongpo Yu tang yan gui tu juan*, literally 'Picture scroll of [Su] Dongpo's return from the Banquet in the Jade Hall'. Horizontal hand scrolls are now, and were in the Ming, *tu juan*, just as vertical hanging scrolls are *tu zhou*. I have already translated *tu* frequently as 'picture', but this ignores the fact that in the Ming it was often used for configurations of text alone, where a word like 'chart' seems more appropriate. The print taken from the encyclopedia 'The Pictorial Compendium of the Three Powers' of 1607, and showing the succession of dynastic houses (illus. 60), is a *tu*, just as much as is any of the 'pictures' or 'paintings' shown elsewhere in this book. A *tu* could be very simple or very complex. The basic geometric forms of square and circle, taken from the *San cai tu hui* are captioned collectively as a *tu* (illus. 61). So also is the *Tai ji He tu*, 'River Chart [or Diagram] of the Supreme Ultimate' (illus. 5), taken from a text printed in 1602, the *Yi jing Lai zhu tu jie*, 'Illustrated Explanation of the Classic of Change Annotated by Mr Lai', by Lai Zhide (1525–1604).[13] Here again, the question of pictures and visuality in the Ming seems to lead back inexorably to the foundational text of so much speculative thinking of the period, the 'Change'. Lai himself used a visual metaphor in speaking of this text, claiming, 'The figures are as a mirror, and in that mirror the myriad things are all reflected'. What distinguishes his text from numerous other commentaries on the 'Change', produced continuously from early imperial times down to the present day, is its concentration on *tu*, 'pictures', 'diagrams' or 'charts', of which it contains well in excess of 100 examples. There was an extremely long and illustrious history of the inclusion of such diagrams in published works of philosophy, dating back to the beginnings of the printed book in the Song period. The *Xing li da quan,* 'Grand Compendium on Spirit and Principle' of the Song philosopher Zhu Xi, whose work was canonical in the Ming examination system, is full of diagrams, and there was a new burst of texts in imitation of it written during the sixteenth century.[14] Such diagrams should not be thought of as merely supportive illustrations to the argument, but in many cases *were* the argument.[15]

The prestige of such *tu* stemmed, although in a way which was by no

60 Woodblock print showing a chart of the orthodox transmission of political power from antiquity to the reigning Ming dynasty, from the encyclopaedia *The Pictorial Compendium of the Three Powers*, 1607.

61 Woodblock print showing geometrical forms, from the encyclopaedia *The Pictorial Compendium of the Three Powers*, 1607.

means uncontested in the Ming, from the primal images, not generated by man, which had been attached to published editions of the 'Classic of Change' since the Song. Of these, perhaps the single most important of all, and one around which learned debate swirled, was the *He tu*, the 'Yellow River Diagram/Chart/Picture'. If one turns to the section on *tu* in any Ming encyclopedia of origins, it is with this magical cosmogram that the explanation invariably begins. Although not presented to the throne until 1701, the enormous compilation *Yuan jian lei han* contains embedded within it the Ming encyclopedia *Tang lei han* of 1618, compiled by Yu Anqi.[16] This makes it clear that for Ming intellectuals the locus classicus of the concept of *tu* was indeed the 'Yellow River Diagram', mentioned in classical texts and believed to have been miraculously voided out of the waters on the back of a magical beast (usually taken to be a horse) in remote antiquity. The first quotation is from the 'Change', and again

from the 'Commentary on the Attached Verbalisations' which is so important for the related concept of *xiang*/figure; 'The River brought forth the Diagram, and the Sage took it as a model'.[17] Numerous other quotations make this the *He tu* the locus classicus of the concept *tu*. As a modern scholar has written quite correctly:

Later commentators on the *He tu* and the *Luo shu*, moreover, interpreted these figures as the paradigms not just of nonary cosmograms, but of all *tu*, a Chinese character that might designate almost any form of graphic representation including charts, diagrams, maps and illustrations in general.[18]

But what exactly is the 'River Diagram'? The early texts that mention it (and there are others from the pre-imperial centuries, including Confucius' own lament that he had not been favored with such a miraculous charter of legitimacy) are silent on its appearance.[19] Thankfully, the question of its origins is less germane to the present discussion than is that of how it was conceptualized and represented in the Ming period, and that is much less problematical. The 'River Diagram' is the pattern of black-and-white dots which appears superimposed on the interlocking spirals in illus. 5. (Those spirals alone form the *Taiji tu*, or 'Diagram of the Supreme Ultimate', often known in English since the 1960s as a 'yin-yang symbol'.) These dots were believed to be collated with the eight trigrams, and hence with the concepts of roundness and of the heavens, while the equally numinous 'Luo River Writing' was a pattern of dots associated with the number nine, with squareness and with the earth.

For a sixteenth-century writer like Gui Youguang, whose interests in artistic representation were certainly only average for a man of his class (he painted no pictures, patronized no famous artists, engaged in no aesthetic debate), the illustrations to the 'Changes' were still of surpassing interest, and his absorption in them may be taken as not untypical. He devotes three separate essays to the subject in his collected works, and significantly they inaugurate the collection as a whole, underlining their importance.[20] However the point of his essays is not to explicate the *tu* printed in editions of the 'Changes' in his day (and which are multiplied to an unprecedented degree in Lai Zhide's work), but to challenge their authenticity head on. Like some other scholars of the sixteenth century, Gui had become convinced that diagrams such as this were not miraculous creations of remotest antiquity, but were instead confections of the Song period. He lays the blame almost exclusively on the great numerological thinker Shao Yong (1011–77), who was certainly the creator of the 'River Diagram' in the form in which it was known after his day.[21] His complaint is that in representing the concepts of the 'Change' in this way they are inevitably limited and in some way trivialized. His views are forerunners

of those yet more forcefully expressed in the seventeenth century and sub-sequently by textual scholars such as Hu Wei (1633–1714), who conclusively disproved the antiquity of these venerable images.[22] What is important for the present enquiry is the existence and prosecution, from the sixteenth century onwards of debate which is essentially about the ade-quacy of representation, and of the contested primacy of visual and purely verbal explanations of phenomena. In some ways it parallels the arguments at court about the representation of Confucius in ritual contexts through sculpture or through written characters alone (and in both cases the ulti-mate victory was to be with the written word, texts were to be the source of state power and not pictures). It is also an argument about the authenticity of illustrations in books. All uses of the word *tu*, and as we have seen they are extraordinarily broad, existed in the context of this debate, which was certainly unknown to the vast majority of the population, but which was to play a part in shifts in the discursive field of representation inhabited by the educated élite.

What is striking about the entirety of the entry on *tu* in the 1701 ency-clopedia *Yuan jian lei han* is how brief and in a sense unproblematical it appears (it covers just two pages). Its selection of quotations in which the term appears goes on to other *tu* mentioned in the Classics, some of which must be what we would call 'pictures', like the 'Phoenix Bit Picture' looked at by the Yellow Emperor and his Minister, and mentioned in the 'Spring and Autumn Annals' attributed to Confucius, and some of which we would call 'maps'. But some are patterns, like the stones the third-century strategist Zhuge Liang laid out to form the famous *ba zhen tu*, 'Diagram of the Eight Configurations', with which he trained his troops in military manoeuvres. Most of these are related to place and space at the beginning, but that gives way to entries (p. 15b) like the 'Picture of the Gathering of Kings' (*Wang hui tu*) showing the tributaries of Tang Taizong, or a more contemporary case like the *Di jian tu shuo* 'Illustrated Account of the Mirror of Emperors', a printed work presented to the throne in 1571 by Zhang Juzheng. There is a listing of a few other Tang, Song, Yuan and Ming famous *tu*, in the sense of 'pictures', all of which are distinguished by being in some way connected with governance, whether they be pic-tures of auspicious omens, or a picture of Luoyang to aid the Hongwu Emperor in considering the city as a capital site at the very beginning of the Ming. These 'pictures' are all anonymous. The selection of entries is very different from Ming discussions of 'picture as art', which forms an entirely different category in another part of the encyclopedia altogether, under the heading of yet another term which now needs to be engaged with, that of *hua*, conventionally 'painting'.

At least one Ming text uses the verb *hua* to describe the activity of creat-

ing the trigrams, and all relevant writers agree on the antiquity of the procedure, however it is understood.[23] Right at the beginning of the Ming, the statesman and philosopher Song Lian (1310–81), not a figure very prominent in the history of painting although distinguished as a calligrapher, provided his explanation of the boundaries of this category in an essay entitled, 'The Origins of Painting' (*Hua yuan*):

Shihuang and Cangjie are both ancient sages. Cangjie created writing (*shu*) and Shihuang made painting (*hua*).[24] Thus writing and painting are not different Ways, but are as one in their origin. When Heaven and Earth first opened up, the ten thousand things were born in transformation, each with their own colour and form, in profusion and multiplicity, yet they had no names, since Heaven and Earth did not have the means to name them. The sages appeared, and rectified the names of the ten thousand things, which were the lofty ones and which the mean, which were the animal ones and which the vegetable, and after this they could be apprehended. Thereupon the forms of sun and moon, wind and thunder, rain and dew, frost and snow above, the manifestation of rivers and seas, mountains and peaks, grasses and trees, birds and beasts below, and in the middle the differentiation of human affairs, separating and uniting, the principles of things, fullness and emptiness were transformed through divine power, made appropriate through alteration, and achieved the needs of the people together with a fulfillment of the desires of things. If there were no writing there would be no means to record things; if there were no painting there would be no means to show things. Is it not that these two reach the same point by different routes? Thus I say that writing and painting are not different Ways, but are as one in their origin.[25]

He goes on to stress the didactic and above all representational aspects of painting, its ability to record the all-important details of clothing and regalia which underlay the ideal hierarchical social order of antiquity. Painting's intimate connections with one of the six traditional classes into which characters were categorized, that of 'figures of forms' (*xiang xing*), make it capable of representational acts which the script forms to which it is so closely allied cannot achieve. Thus it was that in ancient times the classical texts were all illustrated; he names specifically the 'Book of Songs', 'Classic of Filial Piety', the dictionary *Er ya*, the Confucian 'Analects' and the 'Spring and Autumn Annals', and of course the 'Book of Change.' However, with the decay of ancient virtues and morality painting has inevitably declined from its original lofty, and above all mimetically representational, purpose. Now what is represented are the splendours of chariots, horses and servant girls, the beauties of flowers and birds, the remoteness of mountains, rocks and waters, such that 'the ancient intention is decayed'.

Song Lian's analysis may be in line with political discourses of decline from a golden age, but it is not totally idiosyncratic. Several elements of it

are strongly visible nearly two centuries later in the writing of a figure from the mid-Ming who knew many of the most important élite artists of the day, and who wrote extensively on the history and present state of painting, He Liangjun. His entry on the origins of painting forms part of his extensive comments on the subject, contained in his miscellany, 'Collected Discourses from the Studio of the Four Friends', first published in 1569; 'Writing and painting come originally from a common source, for painting is one of the six forms of the script, the so-called "figures of forms" (*xiang xing*)'.[26] He too stresses the mimetic functions of painting in representing correctly the insignia of rule. Clearly as a man of taste in mid-Ming terms, He Liangjun did not believe that it was the function of art slavishly to represent the observable world. He knew far better than that, and indeed says so at other points in his extensive writings on painting.[27] However the stress that he and other writers put on the mimetic, didactic and representational *origins* of the very category *hua* should make us aware that however far 'beyond representation' a number of theorists had gone, the question of representation in visual culture was still a live one in the sixteenth century, a ground of dispute rather than an uncontested foundation. There is an awareness of this in the definitions of painting given in the *Yuan jian lei han*, and taken from a number of early dictionaries:

The *Guang ya* states that painting is similitude (*hua lei ye*). The *Er ya* states that painting is form (*hua xing ye*). The *Kao gong ji* states that the craft of laying on colours is called painting. The *Shuo wen* states that painting is boundaries, that images of the boundaries round fields are painting. The *Shi ming* states that painting is hanging up, hanging up the coloured images of things.[28]

However by comparison with the brief coverage of *tu* as a category in this text, that of *hua* is very extensive, quoting extensively from canonical writers on the history of painting and famous practitioners back to the fifth century, giving mini-biographies of famous artists. This is by and large a discussion not about 'painting' but about *painters*, individual named creators. The reader is given accounts not only of painters and painting drawn from dynastic histories, but also from painting texts and *biji*. A typical example would be the mini-biography/characterisation of Shen Zhou drawn from the writings of Wang Shizhen.[29] The *Yuan jian lei han* is an imperially sponsored compilation, created by a team of leading scholars, but if we look at a much more 'popular' (in the sense of commercially published) encyclopedia of the Ming period, the same concentration on painters as the central part of the discourse of painting is equally evident. The encyclopedia *Shan tang si kao* was brought out in 1619 by a prolific publishing house in Fujian, which catered to the lower end of the (still élite) literate

part of the population.[30] Painting here appears as part of the broad category of 'Skills and Arts', together with not only such activities as medical practice, divination, physiognomy and geomancy (with which it may share a cosmological basis), but also with acting and acrobatics, archery, chess and the game of pitch-pot. What the reader is supplied with is mostly a series of anecdotes about famous painters, culled from a wide range of historical sources. Occasionally these may assume a certain level of knowledge on the part of the reader (e.g. by the use of some of the technical language of aesthetic debate, words like *qi yun* 'spirit consonance'). But more often they provide the reader with the material for cultured conversation, explaining quite clearly topoi of painting like the Tang Dynasty poet Wang Wei's painting of his Wangchuan Villa, and quoting the relevant lines of poetry. There is a heavy concentration on the Tang Dynasty and on citations from Tang poetry, but there are also hefty chunks of the near-canonical writings of Su Shi, mixed in with anecdotes from fiction, including examples of the genre (often with erotic overtones) in which pictures come to life.[31] This density of cultural allusion is one of the things, if not the only thing, that separated the category of 'painting' from the broader category of 'pictures'. One of the proofs of the narrower nature of the category is that it was possible to make a picture of a painting, as is seen in the early fifteenth-century primer *Xin bian dui xiang si yan*, arguably the earliest illustrated primer in the world (illus. 62).[32] Here each object stands to the left of the character that names it (the characters for the right-hand column of pictures are on the facing page), and second from the top on the extreme left is painting, *hua*, clearly a hanging scroll with its mounting, the subject-matter possibly being bamboo and pine. A painting was a thing as well as a category, and as such could be pictured. To picture a picture, a *tu* in the same way would have been impossible.

Ways of looking

Roland Barthes' famous demand for a 'history of looking' might be criticized by now for its rather naive-seeming presumption that there would be *a* history of looking, rather than culturally specific multiple histories of looking. This subject has scarcely been addressed at all with regard to the extremely rich material on the history of visuality in China, and the present attempt can be no more than a sketch of what needs to be done and the questions posed. We need to take up the challenge that Peter Wagner derives from Bourdieu, when he asserts:

For the eye of the beholder is not a given constant; it is the product of institutional settings and social forces constituting that which Bourdieu labels the 'habitus'. It is by historicizing the categories of thinking and perceiving in the

62 Woodblock print, from the primer *Xin bian dui xiang si yan*, 1436. To the right of each picture is the character for that item; *hua*, 'painting' is second from the top on the extreme left-hand column.

observer's experience, not by dehistoricizing them in the construction of a transhistorical ('pure') eye, that we can arrive at an adequate understanding of understanding.[33]

What was the understanding in the Ming period of what it meant to 'look at' a picture? Given that 'picture', as I have attempted to show above, is a complex term, it will be no surprise to engage with the claim that 'looking' was no less complex, and similarly represented by a number of different terms, whose deployment and semantic spread we can barely begin to apprehend without a great deal more work.

It is important to keep hold of the fact that before vision can take place, however it is conceptualized, opportunities for vision must present themselves. The question of who gets to look, where and when, must be considered together with what there was to look at. In some cases it might be purely geographical distance that prevented viewing of some particular thing; Zhang Dafu writes of how 'The Zhanyuanfang of the Jingdesi has sixteen images (*xiang*) of lohan, which are traditionally from the brush of Guanxiu. I have heard of them for twenty years, and today happened to be passing and managed to inspect seven of them'.[34] The writings of the Ming élite are full of such accounts of works which they 'managed to see'. But more usually it was social distance, rather than geo-

graphical, which stood in the way of 'managing to see' some famous picture, especially with the abandonment of the mural format by major artists, and the concomitant rise of more intimate types of picture. In the Ming, what you saw depended on who you were, and who you knew, also on what time of the year you were viewing the work. It is an assumption, but a reasonable one, that seasonal and festival factors may have governed which pictures from a collection were brought out to be shown to visitors; if you visited Xiang Yuanbian in summer you did not look at 'winter subjects' such as plum blossoms. This opens up the possibility of understanding Carlo Ginzburg's 'iconic circuits' in the Chinese setting as seasonal rather than geographical. When it came to 'painting' (*hua*), the formats of handscroll, hanging scroll and album leaf gave the owners of the physical objects a control over the viewing of the representations which was different from that enjoyed by the patron of the larger forms of contemporary painting in Europe. There, access to the space where the picture was (even though this was restricted on the grounds of status or gender) gave access to the picture. In China, where there was no space where the picture continuously 'was', every act of viewing was also an act of social interaction. The great Wen Zhengming, touchstone of taste for the Suzhou élite, was frequently visited by his younger friend He Liangjun who describes what must stand for thousands of such élite interactions over paintings, if at a particularly rarefied level.

Hengshan [= Wen Zhengming] was particularly fond of the criticism of calligraphy and painting. Whenever I visited him, I would always go with something from my collection. The master would examine it for the whole day, and would also produce items that he owned to the best of his abilities. He would often come into his study bearing four scrolls, and when they had ben unrolled he would go in and change them for another four, untiring even though we went through several complete changes.[35]

Such accounts are so ubiquitous as to have become almost invisible, but this example from among so many is worth pausing to consider. It shows, for example, the importance of reciprocity. He Liangjun is shown pictures from Wen's collection so freely precisely because he would 'always go with something from my collection'. Expecting to see but not to show was neither good manners, nor likely to be successful. Indeed it seems likely that the particular place of painting and the viewing of painting in the lives of the Ming élite was made possible precisely by the portability of the pictures they valued, and the ease with which any important work could be transported to an occasion of viewing. Another obvious point emerging from the passage is that looking was, at least ideally (and Wen's behaviour for the admiring He always embodies the ideal) both limited and intense. A few pictures are looked at for a long time, and the visitor

does not see the total scope of the collection, stored in a room different from the one where it is viewed, a room not accessible even to an intimate. There is a reticence of vision here that we shall see more fully expressed in the ideal as the Ming period goes on, an élite reticence which runs directly counter to, and is in tension with, the expanded sphere of the pictorial found in things like books, and on figuratively decorated ceramics, lacquer, textiles and other luxury goods.

Ming pictures that show gentlemen looking at pictures (and which must be taken as representations of ideal circumstances, not as documentary evidence) always stress the collective nature of looking (illus. 68), and it is rarer to see an image of someone looking at a picture entirely by them-selves. In the album leaf shown, which is by the early sixteenth-century professional master Qiu Ying, the small number of pictures on the table is in contrast with the great heaps of archaic bronzes standing ready for connoisseurly perusal. And in an illustration to an early seventeenth-cen-tury drama (illus. 63), which shows gentlemen studying a picture for sale in a relatively modest antique shop, notice again that two heads are bent si-multaneously over the scroll which the shopkeeper holds up. It seems highly likely that many acts of élite looking were indeed precisely acts of communal looking, occasions on which élite values were exchanged, tested, reasserted and spread to members of the younger generation. It is for occasions like this that the encyclopedias such as *Shan tang si kao* are perhaps designed, giving those without extensive collections of their own the cultural capital necessary to participate from the fringes in the pre-sence of their elders and betters.

Another factor should be noted resulting from the physical nature of the formats of painting, and that is the necessity of servants to their manipula-tion. They are present in both illus. 68 and 63, in the former bringing in another picture at the bottom right, and in the latter (the shopkeeper is effectively a servant) holding the picture up. 'Hanging scrolls' as they are known to curators today are not often represented in Ming painting as ac-tually hanging on the walls. Much more often they are shown being held aloft by servants on forked poles, as can be seen on the ceramic jar in illus. 27. This not only limited the amount of time a scroll could be examined (even servants have a limit on how long they can hold something up), but it also emphasized that it was people with servants who were able to look in the socially appropriate manner.

But what was that manner? What are the figures in illus. 68 and 63 actu-ally doing? In the broadest sense what they are doing is covered in Ming usage by the term *shang jian*, a binome meaning both 'discriminate on the grounds of quality' and 'tell true from false'.[36] Several late Ming texts give more precise prescriptions on what they *ought* to be doing, and on how

63 Woodblock print from the drama *Yi zhong yuan*, showing gentlemen inspecting a painting in an antique shop, 1644–61.

pictures ought to be (and ought not to be) looked at. These rules and prescriptions had antecedents which went back at least to the thirteenth century.[37] The *Hui miao*, a text with a Preface dated 1580, contains a fairly typical list of 'Rules (or 'Methods') for contemplating painting' (*Guan hua zhi fa*), opening with what was probably sound advice: 'When you see a shortcoming do not sneer at it, but seek out a strength; when you see dexterity do not praise it but seek out artlessness...'.[38] The social constraints requiring viewers to find something to praise can well be imagined, and explain the often uninformative nature of the colophons

which were added to pictures or their mountings during these acts of collective viewing. However, perhaps the most startling analogy, and one which is repeated in a number of texts, is that between looking at a painting and looking at a woman. 'Looking at a painting is like looking at a beautiful woman (*mei ren*)', says the *Hui miao*, in a formulation which quite startlingly anticipates the idea of the 'gaze', and its development in feminist theory in recent art-historical debate.[39] Women were certainly considered as the objects of a connoisseurly gaze in the Ming, ranked and appraised like other forms of élite male consumption.[40] Other Ming texts make exactly the same connection between women and artworks, which heads for example the miniature essay on 'Connoisseurship' in the 'Treatise on Superfluous Things' of Wen Zhenheng:

Looking at calligraphy or painting is like facing a beautiful woman, one must not have the slightest air of coarseness or frivolity. For the paper or silk of old paintings is brittle, and if one does not do it right when rolling them they can very easily be damaged. Nor must they be exposed to wind or sunlight. One must not look at pictures by lamplight, for fear of falling sparks, or lest candle grease stain them. If after food or wine you wish to contemplate a hand scroll or hanging scroll, you must wash your hands with clean water, and in handling them you must not tear them with your fingernails. Such prescriptions it is not necessary to enumerate further. However one must seek not to offend in all things, and avoid striking a forced air of purity. Only in meeting a true connoisseur, or someone with a deep knowledge of antiquity can one enter into converse with them. If you are faced with some northern dolt do not produce your treasures.[41]

The topos that 'looking at a painting is like looking at a beauty' appears again in the very influential *Shan hu wang hua lu* of 1643, in its section quoting earlier writers on painting. It gives what may be the earliest citation of the phrase, from the writings of Tang Hou (active *c.*1320–30), who made the somatic connection even more explicit; 'Looking at painting is like looking at a beautiful woman. Her air, her spirit, her "bones" are there beside her flesh.'[42] In all these texts, there are a number of words for the act of vision itself, which now needs to be examined more closely. One of these is *kan*, the simple verb 'to see' which every foreign student of Chinese learns in or shortly after the first lesson; in Modern Standard Chinese *Wo kan ni* means 'I see you.' Effort is not necessarily involved. If an object is there, a person will see it. However as used by a late Ming writer like Wang Keyu looking and seeing are not the same thing where painting is concerned. For him, *kan hua*, 'looking at painting', is not a natural physiological act but a learned skill, analogous to the way in modern Chinese *Wo kan shu* means not 'I see the book' but 'I read the book.' He is explicit about the socially limited suitability of 'looking at painting'; 'Looking at painting is basically suitable for the gentleman (*shi da fu*)', who have

the financial resources to collect and the 'strength of eye' (*mu li*) to appreciate. (I will return to 'strength of eye' shortly.) He further states, 'The methods for looking at painting cannot be grasped in one attempt...', and he speaks of 'looking at painting' as something that needs to be 'studied' (the word is *xue*).[43] He also, at least implicitly, explains what will happen if the skills are not mastered:

When people nowadays discuss painting they know nothing of the spiritual subtleties of brush method and spirit consonance, but first point out the resemblances; resemblances are the viewpoint of the vulgar. ... When people nowadays look at painting they mostly grasp the resemblances, not realising that resemblance was the least important thing for the men of antiquity....[44]

The vulgar, the uneducated, will look and will see the wrong things, or the trivial things. But at least they can look, if inadequately. There is another word for the act of regarding a picture in the Ming, which is more restricted in its usage, but richer in its connotations. This better looking, which I have rather unsatisfyingly expressed in the immediately preceding translations with the English word 'contemplate', is conveyed in Chinese by the word *guan*. When Zhang Dafu finally managed to see the lohan scrolls by Guanxiu, this was what he did to them. When Wen Zhenheng talks about purifying oneself after food or drink it is in order to 'contemplate' a scroll. The word has a presence in colloquial as well as highly literary forms of written Ming Chinese; when Master Han sets about studying the corpse of Li Ping'er to paint her portrait, the text says he *da yi guan kan*, literally 'struck a gaze and looked'.[45] Wang Keyu quotes separate rules (*fa*) to do with 'contemplating' painting, which involve the separate 'contemplation' of the sixth-century Six Laws of Xie He, the venerable and enigmatic prescriptive basis for so much later writing on art. These are not visual objects, certainly not things the vulgar can see with their eyes. Even the élite may fail in the act of contemplation; 'When people nowadays contemplate paintings they do not know the Six Laws, but just open the scroll and then add some comment or appreciation. If someone asks them the finer points they do not know how to reply...'.[46]

This act of *guan*, 'contemplation', is therefore for Ming élite theorists the performative part of visuality, beyond the merely physiological. It brings with it connotations of spiritual practice that link it to the written religious traditions of Buddhism and Daoism, as well as to active forms of the religious life which were of ancient origins, but which were infused with new vitality in the late Ming. Scholars of religion who have studied this have tended to use the term 'visualization' to translate *guan*, and this will be adhered to in the immediately following discussion. The sense of *guan* as 'to

scrutinize, to examine carefully' predates the introduction of Buddhism to China, and the formative stages of Daoism as a religion, appearing in the first–second-century dictionary *Shuo wen jie zi*.[47] The question of priority between the two religious systems with regard to the meditative techniques which came to be known under the name does not need to concern us here. What is clear is that, by as early as the fourth century, the idea of 'visualization', often in the form of visualizing cosmic journeys, was central to the religious practices of the Shangqing 'Supreme Purity' School of Daoism. Through internal vision, the adept could assemble within the body vast cosmic forces, and hosts of deities in all the detail of their complex and numinous iconography. This idea in its turn is an element in some of the earliest of Chinese theorizing about representation and the image, theorizing which retained its force in the late Ming.[48] 'Insight meditation', which the French scholar Isabelle Robinet uses to translate *guan* or *neiguan*, is described by her as 'the active, conscious introspection of one's own body and mind'. She has stressed that what is being discussed in the Shangqing texts with regard to visualisation 'cannot be conceived in Western terms as some sort of intellectual or moral introspection, but must be understood in a very concrete way . . . to represent is not simply to evoke but also to create'.[49] And it is this sense of active performance that seems crucial to the concept in all its uses. It is equally present in the Buddhist tradition, permeating the major text to deal with the practices of visualization, the *Guan wu liang shou jing*, or 'Sutra on the Visualization of the Buddha of Immeasurable Life', a fifth-century work that does not have antecedents in the canonical Buddhist literature of India, but is either a translation into Chinese from a lost Central Asian original, or else an original composition in Chinese.[50] Here *guan* 'visualization' or 'contemplation' formed one of the two key practices of the 'Pure Land' tradition of Buddhism; along with oral recitation of the name of the saviour these practices were fully alive in the late Ming. For the great renewer of Buddhism in the late Ming, the monk Yunqi Zhuhong (1535–1615), the 'Sutra on the Visualization of the Buddha of Immeasurable Life', was one of a limited number of texts which novices in the monasteries he founded were required to memorize, and one of the three Pure Land sutras on which public lectures were regularly given, lectures attended by many members of the élite with whom Zhuhong was on social terms.[51] This gave the Buddhist notion of visualisation a continuing presence in Ming culture, although the precise degree of its impact outside the monastic context needs more research.

There is further evidence that the ancient Daoist understanding of visualization was still circulating in the Ming period. The wealthy Hangzhou merchant, playwright and connoisseur Gao Lian, in his 'Eight

Discourses on the Art of Living' (1591), lists Daoist books as among those which are an essential part of any gentleman's library, and he makes explicit use of one of the key texts in his discussion of 'Prescriptions for Enlightening the Eyes and Ears'. He quotes the early sixth-century 'Declarations of the Perfected' (*Zhen gao*) by Tao Hongjing (456–536) as follows: 'In seeking the Way you must first ensure that eyes and ears are quick of apprehension, this is the chief matter. For ears and eyes are the ladder in the search for the True, the door to gathering up the Divine – they bear on acquisition and loss and the discrimination between life and death'. Gao goes on to give his own prescriptions for further empowering the eyes, through a form of massage which after two years will allow the adept to read in the dark, and which will achieve the inner alchemical transformation of the 'eye god' (*mu shen*).[52] The point is that the 'Declarations of the Perfected' is one of the central texts describing visualization practices, which are also visible elsewhere in Gao Lian's prescriptions for a long life through such techniques as 'ingestion of the pneuma of the sun and of the essence of the moon', both of which involve visualizing (*cun*) the relevant heavenly body within one's own physical frame.[53] Although *guan* is not used explicitly by Gao Lian in the sense of visualizing meditation, it is at least possible that the term had some of those shadings for others like himself who were steeped in the classic Daoist texts where it is so prominent.

One other Ming word for the act of engaging visually with a picture must be examined, and that is *du*, with the modern dictionary definition 'to read'. The notion of *du hua*, 'reading a painting' may seem strikingly modern in an age when under the impact of methodologies derived form literary studies it is common to refer to a picture as 'a text'. The presence of written inscriptions on so many Chinese pictures (turning them into the 'iconotexts' studied by Peter Wagner) may make this identification even stronger, as may the numerous statements on the common origins of writing and picturing current in the Ming and discussed above. However we must be wary of giving an unacknowledged primacy to the notion of text over image, when by *du hua* Ming writers may not be using an analogy or metaphor, but drawing attention to a common type of action. The question of motion is crucial with regard to vision here. The idea of *du*, 'reading', above all implies a subject whose vision is moving, scanning the characters of a text or the surface of a picture. Importance was attached not to the legibility of the image but to the act of moving the eye across the surface, particularly of the hand scroll as it is sequentially made visible in the act of unrolling. The presence of duration in Ming ideas of visuality is important here, the idea that pictures could not by their physical nature be taken in all at once. By contrast *guan* is a subject whose vision is fixed,

who may penetrate deeper, see more or see further *into* something, rather than across it. In a striking example of this quoted by Shigehisa Kuriyama, the Bronze Age King Hui of Liang had his thoughts read by one Chunyu Kun, of whom a later writer commented; 'The intention was inside the breast, hidden and invisible, but Kun was able to know it. How? He contemplated (*guan*) the face to peer into the mind'.[54]

The terms *kan, guan,* and *du* all appear in the studio names (names chosen by the adult male himself) of individuals in the Ming and Qing Dynasties.[55] Only one individual has a studio name using *kan*, fourteen have one containing the element *guan*, and eight have one using *du* (usually in the form *du shu*, which may mean 'studying calligraphy' just as much as 'reading books'). To be sure, this is too small and random a sample for anything very meaningful to be extracted from it, but a fruitful line of enquiry might be to consider ways of looking stratified by class or status, with *guan* as a more élite way of looking, whether at a picture, a waterfall or the moon (the connoisseurly discrimination contained in the term *shang jian* is quite explicitly a social attribute). Scholars contemplate, while peasants (along with women, children and eunuchs) just look. Certainly there is a very different relationship to pictures portrayed in illus. 68 and 63 from that shown by an anonymous sixteenth-century artist in illus. 69, depicting an itinerant seller of pictures displaying his wares to a village audience. In the two former pictures, members of the élite lean into the album leaves and the hanging scroll they are inspecting, their body language speaking of an active engagement, as well as of concentrated and focused intelligences. By contrast, the unsophisticated peasants in illus. 69 react with amazement and even horror, one woman covering her face as another hides behind her body, and a young girl turns away. Their bodies stiffen at the sight of the terrifying visage of Zhongkui, queller of demons, since for them the picture is real, they are the uneducated who remain at the level of 'resemblances' and for whom mimesis retains its full and terrifying force.

However art–historical theorists were not the only people to whom looking, seeing and visualizing were of concern. Some of the most interesting recent work on the subject of visuality in China approaches it from the point of view of medical practice, and it is to this area, together with some comments on the broad understanding of the act of vision as physiological rather than cultural practice (admitting that to separate these two categories is a very dubious procedure), that I will now turn.

The development of powers of seeing is an aim shared by the medical practitioner, the connoisseur of art and the religious adept alike; indeed to view 'medicine' and 'religion' in early China as separate discourses may be to commit another serious mistake. Robinet describes how Daoist practices sought not only to make the adept invisible, but also to increase

64 Qiu Ying (active *c.*1494–*c.*1552), *Thatched House in the Peach-Blossom Village*, first half of 16th century. Palace Museum, Beijing. Inscriptions make it clear this picture was ordered from this famous professional master to be used as a birthday gift.

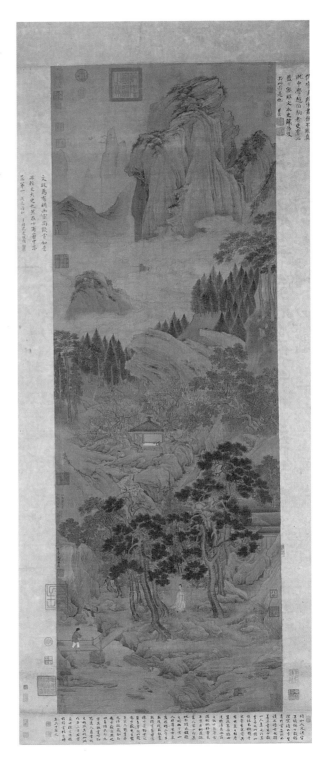

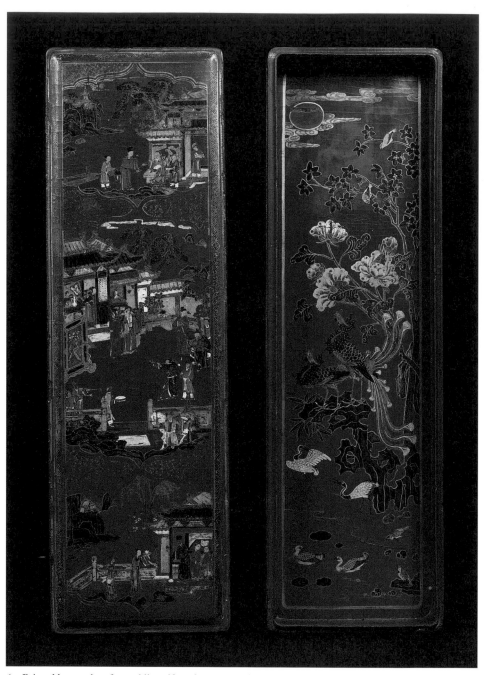

65 Painted lacquer box for wedding gifts or horoscopes, dated 1600. Victoria and Albert Museum, London.

66 Colour woodblock print, from *Conspectus of Sights of the Lakes and Hills* c.1620–40.
Bibliothèque nationale de France, Paris (Estampes).

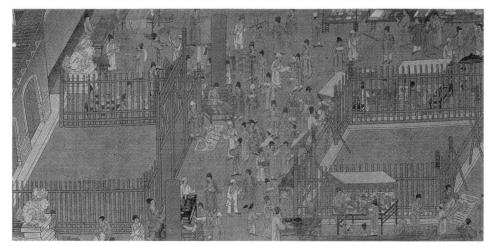

67 Anon, *Splendours of the Imperial Capital* (detail), 16th century, ink and colour on silk. Historical Museum, Beijing.

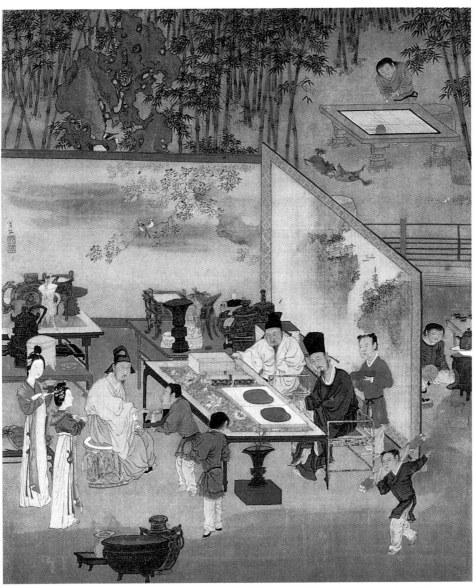

68 Qiu Ying (active *c.*1494–*c.*1552), 'Ranking Ancient Works in a Bamboo Court', from the album *A Painted Album of Figures and Stories*, first half of 16th century, ink and colour on paper, Palace Museum, Beijing.

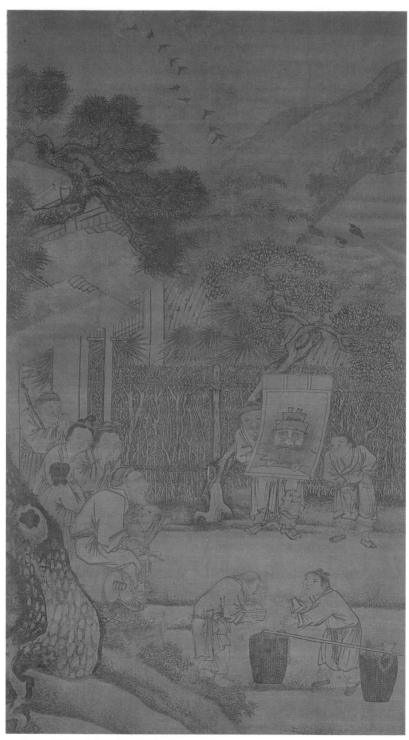

69 Anon, *Village Painter Showing his Wares,* 16th century, ink on silk. Freer Gallery of Art, Washington, DC.

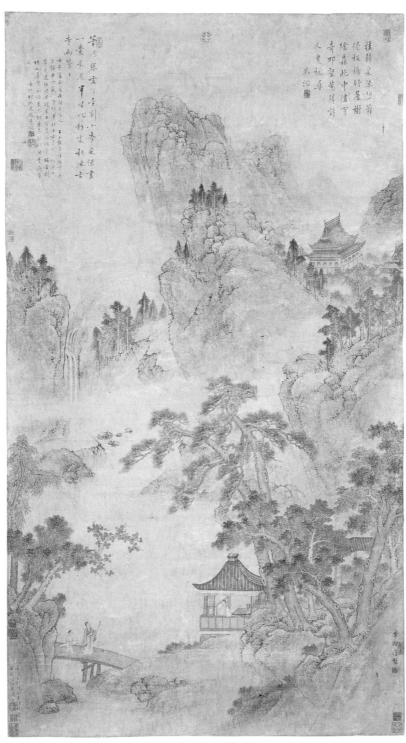

70 Anonymous, *Landscape,* fraudulent signature of the Tang dynasty master Li Zhaodao, late 16th century, ink and colour on paper. Victoria and Albert Museum, London.

71 Contract dated 1640, written on colourprinted stationery. Such decorated
stationery was widespread by the 17th century.

vastly the power of his own sight, through exercises which involve visualizing (*guan*) the transformation of the left eye into a shooting star and the right eye into a bolt of lightning. This is the type of practice described in a different form by Gao Lian in 1591.[56] The earliest sources on one of the quasi-mythical founders of the medical tradition tell how an elixir given to him by a mysterious stranger gave him the power to see through walls and inside bodies, a testimony to 'the special affinity between medicine and the gaze'.[57] Differences between the post-Hippocratic Western medical tradition and that in China have recently been studied in a way which shows that, although from the perspective of Western anatomy, Chinese practice may appear as a 'failure to look', it is actually as dependent on visuality; a different visuality. What has been called the 'primacy of the gaze', over touch or smell, for example, is every bit as evident as an ideal in the early Chinese medical texts, even if the word used for the performed gaze is yet another one (*wang*), which is rarely used of the act of looking at pictures.

But what of the act of looking as it was understood physiologically? What did Ming thinkers believe was happening when one looked, at a picture or at anything else? An otherwise rather obscure writer named Chen Quanzhi, active in the mid-sixteenth century, supplies a passage which may be helpful as a point of entry:

Eyes are the mirrors of the self, ears are the windows of the body. With much looking the mirrors are dimmed, with too much hearing the windows are stopped. The face is the courtyard of the spirit, the hair is the glory of the brain. If the heart is sad then the face is distressed, if the brain is weakened then the hair is whitened. The essence (or 'sperm', *jing*) is the spirit of the body, the intelligence is the treasure of the self. With too much labour the essence is dispersed, planning to the point of exhaustion causes the intelligence to be diminished.[58]

This vitalist position holds that the eyes are possessed of a certain degree of power or force, which can be exhausted if too much looking is done. This is surely bound up with the idea of *mu li*, 'force of eye', mentioned above and often referred to in Ming art-historical writing as a desirable attribute of the connoisseur. It is also something which the portraitist aims to capture.[59] An encyclopedia repeats the classical prescription from the ancient text *Laozi*, which states, 'The five colours will render the eyes of man blind'. The mythical culture heroes of the remotest past were often possessed of extraordinary ocular apparatus; Cangjie the inventor of writing had four eyes, while the Emperor Shun famously had double pupils, as a symbol of his 'double intelligence'.[60] Indeed there is a wealth of material in such texts from which a cultural history of vision in China, touching on topics such as blindness and mantic vision could be constructed. This will not be attempted here, although the continued necessity for such a project must render everything said in this chapter somewhat tentative.

Those who have engaged with the Chinese literature on optics (not the same thing as visuality, which is not reducible to it) generally do so from the standpoint first adumbrated by Joseph Needham in a relatively early volume of *Science and Civilization in China*. Here he stresses one of the main themes of his work, that Chinese thought about the physical world is dominated by a notion of waves and fields of energy, rather than by colliding particles, the world view he characterizes as 'billiard ball physics'.[61] He discusses in detail the extensive material on optics found in the late Bronze Age text known as the *Mozi*, its understanding of light as linear, its experiments with shadows, focal points, pinholes, inversions of the image, mirrors and refraction. He stresses that Chinese writers on the subject never propose the idea, standard in the Mediterranean world from the Greek Pythagoras down to the work of the Arab Ibn al-Haytham (965–1039 CE), that the eyes emit visual rays that touch the object seen, to give the sensation of sight. Rather the flow is in the opposite direction, from the object to the eye, as the Epicureans believed. However he goes on: 'Little is known as yet about optical studies in later times. ... Presumably optics and catoptrics shared in the general decline of the physical sciences during the Ming period, but after the coming of the Jesuits interest was stimulated as in so many other scientific topics'.[62] This image of Ming decline in the sciences, revived under Jesuit stimulus, is the master narrative of *Science and Civilization in China*. Certainly it seems to be the case that there was little explicit scholarly interest in the fifteenth to seventeenth centuries, in the complex and corrupt text of the *Mozi*. Few people seem to have read it.[63] However the perceived lack of a 'scientific' discourse of optics should not be read as a lack of a discourse of visuality, which may be much more widely diffused.

A recent important attempt to bring the discourse of visuality to bear on Chinese image-making at the very end of the seventeenth century, and to engage in a less teleological way with the 'impact' of imported technologies of vision, is found in an article by Anne Burkus-Chasson.[64] Her discussion of the painting 'Waterfall on Mount Lu', executed in 1699–1700 by the painter Shitao, describes the work as not a topographical recording of place but 'a representation of looking that problematized the acts and techniques of the observing subject'.[65] Both the picture and the inscriptions on it deal with the act of *guan*, of performative looking discussed above. She goes on to make it clear that Shitao's views on vision participated in a mainstream discourse of sensory perception which was voiced by the extremely influential mid-Ming philosopher Wang Yangming (1472–1529), who stated, 'The eye has no substance of its own. Its substance consists of the colours of all things'.[66] Wang's philosophical position, which became generally normative among the educated élite of the Ming, held that the

sensory apparatus was both essentially passive, a receptor of stimuli, and of an inferior ontological status to the mind, which it linked to the external world. This primacy of 'mind' seems to fit well with the observed anti-mimetic, anti-transcriptional bias of Ming élite aesthetic theory. But it seems to exist in tension with the idea of an active eye, almost a personified eye, present in the notion of 'strength of eye' as well as in more popular notions of how vision worked. A short story by the seventeenth-century writer Pu Songling (1640–1715) contains a striking image of the eye as entirely divorced from the workings of the mind. It tells how a lascivious young scholar named Fang Dong chances on a fairy princess, going home on a visit to her family, and ogles her shamelessly. His career as a voyeur is cut short when she flings a handful of magic dust in his face, blinding him completely by causing a thick film to grow over both eyes. While repeating a Buddhist text as an act of repentance, he hears the two tiny figures who inhabit the pupils of his eyes in conversation. These tiny people are subsequently seen exiting his face via a nostril, and returning the same way. They are heard planning to break open the film over one eye from the inside, and subsequently do so, giving the unfortunate Mr Fang back his vision in one eye, but leaving him with a double pupil in his good eye as both 'pupils' take up residence on one side of his face.[67] This belief in miniature inhabitants of the eyeball is widely spread across the cultures of the world, and is presumed to have its origins in the observation of corneal reflections of the human figure there.[68] Just how literally educated people like Pu Songling, or his Ming predecessors, took such beliefs is at present hard to gauge.

The situation is complicated by the presence during the Ming of what were new technologies of vision, some of them of imported origin. One of these was spectacles, first referred to in the middle of the fifteenth century.[69] A late sixteenth-century source claims their first appearance was as a diplomatic gift from the Kings of Malacca in 1410, and certainly Lang Ying in the mid-sixteenth century sees them as originating in the 'Western Ocean'.[70] Magnifying lenses in the Ming were, according to the very limited sources, seemingly restricted to a single lense rather than a pair, and were worn on a ribbon or on a handle like a lorgnette. Eyeglasses as we know them now were worn in the Ming, but some of the references seem to be to pairs used not so much to improve the sight through magnification, as to prevent and cure inflammations of the eye such as conjunctivitis. For this purpose, lenses were made not out of clear crystal (glass was not used before the nineteenth century), but out of naturally darkened crystal, often of the kind known as 'tea crystal'.[71] Both kinds probably remained very rare until the end of the Ming. It was only in the second half of the seventeenth century that occasional imports began to be

augmented by spectacles manufactured in any quantity in China, first of all in Guangzhou and Suzhou, and later in Hangzhou, Beijing and Shanghai. The earliest named businesses manufacturing them all date from after 1700, although a specialist named Sun Yunqiu (c.1630–c.1662) is known to have been active as a maker in Suzhou in mid-century, and wrote a treatise on this and other pieces of optical apparatus, a text which has not survived.[72]

Spectacles' impact on notions of visuality may have ben reinforced by that of the telescope, first introduced to China in the late Ming by European missionaries. This piece of apparatus was first mentioned in writing in a Chinese text by the Jesuit Emmanual Diaz published in 1615, where significantly Galileo is said to have invented the device because he 'lamented the strength of the eye [as insufficient]'. Here again is the notion of 'strength of eye', *mu li*, although now it is something which can be augmented. The first telescope is believed to have been brought to China in 1618, and presented to the emperor in 1634, while in 1626 Adam Schall von Bell published his 'Treatise on the Far-seeing Lense' (*Yuan jing shuo*), illustrating and discussing the apparatus in some detail.[73] Telescopes were discussed by late Ming intellectuals, and the instrument provides another fictional voyeur of the period with the ability to spy unobserved on distant beauties. Sun Yunqiu was manufacturing them in mid-century Suzhou. Burkus-Chasson has therefore written of two competing models of vision as available to the élite of the early and middle seventeenth century. One of these, which she argues was ultimately to prove hegemonic in China, was of 'the eye/body within the body of the natural world'. A 'competing model of vision' was however available (but rejected) in the form of the Cartesian disjunction of the observer from the thing observed.[74] This is cogently argued, and difficult to refute on the existing evidence. However, her findings may be strengthened by an acknowledgment that there may well have been 'competing models of vision' that predated and owed nothing to the introduction of new technologies of the visual under Jesuit auspices. In addition to the expansion in the use and manufacture of spectacles (which had a foreign origin but were independent of Jesuit agency), the late Ming/early Qing seems to have been a period of experiment with regard to a range of optical toys and entertainments. Sun Yunqiu also manufactured kaleidoscopes, while various forms of zeotrope were also used, and reported by Western observers.[75] When the Jesuit Martin Martini (1614–61) lectured at Louvain in 1654 using lantern slides for what may have been the first time in Europe, he may have been deploying a technology he had seen used in his time in China. It therefore seems possible that the hegemonic model of mind/eye consonance might have faced a certain amount of, if not opposition, then supplementing, by optical

novelties not wholly of Jesuit introduction. A range of ways of seeing may well have been available for appropriation throughout the Ming period, as earlier.

What these ways of seeing may have shared is a common sense of the act of vision as being not a mechanistic response to stimuli, but an act of creation at the same time. The sense of representing as creating fits quite comfortably with recent important if speculative work in the field of epistemology in China. The anthropologist Judith Farquhar, faced with a definition of epistemology as 'a self-conscious theory of Knowledge' is reported to have remarked that for a sinologist every word of the definition would have to be reinterpreted, 'quite possibly including "of" '.[76] Roger T. Ames, whose work both on his own and with David Hall has been central to this enterprise of reinterpretation, has in an important article focused attention on how translating the Chinese character *zhi* as 'to know/knowledge' inevitably forces it into specifically Western patterns of thought centred on the distinction between object and idea. He argues by contrast that in the early Chinese thought he has studied, 'There is an unbroken line between image as what is real, image as the presentation (*not* re-presentation) of what is real, and image as the meaning of what is real. Image *is* reality'.[77] The insistence of Hall and Ames in their collective work that *zhi* is 'fundamentally performative – it is "realizing" in the sense of "making real" '[78] must be engaged with by art historians and those interested in the history of visuality of China, not least for its striking congruence with the sense of vision which is present in the Buddhist and Daoist traditions, and which through them forms part of educated discourse of the image in all later periods. If 'epistemology' in China is, as a number of recent scholars have argued, fundamentally about the centring of knowledge in the knower, then might it not be the case equally that visuality in China is about the centring of seeing in the seer?[79] The implications of this for the history of the visual image in China have only been dimly discerned at present, but if these ideas were to turn out to have any force at all then to locate the 'difference' between something called 'Chinese painting' and something called 'Western painting' *within the painting* would be to commit a fundamental error. Instead, attention would need to be directed to differences expressed through ways of seeing, ways of knowing, ways of connoiseurship. 'Seeing' in the Ming would in this argument not be about the production of knowledge but about the production of knowing subjects, a possibility which will be explored further with a case study of one Ming text about pictures aimed at producing a new kind of such subjects.

5 The Work of Art in the Age of Woodblock Reproduction

Practices create subjects, it is being argued here, yet subjects are not on some sort of historical auto-pilot, but retain agency in the deployment of those practices. 'Chinese painting' is neither a naturally occuring object, nor is it a conscious conspiracy of some machiavellian orientalist centre. It has a history that is not exactly contiguous with all the acts which go to make it up. The canonical view of 'Chinese painting' as an object of study in the West has historically privileged monochrome painting in ink over that involving the use of colour. The work by Shen Zhou (see illus. 3) has been much more comfortably discussed than has that by the same artist (illus. 29), with its vibrant use of expensive mineral pigments. Uses of colour by 'scholar' artists have generally been explained as an 'archaizing' feature, a reference to the 'green and blue' style associated with artists of the Tang period and earlier in the minds of Ming connoisseurs and theorists. Undoubtedly this is often the case. However, the modern art-historical literature also contains an echo of an authentic prejudice against colour which those same theorists held, and expressed unambiguously in their works. Like 'form likeness', which it so often existed to serve, colour was an aspect of the pictorial likely to appeal to inferior minds. Although conformity of colour was one of the 'Six Laws' of painting of the sixth-century writer Xie He, and although *dan qing* 'cinnabar red and green/blue' was one of the oldest appellations for painting as a craft, the more standard view of the theorists was that expressed as early as the ninth century by Zhang Yanyuan, who argued, 'one may be said to have fulfilled one's aim when the five colours are all present in the management of ink [alone]. If one's mind dwells on the five colours, then the images of things will go wrong'.[1] The 'five colours' (*wu se*: blue, yellow, red, white, black) is a concept with a semantic spread well outside the realm of picture making, including a political/cosmological aspect in their correlation with the five directions and five elements, and is active most particularly in the classical medical texts, texts still current in the Ming. The five colours are what the physician sees; 'Practically, colours command the most consistent and sustained visual attention. Theoretically, colours define the function and

rationale of sight'.[2] They are also what, in the words of Laozi (see p. 129) will 'render the eyes of man blind' if gazed on too avidly. The five colours (blue, yellow, red, white and black) were correlated with the five directions, the five elements and other aspects of the five-fold cosmology of the early imperial dynasties. Nor were such notions extinct in the Ming, when the colours of imperial banners and the red robes of officialdom were governed by these considerations. Lang Ying talks about how he has often seen painters make up green by blending yellow and blue (*qing*), and argues that this proves the essential original colour of trees, which only appear green, to be really *qing*.[3] He is making a point here not about painterly practice but about the correlation of colour with wood, one of the five elements.

But *se* had meanings above and beyond the chromatic.[4] It is the countenance of the human face, and by extension in Buddhist usage it is the entire (illusory) world of sensory phenomena. This Buddhist misprision of appearance/colour must have had an impact on the development of Chinese aesthetic theorizing of the visual, which has yet to be fully investigated. It is also sexual desire, and as such links notions of avidity for colour with avidity for sexual intercourse, both of which will tend to exhaust the vital essence of the male and bring about premature ageing and death. Colour, in this sense, could be fatal to a man. Whether this led to associations of the colourful with the female would need further investigation, although it does shed an intriguing light on the 'looking at a picture is like looking at a beautiful woman' topos discussed above. But what is clear is that once again the theory must not be mistaken for practice. Lots of Ming pictures were very colourful, even if they are the types of picture that have tended to be overlooked until quite recently in constructing totalizing views of 'Chinese art'. Even after the inevitable fading that water-bound paints will undergo over several centuries, some (see illus. 28, 29, 34 or 64) remain strikingly unlike the monochromatic ideal expressed by the phrase 'the colours of ink'. In a novel such as *Jin Ping Mei*, 'The Plum in the Golden Vase', colours (and indeed sex) are everywhere lovingly listed and even celebrated in the descriptions of clothing, furnishings, architecture and pictures. The point is satirical, that these are people who have no taste, but the satire would again have no edge if it were not the case that an acceptance of, even a revelling in, the possibilities of colour was more widely spread than the scant degree of recognition given to the subject in élite writing on *painting* would suggest. Many Ming luxury goods like lacquer, ceramics and textiles, goods whose expense put them well beyond the means of the common mass of the people, were extremely highly coloured (illus. 18 and 31, for example). Here again there is evidence that arbiters of taste mistrusted such objects in at least some circum-

stances, as with the case of ceramics for the male studio, where Wen Zhen-heng favours monochrome wares of the Song period over the more polychrome productions of his own times.

There can be no doubt of the lower theoretical status of colour as an element of painting. It was part of the greatness of the major names of Tang painting that they had their work coloured by assistants, and too great an interest in the handling of colour was deemed to reduce an artist's standing in the eyes of later critics.[5] Genre of painting executed in ink alone enjoyed commensurately greater prestige in theory, chief among these being 'ink bamboo' (*mo zhu*) and 'ink plum' (*mo mei*).[6] The depiction of pine trees in ink had something of the same status, and it is probably not a coincidence that it is some combination of these three (possibly even the grouping known as the 'Three Friends of the Cold Season') which forms the subject of the generic 'painting' in the fifteenth-century child's primer (see illus. 62).

This 'painting' is itself a picture in black and white, rendered so in the medium of wood-block printing, which would not develop the technology of colour until the end of the sixteenth century. It is therefore not surprising that some of the earliest painting subjects to be rendered through printing were also those which were generally associated with ink on paper alone; pine, bamboo and above all plum. What is generally considered to be the earliest printed book in which the pictures enjoy an independent status, rather than as support to a text which is the work's essential part, is the mid-thirteenth-century *Mei hua xi shen pu*, or 'Register of Plum-Blossom Portraits' of Song Boren. Maggie Bickford has demonstrated both the complexity of the political allusions encoded in the poetry that forms the text of the work, and stressed the way in which its author adapted the conventions of the technical painting manual to make new meanings for the representation of plum blossoms, which continued to be meaningful for élite painters over several centuries.[7] This is not a 'how-to paint' book. However, its very stress on separating itself from such works says something about their prevalence even in the thirteenth century. By the Ming, they were everywhere in the printing industry, and as Bickford shows the subtle and allusive meanings of the individual pictures were absorbed into the broader and cruder cultural currency of the whole genre of 'ink plum'. The material of *Mei hua xi shen pu* was incorporated into numerous painting manuals from the mid-fourteenth century on, including *Luofu huan zhi* of 1597, and Wang Siyi's *Xiang xue lin ji* 'Fragrant Snow Forest Collection' of 1603.[8] The first of these books formed part of a large collection of painting manuals covering a range of subjects, published in the collection *Yi men guang du* by Zhou Lüjing, a gentleman publisher from the lower Yangtze city of Jiaxing.

72 Woodblock print showing types of human figure, from *Classified Manual for Painting*, Yibai tang 1607 edition.

This was far from being the only such manual to be published in the Ming period. One of the most widely circulated was the *Tu hui zong yi*, 'Ancestral Treasures of Painting', by Yang Erzeng, first published in Nanjing in 1606 and almost simultaneously in Hangzhou.[9] The very tangled publishing history of Ming painting manuals remains as topic for investigation, but what is clear is the very great quantity of mutual borrowing between the various texts. Thus the figures in illus. 72 appear variously in *Yi men guang du* (1597), *Tu hui zong yi* (1606/7) and *San cai tu hui* (1610), as well as going on to feature in well-known compilations of the later seventeenth century like the best known of all painting manuals, the *Jie zi yuan hua pu*, 'Mustard Seed Garden Manual of Painting'. As well as specialized painting manuals, Ming encyclopaedias with a much wider circulation contained some material of a 'how-to' nature on painting. The popular *Si min bian lan san tai wan yong zheng zong*, 'Orthodox Teaching for a Myriad Uses to Benefit the Four Sorts of People', of 1599, includes a section on 'The manner of painting the portraits of the plum blossom' (illus. 73),

which descends ultimately from Song Boren's work.[10] By the late Ming, formerly élite and even arcane conventions of picturing had been appropriated by a much wider audience.

We do not know how these books were used. Their rhetoric is about enabling the reader to *do* something, to create certain types of representation for themselves, even if the extent to which they were used as practical guides to action is unknowable. However these were not the only types of intersection between paintings and books, and a very different sense of what could be done with the reproductions of putative paintings as a whole, rather then the elements which might make up a painting, can be gleaned from a text of the same broad period entitled *Gu shi hua pu*, 'Master Gu's Pictorial Album'. The 106 illustrations of this 'Album', published in 1603 in Hangzhou, have no immediate precedent, and few long-term successors, in the world of Ming pictures. They purport to reproduce original works of art, paintings by a range of artists from the fourth-century master Gu Kaizhi (*c*.345–*c*.406 CE) to some who were still living at the time of publication, such as Dong Qichang (1555–1636). The existence of such a book can be seen on one level as part of the broader 'commodification of knowledge' observable for the first time in a number of areas of sixteenth–seventeenth-century culture; the purchaser acquires cultural capital by the acquisition of the volume, with its thumbnail sketches of the careers of the artists alongside a sample of their work. But it can also be seen as a evidence of shift in the very culture of visuality at this period, bearing on what to look at, how to look and how to conceptualize the act of looking. It is not in this construction a peripheral curiosity of the book market, but an important text in its own right.[11]

Very little is known about the work's compiler/publisher, the eponymous Master Gu. His name was Gu Bing, and the Preface to the standard modern reprint of his work extracts from the prefaces to the text the information that he was from Hangzhou, was orphaned at an early age and was brought up by his grandfather, who 'spared him from rote-learning, and let him study the ink traces and fragments of pictures by famous people he had collected of old'. This suggests a background of professional painters. Gu Bing trained as an artist with a special competence in flower and bird painting, and in 1599 was selected for service in the Imperial Palace, where he formed part of the very murky world of late Ming court art.[12] A standard seventeenth-century collection of artists' biographies makes the 'Album', his published compendium of masterpieces real and imagined, the major feature of its brief notice, with the words:

Gu Bing, *zi* Anran, was a Hangzhou man. In the Wanli era he was presented for service at court as being excellent in painting. On the basis of what he heard and saw he drew a pictorial album, transmitting copies of everything from the Jin and Tang onwards, preserving a rough outline, smelting the modern with the ancient to assemble a great synthesis.[13]

The suggestion that access to the imperial collections lay at the heart of the project is an intriguing one, which is repeated in a number of later texts.[14] However, there can be little doubt of the essentially commercial and speculative nature of the book's production, even if it was not produced by a major publisher. The 1603 edition emanated from the Shuanggui tang 'Double Cassia Hall', a Hangzhou operation with no other known titles to its credit, suggesting an essentially self-published operation.[15] There is some confusion about the possible existence of another edition in 1613 or 1619, but this similarly does not seem to have been a product of a major publishing operation with many other titles to its credit. The authors of the prefaces are slightly shadowy, if eminently respectable figures, at least one of whom, Zhu Zhifan (1548–1626) was a member of the highest degree-holding élite, with a reputation of his own as a painter, even if he came from an undistinguished region of Shandong province.[16] Presumably Gu Bing met him (was patronised by him?) in Beijing in the very early 1600s, when both men were in the city, and his presence in the book says something about Gu's involvement with a member of the degree-holding élite, even if with one whose background was not outstandingly distinguished and whose career was hardly stellar. However it is noteworthy that the book was not published in the capital but in the much more culturally rich and economically productive southern city of Hangzhou, Gu Bing's native place where he presumably retained some connections.

The complex publishing history of the book is less germane to the argument here than are the contents, examples of which are reproduced (see illus. 74–6). The biographical texts on each artist are slightly easier to account for than the pictures. All of those that refer to pre-Ming artists (rather more than half), are copied more-or-less word for word from a text of 1365 entitled, *Tu hui bao jian*, 'The Precious Mirror of Painting', one of the most widely quoted of all compendia of artists' biographies. This work was published in the Ming in various continuations, including material on artists down to the sixteenth century, and in some but not all cases these continuations are the source for the notices of more recent painters in *Gu shi hua pu*.[17] The author follows this text in his placing of artists within dynasties, for example listing Jing Hao as a Tang painter and Gu Deqian as a Song painter, when both are nowadays more often thought of as active in the intermediate era of the Five Dynasties. The biographies are written out in what purport to be the hands of, and are signed and sealed by, a wide range of contemporary luminaries, although given what we know about the practices of Ming publishing there is no reason to accept the supposed evidence of their participation in the project at face value.

There is no such single source for the pictures, some of which reproduce surviving early pictures, but many of which must be presumed to be of Gu Bing's own composition. One striking thing about them, given that they are meant to be reproductions of pictures, is their difference in one major respect from any real pictures (or for that matter, fake pictures) circulating in the Ming art market at the time of their printing. Very few carry inscriptions or seals, not even in any case the signature of the putative artist. They are 'pure' pictures. As such they are supremely *unlike* what they purport realistically to reproduce, and they are so in a context where, as has frequently been pointed out, traces of production, and of previous states of ownership and acts of connoisseurship were a major part of what made an important painting important to the Ming élite.[18] This is all the more striking when we consider the types of paintings which Gu Bing's album contains.

As his brief biography suggests, Master Gu goes right back to the founding father of the painting tradition in the fourth century CE, beginning with a work by the Jin Dynasty artist Gu Kaizhi. All Ming sources cite Gu Kaizhi as effectively the originary moment of the painting tradition, the first artist to have a persona and of whose style Ming connoisseurs had some idealized vision. The second artist included is Lu Tanwei (d. *c*.485 CE), who is as famous but if anything even more fabulously inaccessible to the period in which Master Gu lived. Connoisseurs of the Ming were well aware that hardly any pre-Song Dynasty painting survived, and

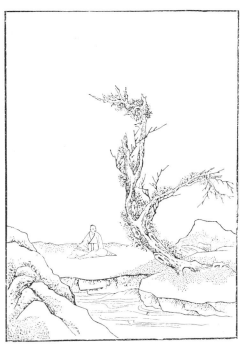

74 *Top left* Woodblock print, 'Painting by Li Zhaodao', from Gu Bing, *Master Gu's Pictorial Album*, 1603.

75 *Top right* Woodblock print, 'Painting by Wen Zhengming', from Gu Bing, *Master Gu's Pictorial Album*, 1603.

76 *Below* Woodblock print, 'Painting by Dong Qichang' from Gu Bing, *Master Gu's Pictorial Album*, 1603.

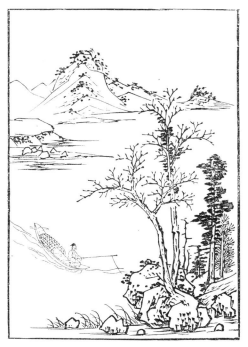

that pre-Tang painting was almost literally fabulous. In his *Zhang wu zhi* (Treatise on Superfluous Things) of *c*.1615–20 Wen Zhenheng, in his section on what to collect in the way of paintings, forbore to talk about the artists of remote antiquity whose work he had never seen, even though in his more abstract discussions of pictorial aesthetics he was happy to characterize their style as 'pure and weighty, elegant and upright, their manners proceeding from very Nature'.[19] Even the wealthiest collectors did not believe they owned a Lu Tanwei (there was none, and nothing by Gu Kaizhi either, in the enormous collection of the disgraced sixteenth-century Grand Secretary Yan Song). Few sixteenth-century collections were grander or more comprehensive than that of Xiang Yuanbian (1525–90), and even he did not think he owned one, although he did possess the famous *Admonitions* scroll (now in the British Museum, London), which was accepted in the Ming as being a genuine work from the hand of Gu Kaizhi, plus a picture attributed to Zhang Sengyu (fl. 502–19), and no less than four pictures by the Tang culture-hero Wang Wei.[20]

The absence of seals and inscriptions from 'reproductions' of work by these early artists is striking. The idea that a Gu Kaizhi or a Lu Tanwei *that no-one else had seen* might be out there somewhere was both unrealistic and implausible, but this is the very fantasy which the book feeds. You the reader not only have 'a great synthesis' of the art of the past spread out before you, you have it essentially for your *private* and strictly personal consumption, in a manner far removed from the social acts of communal viewing which were the most sanctioned form of élite interaction with the realm of visuality. Your vision took possession for the first time of a work free from the traces of past viewings, of past owners. This was a new type of 'spiritual communion' with the pictorial, a privatization of vision which paralleled the decline of mural painting (especially of secular subjects) and the growing distaste of at least some connoisseurs for large-format pictures of any sort on the grounds of their 'vulgarity'. It parallels another contemporary ideal collection, which has been discussed by Joan Stanley-Baker, and which is if anything even more optimistic in its listing of things which the writer feels passionately *ought* to exist, even if the mundane facts of survival are stacked against him. Zhang Taijie's *Bao hui lu* of 1633 has been described as 'a historical costume movie', the effect of which is to fill the reader with 'joy and longing'.[21]

The act of reproduction produces other effects on the works contained in the 'Album'. Obviously, everything reproduced is the same size, that which fits on the page (27 x 18 cm) of the printed book. A landscape by the eleventh-century monumental landscapist Guo Xi, which in the 'original' might be 2m high, appears to be the same size as an album leaf. The work of Ming élite and professional artists is the same size, even though

the issue of size was an area of concern in contemporary writing on painting, and it is clear that *not* making things too big was an important part of élite artistic practice. The very format of the book forces all the pictures into the vertical format of the hanging scroll, with only two attempts to reproduce the format of the horizontal hand scroll (in the cases of the Yuan artists Zhao Mengjian and Ni Zan). Perhaps most significant is the book's assumption that the monochrome medium of woodblock printing is itself a sufficient medium for the reproduction of painting. Colour is not an issue.

If we compare the *Gu shi hua pu* version of a painting by the Tang artist Li Zhaodao (fl. 713–41), (illus. 74), with a fake painting of late Ming date signed by the same artist (illus. 70), the difference is rather obvious. The latter is dominated by its fraudulent colophons, testimonials to the work's quality and provenance which range from a seal of the Song Dynasty imperial collections in the upper centre, to admiring statements by the curator of the Yuan imperial collections Ke Jiusi (1290–1343) and by the great arbiter of art in Ming Dynasty Suzhou, Wen Zhengming himself.[22] They are there to make it sell. The printed version has no such apparatus. All it has to tie to the name 'Li Zhaodao' is an idea of style (here defined more by subject-matter and by composition than by brushwork), given that no genuine work by the artist was in existence, and probably had not been for centuries. Yet the prefaces to *Gu shi hua pu* make it clear that pervasive Ming concerns with pictorial authenticity, in an art market rife with trickery, were operational here too. One of the purposes of the book is to safeguard the unwary against forgeries, and it certainly takes the existence of a commodity market in works of art very much as a given. It might even be worth speculating (and it is no more than that) along the lines that Gu Bing himself might have been an art dealer, and the book designed to educate an audience into consumption of the *real* wares in which he traded, much as contemporary auction houses support publishing designed to bring on a new generation of collectors and potential clients.

What did Gu have to go on, in reproducing the unreproducable? For very early artists, he went mostly on subject-matter. The Tang painter Han Gan is represented by one of the horses with which his name was forever associated, just as Wu Daozi is represented by a Buddhist figure subject. In a number of cases we know that he reproduced actual pictures, although not always attaching them to the names they had originally born. For example the picture of grooms feeding horses which appears in *Gu shi hua pu* as by Zhao Yong (*c*.1289–*c*.1362) is in reality a section of well-known work now accepted as being by his close contemporary Ren Renfa (1255–1328), a painter who is omitted altogether.[23] Nevertheless many of his subjects verge on the fantastical. His 'Gu Deqian' shows a group of men

143

studying works of art and antiquities, a type of subject common in the work of Ming professional painters like Qiu Ying and Du Jin (see illus. 68, for example), but which is not recorded in any early catalogue as having been executed by Gu Deqian. In addition to identifying artists with certain subject-matters, there is also from the beginning an attempt to see 'style', or rather 'brush method', *bi fa*, as the thing which separates one artist from another. The picture attributed to the Tang landscape painter Wang Wei, by 1603 firmly ensconced as the founder of 'scholar painting', is dominated by 'hemp' strokes, while that by Jing Hao is associated with 'axe-cut' strokes. This differentiation by style is clearer if we look at the way Gu Bing handles work by contemporary artists. His 'Wen Zhengming' (illus. 75) attempts to reproduce its subject's famously sparse and dry brushwork, as well as his distinctively gnarled trees (compare illus. 77), while his 'Dong Qichang' (illus. 76) imitates a much wetter brush, and the foreground/background division which is seen in so many of the artist's genuine works (compare illus. 78). These pictures may be fabulous, in the sense that they do not reproduce any single genuine work by the artists involved, but they are not fantastical. Just as many readers could, if asked, sketch a 'Jackson Pollock' or a 'Mondrian', so these 'cartoon' versions of works of art encapsulate some quite real perception of what a typical work by a given named artist might be like. The book is useless in reconstructing the work of ancient artists like Gu Kaizhi or Li Zhaodao, whose total oeuvre is now lost. It was already lost in the Ming period. But it is an extremely useful insight into the history of pictures as seen from a Ming point of view, the view of a professional artist, a man who on the evidence of the book's prefaces had not received a classical education, but who was perhaps involved with members of the élite and, more crucially, with aspirant members of the élite. The sheer fact of its illustration is also, it must be stressed, a novelty. It had long been the practise to attempt to pin down the style of individual artists in single phrases which would reduce a range of pictorial practises to a single image, but crucially that was to a verbal image. An influential piece of Ming writing that operates in this manner is the *Zhong yue hua pin* of Li Kaixian (1502–82), famous for its robust defence of professional painters and its dismissal of the work of Shen Zhou, one of the great gentleman artists, with the simile, 'Shen Shitian [Zhou] is like a monk in the mountainous woods, nothing but withered and sparse'. This is only one of a great series of such formulae, a second set of which attempt to pin down artists by their 'origins', i.e. in terms of their stylistic affiliation to predecessors, using sentences like 'Tang Yin's origins are in Zhou Chen and Shen Shitian'.[24]

How does the history of painting look to Gu Bing? Who does it include and exclude? How does it compare with other versions of the canon, for

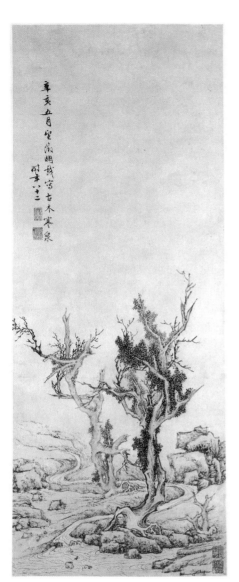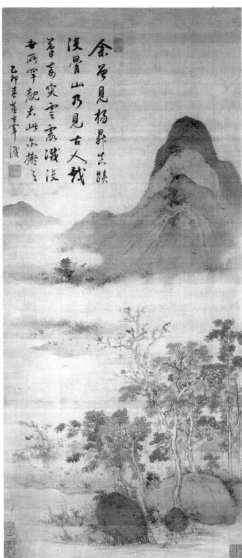

77 *Left* Wen Zhengming (1470–1559), *Old Trees by a Wintry Brook*, dated 1551, ink and colour on paper, Cleveland Museum of Art.

78 *Right* Dong Qichang (1555–1636), *Boneless Landscape after Yang Sheng*, dated 1615, hanging scroll, colours on silk, Nelson Atkins Museum of Art, Kansas City, MO.

example that supplied by Wen Zhenheng in the 'Treatise on Superfluous Things'?[25] Certainly there are overlaps and a minimum 'core' canon of artists can be easily discerned, but this core is not equally firm for all periods. Only four Tang artists make it onto both lists: Li Sixun, Li Zhaodao, Wang Wei and Jing Hao. There are eleven Tang artists in Master Gu's pictorial 'Album', but Xiang Yuanbian owned work by only two of them, possessing on the contrary works by an additional seven Tang artists Master Gu did not include. Similarly *Gu shi hua pu* lists thirty-one artists of the Song, only fifteen of which it shares with Wen's 'Treatise' (and neither includes the work of the aesthete-emperor Huizong, excluded perhaps on moral grounds). The overlap is generally poorer than we might expect.

With regard to the Yuan Dynasty the consensus is much more firm, with thirteen of Gu Bing's total of fifteen names also appearing in the 'Treatise'. There are also fewer omissions or inclusions which do not chime with currently accepted canon of 'Yuan masters'. They part company again with regard to aspects of Ming art, where Gu Bing includes work by all the major fifteenth-century court painters such as Lin Liang and Lü Ji (remembering he was a court painter himself, and certainly had an opportunity to see their work), but where Dai Jin is the only one of this group also to be mentioned by Wen Zhenheng. They differ too in their approach to contemporary art. Wen lists no one later than his ancestor Wen Jia, who died before he was born, and there is no art by living contemporaries listed as worth collecting at all. Significantly, Dong Qichang is listed by Wen as a calligrapher but not as a painter. If anything Wen is distinctly rude about contemporary artists, remarking acidly, 'as for the dot-and-splash gentlemen of recent times, I do not dare touch upon them lightly'.[26]

If 'Master Gu's Pictorial Album' and the 'Treatise on Superfluous Things' are not in total consonance over what is worth collecting, are they nevertheless part of the same message about the role of collecting, and the role of painting, in the creation and sustenance of élite subjects in Ming culture? Does it matter that one is illustrated and the other is not? If we start from the point of view of the subject position created by both texts, there are similarities, above all in the aim of comprehensiveness. The empowered viewing subject sees everything, including that which is lost, or hidden away in the boxes of others, or in the ultimate impenetrability of the imperial palace collections, a focus of fantasy in the Ming as now. You may not own a Gu Kaizhi or a Lu Tanwei now, but you might own one at some time in the future, and therefore knowing what such a treasure looks like is a necessary accomplishment. This of course posits the existence of a market society, in which such a thing may come your way. But whereas the 'Treatise on Superfluous Things' is a simple list of names, presupposing some knowledge of dates and biographies, 'Master Gu's

Pictorial Album' offers much more in the way of 'new readers start here'. The biographical texts, like the encyclopaedias discussed above, give the reader the matter of educated conversation about pictures, they empower him (they potentially empower her too) to talk about work as it is shown, making linkages between artists, sounding authoritative about style, adding little anecdotes which are the small change of élite intercourse about culture. They enable discourse about 'painting', even in the absence of actual works of art, and by their stress on artists and styles they participate in the burgeoning separation of 'painting' as a discursive object from the wider context of 'pictures'. The 'Album' is also a 'collection' in the full and specialized sense of the word employed by the literary critic Susan Stewart, who writes:

In contrast to the souvenir, the collection offers example rather than sample, metaphor rather than metonymy. The collection does not displace attention to the past; rather the past is at the service of the collection, for whereas the souvenir lends authenticity to the past, the past lends authenticity to the collection. The collections seeks a form of self-enclosure which is possible because of its ahistoricism. The collection replaces history with *classification*, with order beyond the realm of temporality. In the collection, time is not made something to be restored to an origin; rather; all time is made simultaneous or synchronous within the collection's world.[27]

In contrast with the traces of production that, as Richard Vinograd among others has elegantly argued, encode an act of remembering in every act of viewing an actual work of art, the totality of the *Gu shi hua pu* places its pictures outside time (or certainly outside duration) and outside contingency. This is equally so of certain hand-painted collections of 'reproductions' of earlier works of art, such as a famous album 'Large Emerging from Small', created for Dong Qichang by Wang Shimin (1592–1680), and another of the same name painted in turn in 1672 for Wang Shimin by his pupil Wang Hui (1632–1717).[28]

The title of this chapter alludes of course somewhat flippantly to Walter Benjamin's celebrated essay 'The Work of Art in the Age of Mechanical Reproduction', in which he argues that it is only in the twentieth century that changing modes of reproduction of the work of art have seriously challenged the authenticity of the original. He acknowledges the existence of the reproductive print in early modern Europe, but his investment in the rhetoric of 'modernity' is such that he cannot permit it that such copying should have seriously affected the aura of the authentic, which withers only in the age of 'mechanical reproduction'; for Benjamin the moment of modernity is inaugurated by the technique of lithography. He argues:

The authenticity of a thing is the essence of all that is transmissible from its beginning, ranging from its substantive duration to its testimony to the history

which it has experienced. Since the historical testimony rests on the authenticity, the former, too, is jeopardized by reproduction when substantive duration ceases to matter. And what is really jeopardized when the historical testimony is affected is the authority of the object.[29]

But is this not in fact the very possibility opened up by Master Gu's 'Album'? The 'historical testimony', which in the Chinese pictorial tradition is made manifest on the surface of the work through colophons and seals that record the object's biography, is precisely what is elided in the publication of these often imaginary 'reproductions'. Without seals and colophons a very different sense of the pictorial is implied. Clearly the *Gu shi hua pu* has a somewhat different status from a photograph of the *Mona Lisa*, simply by virtue of the less extensive circulation in which it was inserted. As stated at the outset, it is a work largely without parallel, and very different in many ways from the majority of the 'pictorial manuals' (*hua pu*) discussed above. It is not a 'how to' book. It separates knowing about painting from knowing how to do painting, and as such is certainly more closely parallel to a range of late Ming texts which reconfigure the conditions for knowledge in this way. Another good example would be the *Xiu shi lu*, 'Records of Lacquering' of 1625, which provides seemingly technical information but which is in fact about the manufacture of knowing subjects rather than about the manufacture of lacquer bowls and plates and vases.[30] But its 'unsuccessful' project does in fact go hand in hand with a reconfiguration of the pictorial which was taking place in élite theory at precisely the time of its production, a reconfiguration which has remained beyond the ken of parochial thinkers on aesthetics in twentieth-century Europe and North America, geniuses like Benjamin not excepted. Benjamin found in a sort of technological determinism merely an echo of his Marxist base/superstructure model, which acted simply to confirm pre-existent assumptions about the 'modernity' of the West. The *Gu shi hua pu* must simply be an antiquarian curiosity? It could not possibly mean that 'the Chinese' were 'there first'? Or even worse, could it mean that (to borrow Gertrude Stein's notorious put-down), there is no 'there' there, that on the contrary the 'modern' has no single, safe home in the West, pictorially or otherwise?

6 Fears of the Image

Controlling the image

Opposition to mimetic pictorial representation on the part of élite theorists in Ming China was not simply based on aesthetic grounds, or on the kinds of philosophical position about the unrepresentability of the higher powers which motivated Qiu Jun's iconoclasm. Many, and particularly those involved with the power of the state as magistrates, voiced censure of certain pictures on the grounds that they would derange the social and cultural order through their obscene or lascivious content. They called for these images not simply to be disdained but for their physical destruction. The issue of the lewd or pornographic image in the Ming touches on a range of other questions, and suggests links connecting representation to gender and other hierarchies, as I shall argue. However, sexual content was not the only grounds that led to demands for pictures to be destroyed. The Buddhist reformer Yunqi Zhuhong, in his complex calculus of merits and demerits, had to include the possibility of the destruction of what were to him holy images, but to others might be the reverse:

For the destruction of each hundred cash value of images of celestial beings, orthodox gods who govern the world, saints, and good men, count one demerit. No fault applies if the image is of a heretical god who demands blood offerings and has deceived the world.[1]

This is a reminder that in the religious plurality of the Ming one person's 'celestial being' could easily be another's 'heretical god', with concomitant degrees of reverence or repulsion directed towards their painted, printed or sculpted images. Zhuhong's contemporary and opponent, the Jesuit Matteo Ricci certainly bears out the presence of pictures created *ad hoc* for religious ceremonies, complaining about exorcists who 'cover the walls of the house with pictures of horrid monsters drawn in ink on yellow paper'.[2]

This issue may have been of importance to the moralising writers of the 'Ledgers of Merit and Demerit', to officials of the state worried about the religious dissident, and to religious professionals like Zhuhong. A set of regulations for communal life by Huang Zuo (1490–1566) includes a pro-

hibition on heterodox religious practitioners who 'falsely paint pictures of hells', among other undesirable activities.[3] They worried just as much about 'lewdness', an catch-all term for a set of undesirable practices in which the making and consumption of pictures certainly played a part. They certainly feature in the censures of one of the earliest and most important of the authors of such ledgers, Yuan Huang (1533–1606):

Destroying the blocks of a lewd book: 300 merits.
Writing a book forbidding lewdness: 100 merits.
Maintaining actors, singing girls and handsome servants in the house, causing evil and lewdness: 10 demerits per day.
Allowing wives and daughters to hear lewd lyrics: 30 demerits per occasion.
Keeping lewd books or lewd paintings: 10 demerits per day.
Writing a lewd book, painting a lewd painting, leaving them to circulate in the world . . .: limitless demerits.
Selling lewd books, lewd paintings or obscene things (*chun le*, literally 'spring pleasures') for profit: limitless demerits.[4]

Élite writers of the *biji*, 'note-form literature', are much more likely than writers of moral tracts to take account of sexually explicit material in detail, which they do with varying degrees of censoriousness. Sometimes the mention of such pictures is in a tone of detached antiquarianism, like that affected by contemporary European scholars with their interest in Priapic representations in ancient Greek and Roman art. He Liangjun in the mid-sixteenth century mentions the existence in his collection of Han Dynasty (221 BCE–220 CE) painted clam shells, some of which depict explicit scenes of sexual encounters both heterosexual and homosexual (*nan se*, 'male *se*'). He acquired them from robbed tombs, he says, and discusses them more in terms of what they reveal about the most ancient painting, prior to the most remote of named masters, Gu Kaizhi and Lu Tanwei (see p. 142), than in terms of the subject-matter.[5] He is interested in boasting of their rarity, discussing their stylistic affiliations and recording the circumstances of their acquisition (brought back from Shandong Province by a Suzhou bookseller who went there to sell his products) rather than censuring them for supposed obscenity. He also discusses in a learned manner the apotropaic uses of such representations in ancient times, protecting the coffins of the dead from disturbance by foxes and hares. The phrase he uses to describe erotic images is *chun hua*, 'spring paintings', the standard Ming term for works of this type, and the name by which they are usually referred to in the writings of his contemporaries. (Another phrase, *chun gong hua* or 'spring palace paintings' is also seen, but less commonly.)

One of his contemporaries, Lang Ying, provides a historical account of 'Spring Pictures and Instruments of Debauchery', which is much more

outspoken in its condemnation. He situates the origins of erotic representations in the Han Dynasty, at the court of Emperor Chengdi (r.32–7 BCE), where screens were decorated with scenes of the bad last ruler of the Shang Dynasty, Zhou, in congress with his concubines. Lang wishes to correct the popular misconception that it is the abandoned and lascivious Zhou who was himself responsible for the first 'spring pictures'. As an evil man, all evil things (including the sexual toys described as 'instruments of debauchery') are unfairly attributed to his depraved imagination.[6] At the beginning of the seventeenth century, another writer named Shen Defu covers the topic more extensively in his *Wanli ye huo bian*, 'Random Gatherings of the Wanli Era', of 1606.[7] He too situates the origins of erotic representation in the Han (though under a different emperor), and goes on to list other rulers (all of them conspicuously 'bad kings' in the standard historical accounts) who shared this predilection. He tells, for example, how the female ruler of the Tang period, Empress Wu (r.684–704 CE), a notorious focus of misogynist polemic, used such pictures to 'spread debauchery'. He mentions the finds of erotically decorated bricks in tombs, including those showing male same-sex erotic encounters. He also introduces a discussion of the use at court of Buddhist images, Tibetan in style, showing the male and female aspects of deities in sexual congress, and of their origins in the practices of the Mongol Yuan Dynasty. However, he fails to understand the religious aspect of this, instead introducing the canard (alive and well in guidebooks this century) that such images were shown to members of the imperial family on the eve of their wedding, as models to be imitated. Such images, he says, are currently available on the antique market, imported from outside China itself (i.e. from Mongolia and Tibet). He lists in addition sexually explicit images worked in jade, woven or embroidered in silk, and the erotic ivory carvings of Fujian, but adds that none come up to the painted representations in ingenuity of lewdness:

Previously there was Tang Yin (1470–1523) and after him Qiu Ying (c.1494–c.1552), but nowadays forgeries of their work [of this type] are everywhere. However the elegant and the vulgar are very easy to distinguish. Japanese [spring] pictures are very fine, though dissimilar to those of Tang and Qiu. The painted fans are particularly good. I once had one, painted with two people in illicit congress, with someone charging in with a drawn sword, and someone holding their arm to restrain them, the emotions and attitudes very lifelike. I subsequently lost it.

The presence in the Ming market place of 'spring pictures' from Japan (the Japanese term *shunga* means exactly the same) is attested by another author from slightly earlier in the Ming. Li Xu (1505–93), in a book published in 1597, writes of the 'extremely detestable custom of spring

paintings', which merchants import for sale from Japan, of the quality of their workmanship and of the high prices they fetch.[8]

What exactly did the 'lewd pictures' and 'spring paintings' of the Ming period look like? Under the first category could certainly come the publicly displayed bawdy representations of Europeans about which Ricci had cause to complain:

Certain stage players came from Macao to Xaucea [Shaozhou, Guangdong Province], and during the days of the market fair they painted posters and put on shows ridiculing everything which the Chinese dislike in the Portuguese. Some of the signs they painted were vulgar, and to omit the manner in which they endeavoured to provoke the people to laughter by making fun of the short costumes of the Portuguese, we shall mention how they found fault with those who professed Christianity. They pictured men saying the rosary in church, and wearing swords in their belts, and drew awkward caricatures of men adoring God, on only one knee, of men fighting a duel, and of gatherings in which women were present with men, which the Chinese abhor.[9]

Nothing of this type survives, and Ricci's 'vulgar signs' mocking the short European doublets can only be imagined (with not too much difficulty, at least in broad outline). The passage is an extremely important and rare glimpse of a sort of irruption of the bawdy into public space, something which Ricci would have been familiar with from his homeland under the general rubric of the 'carnavalesque' (and which his own order, the Jesuits, would work so hard to replace with more seemly forms of entertainment). As in the European context it is connected to the public art of the theatre, very much a locus of élite concern for its potential depraving effects on the impressionable lower orders. The theatre was perceived in the Ming above all as a *visual* spectacle. This is not the case today, when aficionados talk about going to the theatre to *ting xi* 'hear the play', and when in recognition of that fact the major dramatic form is usually referred to in English as 'Peking *opera*'.[10] In the Ming by contrast, a moralist like Gao Panlong (1562–1626) could complain, 'When there is a performance on stage, there can be thousands of men and women in front of the stage who gather to watch (*guan*, the same word as translated by 'contemplate' in Chapter 4), among which an uncountable number are secretly harmed by it, and who harm others and themselves, making mischief without end'.[11] His was but one complaint among many.

The use of images on fans, which were carried and displayed outside the home, was another site for the 'public' exposure of sexually explicit material (and again no such fans survive). Nevertheless the major contexts for viewing erotic or pornographic representations in the Ming are perhaps more often likely to have been intimate and private. One important thing to note from the texts above is their association with palaces, and with the

palaces of the Han Dynasty above all. It is tempting to see here a dramatization of a cultural tension between the imperial court and the educated classes of the empire, with the latter fantasizing the former as a site of transgressive looking, improper acts of vision, along with many other kinds of excess. Charlotte Furth has drawn attention to the fact that in the 'bedchamber manuals' of sexual techniques the 'social male behind the fantasy is less an ordinary polygamist than a prince, one whose well-populated inner quarters would be a badge of royal rank'.[12] Scrolls showing the palace ladies of the Han amusing themselves at what now appear to be entirely decorous pastimes may well have possessed an erotic charge for the male Ming viewer which it is now hard to grasp. This subject was certainly in the repertoire of the great Suzhou professional painter Qiu Ying, who is credited over fifty years after his death with the production of 'spring paintings'. 'Spring Morning in the Han Palace' is one of his most celebrated surviving works, one which may have brought frissons to its original owner which are scarcely reproducible today.[13] Similarly a picture such as illus. 28, with its palace lady, dressed not in the fashion of the Ming but in a sort of generalized costume of 'long-ago', and languorously arranging her hair in a manner completely open to the male gaze, may well have been constructed as a 'lewd picture' in terms of strictest morality. Any picture showing men and women in intimate association together was technically an infringement of the strict separation of the sexes demanded by the normative codes of élite morality, which all the evidence suggests were actually adhered to in upper-class houses. This would make many of the representations in this book liable to censure: illus. 29, with its louche aristocrat attended by women servants; illus. 6, 8 and 32, all three illustrations to romantic dramas which were themselves the object of condemnation; illus. 34 and 21, both objects carrying decoration in which men and woman mingle, and in the latter case are practically touching each other. All of these carry an erotic charge for their original audiences.

However there also exist very explicit representations of sexual activity from the Ming period (illus. 79, 80), with all the evidence pointing to the fact that there once existed many more than the very meagre number surviving today, and that the years between c.1560 and c.1640 represented some sort of high point in the quantities in which they were produced. This was certainly the high point in the production of pornographic fiction, which one recent study sees as succumbing in the Qing period to more intense and more effective censorship.[14] Certainly nothing like these prints exists that can be ascribed with any confidence to a named artist with a respectable reputation, such as Tang Yin or Qiu Ying, despite the number of works which optimistically bear their signatures but are certainly of much later date. In fact the evidence for their production of

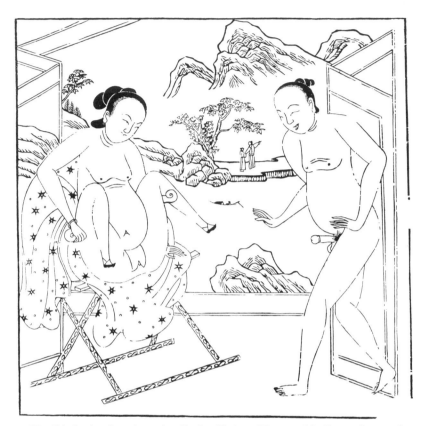

79 Woodblock print, from the erotic collection *Variegated Postures of the Flowery Camp*, early 17th century.

sexually explicit paintings at all is very unreliable. However Ming collectors did believe in the genuineness of works of this kind from the brush not just of these luminaries but from much earlier and even more famous artists. The Ming writer Zhang Chou (1577?–1643) records how in 1618 he bought a handscroll entitled 'Secret Sports of a Spring Night', which had been painted by Zhou Fang (*c*.730–*c*.800), and had once resided in the collection of Zhao Mengfu (1254–1322).[15] Both of these are very famous figures in the art-historical canon. However the attachment of illustrious names was a a common marketing strategy in the art market and in Ming publishing, with pornographic material as much as with many other sorts of literary or pictorial goods. In addition to sexually explicit paintings and books, there almost certainly existed similar types of single sheet print. A mid-seventeenth-century novel includes at one point a deck of cards to be used in a drinking game, each depicting a sexual posture to be imitated by the members of the (mixed) company.[16] Whether such things ever actually existed, or remained within the (extremely fertile) imagination of the

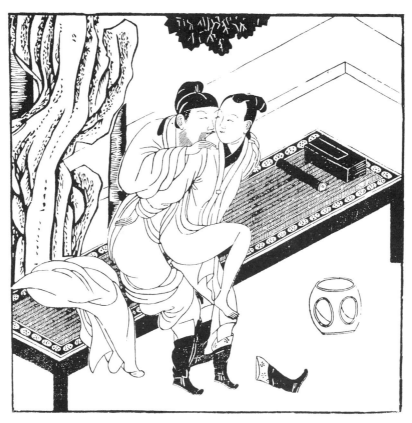

80 Woodblock print, from the erotic collection *Variegated Postures of the Flowery Camp*, early 17th century.

novel's author, is hard to say conclusively. What is clear is that, just as with the eighteenth-century French evidence studied by Robert Darnton, it would be anachronistic to introduce the nineteenth-century concept of 'pornography' as a discursive category, but it would be equally wrong to 'relativise the concept out of existence'.[17] Both official and private censors were certainly aware of a category of sexually based 'lewdness', existing in both pictorial and textual form, which ought to be forbidden from circulation and destroyed if it came within their grasp.

Two scenes (see illus. 79 and 80) are taken from what may plausibly be believed to be a rare survival of an erotic album of the late Ming period, entitled *Hua ying jin zhen*, 'Variegated Battle Arrays of the Flowery Camp'. No Ming edition of this text survives, and all modern reproductions derive from images taken from a set of wood printing blocks, bought in the Tokyo antique market by the Dutch sinologist Robert H. van Gulik in 1949. The present whereabouts of these blocks is not known.[18] Although a slight question mark must continue to hang over

the authenticity of this work, the balance of evidence favours its contents' being a sample of the sort of album referred to in Ming fiction, in both printed and painted forms. Several of these books claim to have been designed by the painter Tang Yin, to whom such pictures are ascribed in the passage by Shen Defu quoted above, although there is no reason to believe these assertions. Van Gulik argues that most of them were published in Nanjing, and situates the high point of their production around 1610. Their flourishing would thus coincide with all the other sorts of ostensibly 'how-to' manuals which are such a distinctive element of the late Ming publishing scene; books on agronomy and military techniques, on travel and technology, on lacquer making and flowers, all of which aim to produce the knowing subject, as much as or even more than they do to transmit knowledge conceptualized as something discrete from those who know.

The text's grouping of twenty-four sexual postures would appear to have been some sort of standard in works of this type, as can be seen from the novel *Jin Ping Mei*, whose debauched central character Ximen Qing brings just such an album to one of his wives, the equally abandoned Pan Jinlian ['Chin-lien' in David Roy's translation]:

One day he reached into his sleeve and pulled out an object, which he handed to Chin-lien to look at, saying, 'This is an album of paintings from the Palace Treasury that the old eunuch director obtained during his service in the Imperial Household Department. The two of us can consult it by lamplight and then attempt to emulate the procedings'.
Chin-lien took the album in her hand and opened it up to take a look. There is a lyric that testifies to this:
Mounted on patterned damask in the imperial palace,
Fastened with ivory pins on brocade ribbons;
Vividly traced in outlines of gold, enhanced by blue and green colours;
The square painting on each folio leaf is neatly framed.
The women vie with the Goddess of Witches Mountain,
The men resemble that handsome paragon, Sung Yu.
Pair by pair, within the bed curtains they show themselves to be practised combatants.
The names of the positions are twenty-four in number;
Each one designed to arouse the lust of the beholder.
Chin-lien, having perused it from beginning to end, was reluctant to let it out of her hands and, turning it over to Ch'un-mei, said, 'put it away safely in my trunk so we can amuse ourselves with it whenever we want to'.[19]

Roy notes that the 'twenty-four positions' are referred to elsewhere in the novel as the standard repertoire of sexual encounters, and that the same number makes up the contents not only of *Hua ying jin zhen*, but of another contemporary manual *Feng liu jue chang*, or 'Summa elegantiae',

which is also discussed by van Gulik.[20] The passage from the novel again makes the connection of erotic literature with the imperial palace, a space characterized in several Ming locutions by interiority, as the 'Great Within'. The gender implications of this language are intriguing and worth further investigation.

What is also worth noting in this passage is that the scene is one in which a man brings erotically stimulating literature and images to a woman. This is the standard topos with such material, which is never described in Ming literature as being for the solitary masturbatory pleasure of the male viewer. The latter is by contrast a context frequently ascribed to pornography in early modern Europe (with its books famously destined 'to be read with one hand'). Perhaps some books at least were read so in Ming China too. The *Hua ying jin zhen* contains at least one scene of anal intercourse between a mature man and a young boy (illus. 80) suggesting as a potential viewing subject not so much the heterosexual couple as the empowered solitary male who would have access both within the home and commercially to male and female sexual partners equally, and who was likely to seek to derive pleasure from both outwith modern constructions of an exclusive 'sexuality'. In the case of Pan Jinlian, a women as erotically hyperactive as is her husband, the effect of the album is to stimulate her desire to carry out actions already familiar to her. In another, later, seventeenth-century novel, erotic representations of this kind have the effect of kindling in a woman for the first time desires which had hitherto been repressed. In the novel *Rou pu tuan*, 'The Prayer Mat of Flesh', generally ascribed to Li Yu (1610–80), the male central character is disenchanted with his highly educated new wife's lack of sexual responsiveness, and so buys from a bookseller an illustrated volume entitled *Chun tang* 'The Spring Palace'. Its thirty-six pictures of sexual postures are ascribed to none other than the great Yuan statesman and literati painter Zhao Mengfu himself:

Unsuspectingly, Noble Scent took the volume and opened it. When she turned to the second page and read the big bold heading: *Han-kung yi-chao*, 'Traditional Portraits from the Imperial Palace of the Han dynasty . . . she thought to herself:
'There were many noble and virtuous beauties at the court of the ancient Han rulers – the book must contain portraits of them. Very well, let us see what the venerable ladies looked like.' And she turned another page. In the midst of an artificial rock garden a man and a woman in rosy nakedness, most intimately intertwined. Blushing crimson for shame and indignation, she cried out:
'Foo! How disgusting! Where did you ever get such a thing? Why, it sullies and befouls the atmosphere of my chaste bedchamber.'[21]

The hero protests that it cost a lot of money (100 ounces of silver is the sum mentioned, an enormous amount for any work of art). He prays in aid of

the reputation of the great painter and of a famous publisher – the deluxe nature of the edition is itself proof of its respectability. After an extensive argument he prevails upon her to look through the volume with him, and soon finds that she is much more responsive to his embraces. Discovering the pleasures of sex, she is soon clamouring for more and more manuals of sexual technique:

The prim 'little saint' grew to be a past mistress at the arts of love. Determined to keep her vernal fires supplied with fuel, the Before Midnight Scholar ran untiringly from bookshop to bookshop, buying more books of the same kind, such as the *Hsiu-t'a yeh-shih*, 'The Fantastic Tale of the Silk-Embroidered Pillows', or the *Ju-yi-ch'un chuan*, 'The Tale of the Perfect Gallant', the *Ch'i p'o-tzu chuan*, 'The Tale of the Love-Maddened Women' and so on. In all, he bought some twenty such books and piled them up on his desk.[22]

This is a male fantasy. It is a fantasy about how women will behave, but more specifically it is a fantasy about how women will respond to pictorial representation. They will imitate what they see. As such it is in congruence with Ming élite male constructions regarding the realm of the pictorial, where it is the socially subaltern (women, children, eunuchs, Mongol princes) who will be unable to go 'beyond representation', but who will be entranced by what they see, who will imitate the (good or bad) actions represented to them.

The troubling nature of women's relationship to representation was remarked on by several male commentators (see p. 33 for the context of the complaint that 'ignorant women are particularly crazy about' illustrated novels), but it was a relationship which was expanding in the late Ming period. For a start, never before had so many élite and non-élite woman been involved in the manufacture of representations, in various forms. A high proportion of the names of women artists surviving (if marginalized) within the art-historical canon date from this period. Some were members of élite families, in which the practice of artistic culture was already well rooted. Some were religious professionals. Some were the members of families of professional artisan painters. Many were women who worked as 'courtesans' a term covering the provision of a range of social and sexual services to male clients.[23] All were restricted by convention in the range of subject-matters they might attempt, and the great majority of the pictures surviving by women painters are of floral subjects (illus. 81). (This of course raises the question of whether they once painted other subjects, which the mechanisms of the market and the collection have not preserved.) Thus Ming theories of the image are not comprehensible without some account of gender.

The hanging scroll illustrated is by Ma Shouzhen (1548–1605) a prominent Nanjing courtesan, and is dated 1572, when the painter was in her

81 Ma Shouzhen (1548–1604), *Orchid and Rock*, dated 1572, ink on paper, Metropolitan Museum of Art, New York. A common subject for courtesan painters, of whom Ma Shouzhen was one of the most celebrated of the Ming period.

mid-twenties. The subject of orchids is one associated not only with her but also with other female contemporaries, having rich intertextual associations of seclusion and purity but also of sexually available lushness. These associations are explicit in the poem by Xue Mingyi (fl. *c.*1600), the central of the three poems on the top of the picture, which reads:

In a deserted valley, secluded orchids grow dense –
Unnoticed, but naturally fragrant;
Unfurling elegant colours to welcome the spring,
Dew-moisted, sending off their pure fragrance.[24]

Someone like Ma Shouzhen learned the technical and stylistic aspects of painting as part of her training in how to attract and hold on to clients and 'protectors'. Quite how widespread artistic competence was among Ming women outside the brothels, or outside certain élite families like the Suzhou Wen, is very hard to say. The author of *Jin Ping Mei* describes the education of one of its central female characters, Pan Jinlian, who as a girl of fourteen learns how to 'draw phoenix designs and execute them in

embroidery'.[25] She learns these skills, along with the arts of music, not in the house of her natural father (even though he is a tailor), but in the mansion of a grandee to whom she is sold at the age of eight. Such accomplishments are therefore part of her value as a potential commodity, putting her at some point quite possibly in the same sort of position as Ma Shouzhen.

The quantity of material surviving regarding woman as producers of pictures may be meagre, but it is still very much greater than that regarding their roles as patrons and consumers of pictures. We know that pictures were commissioned *by* men as gifts *for* women. An example of a painting of this type is illus. 35, and it is far from being the only one, but there is no sign in the transaction of the possibility of female agency. Similarly, the boxes decorated with wedding imagery (illus. 36, 65) must have been seen by women in the course of the rituals, but they are more easily construed as a material culture *for* women than a material culture *of* women, carrying as they do scenes of normative wifely submission and deference. This is not to say that such imagery, and other scenes like it, were not appropriated by women in ways which could give them power even within the patriarchal family, but it is to accept that such strategies of empowerment must in the present state of knowledge remain very much in the realm of conjecture. It seems possible that one way of pursuing such questions further would be to pay more attention to the areas of textiles, dress and embroidery, types of cultural activity which were sanctioned by the canonical classics as proper for women. Dorothy Ko, one of several scholars who see the late Ming as being a time at least of possibility for female productions of meaning to establish themselves in a number of cultural practices, has drawn attention to this. In particular she has highlighted the work of members of the Gu family, famed élite producers of embroidery, sometimes copying the work of known élite artists.[26]

It seems certain that women did both own pictures and make consumption choices relating to their acquisition, although much of the evidence for this is from fiction, and hence subject to particular caution. In the *Jin Ping Mei* (again) there is a description of the reception room of Meng Yulou, widow of a rich dye-merchant. She is visited by Auntie Xue, a formidable woman of business who deals in jewellery, acts as a go-between in marriage negotiations and occasionally does a bit of discreet pandering. The widow Meng is a fictional type, but that is not to say that no independent woman of her stamp existed in the late Ming urban scene. In chapter 7 of the novel, the hero Ximen Qing visits her mansion, and is entertained in the reception room there, dominated by an image of the bodhisattva Guanyin, and where 'Landscape paintings by well-known artists hung on

82 Handcoloured woodblock print, *The Bodhisattva Manjusri*, dated 1578, Boston Musum of Fine Arts.

the other walls'.[27] The publishers of the book choose to illustrate this scene (illus. 85), at the point where the old matchmaker scandalously raises the young widow's skirt to display to an appreciative Ximen Qing the bound feet, focus above all of erotic fantasy for the Ming male. This is louche behaviour indeed, to be witnessed by an icon of the deity and by the products of the great landscape masters. It reminds us of the commercial nature of the art market (Meng Yulou's dead husband was rich so she can still afford quality art to enhance the aura of culture surrounding her), and of the imbricated nature of what might be thought of as 'secular' and 'religious' iconic circuits in Ming interior design. The use of religious pictures in a domestic setting, particularly images of Guanyin who was particularly (though not exclusively) the object of devotion by women, was not restricted to images displayed on walls, which it should be remembered might be single sheet prints as well as paintings (illus. 82). A picture of the deity even appears as part of the furnishings of a fancy brothel, where she is flanked this time by four beauties, one for each season of the year, a

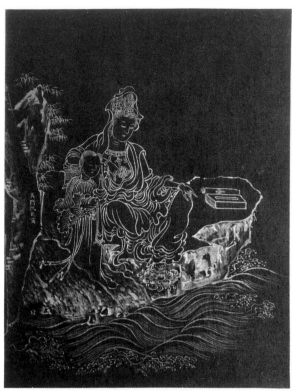

83 Miss Qiu, *Portrait of Guanyin*, from an album of 26 leaves, mid–16th century, gold on black paper. Private collection.

84 Woodblock print, from the popular religious novel *Guanyin chu shen nan you ji*, 1571–1602 Huanwen tang edition.

85 Woodblock print, from chapter 7 of the novel *Jin Ping Mei*, Chongzhen edition.

86 Woodblock print, from chapter 74 of the novel *Jin Ping Mei*, Chongzhen edition.

type of picture represented by illus. 28, and a similar scroll is also prominent in the apartments of Pan Jinlian, a woman not notable for her piety and religious life.[28]

There were also books in the lives of Ming women, both hand-painted luxury editions and the full range of quality provided by the printing industry (illus. 83 and 84). It is from one of these that a Buddhist nun is reading to the assembled ladies of Ximen Qing's household in another illustration from the novel, this time taken from chapter 74 (illus. 86). The text in question here is a *bao juan*, 'precious scroll', entitled 'The Scroll of the Daughter of the Huang Family', and there is no mention in the novel of illustrations being involved in this particular case.[29] However such communal contexts of recitation might certainly involve texts with illustrations, which could be shown to the assembled intimate group.

Perhaps this was the context for something like the very luxurious image of Guanyin (illus. 83), painted in gold on black paper, one of an album of twenty-six such images and accompanying texts executed by Miss Qiu (her personal name is not certain), the daughter of the professional artist Qiu Ying, who painted illus. 64. The images accompany the text of the

'Heart Sutra', a key devotional text of Buddhism, written out in the calligraphy of a major late Ming cultural figure, Tu Long (1542–1605).[30] Thus the likelihood is that the original owners of this presumably rather expensive volume were people of considerable wealth and some level of social connection, since Tu Long's fame, matched by that of Miss Qiu herself, meant he did not have to accept commissions from anyone but could afford to demand the kinds of civility which masked an essentially commercial transaction with the forms of gift-giving and reciprocity.

The texts accompanying the twenty-six images are not part of the Buddhist canon but of the much larger body of para-canonical material which circulated in the Ming. The same is true of a published text that shares the iconography of Miss Qiu's album, but is presumably aimed at customers with a different disposable income (illus. 84). This has been categorized as part of the wider category of 'popular fiction', and was produced between c.1571 and 1602 by a Fujian publisher operating at the bottom end of the market.[31] Again it would be unsafe to assume a specifically female audience for such a book, based simply on the gender of the deity Guanyin and of the presumed majority of her devotees. Men purchased and read such stories as well.

Banishing the image

However, if the purchasers of such a book as the 'Completely Illustrated Record of the Manifestation and Southern Voyage of Guanyin' were not distinguished by their gender, they were likely to have excluded those who saw themselves as being at the peak of the multiple status hierarchies of the Ming, the adult males of the élite. And it is not just the popular religious aspects of the text that made it undesirable in their eyes, since in fact many élite males were devotees of the Guanyin cult at this time. Rather it is the presence and nature of the illustrations accompanying the text that put it beyond the pale of elegant notice. There was no stricture against owning a copy of the sutras, or reciting Pure Land Buddhist texts, but pictures of this kind were classed as unacceptable parts of the lifestyle of the aspirant man of taste, certainly by 1600 if not well before. Certain sections of the Ming élite certainly fell into Martin Jay's category of those who, believing themselves to be above the lust of the eyes, chose to resist the 'pleasures of the spectacle'.[32] The world of text was the source of their cultural capital above all, and an ability to engage with it was crucial to élite status; a gentleman had to write poetry, he did not have to paint.

Wu Hung has recently drawn attention to the importance and pervasiveness of representations of the screen within Chinese painting, as encoding an awareness of the problems of representation within the practices of élite

art. He also points out how, starting in the fourteenth century, the screens depicted within paintings by the most prestigious of élite artists are generally blank ones. And he provides plenty of evidence for the importance of the 'pure screen' as signifier of élite status within Ming painting, particularly in the practice of the paragon of 'scholar amateur' artists, Wen Zhengming (1470–1559).[33] This was not simply a pictorial convention. (We have seen, for example, how Wen's practices in picture viewing were scrupulous in restricting the amount of pictures looked at in a single session.) By the time of Wen Zhengming's descendant Wen Zhenheng, the idealized surroundings of the élite male were to a considerable extent devoid of representations, at least in the prescriptive sources. We have already quoted (p. 27) his strictures against wall paintings, and his prescription that 'plain walls are best'. Significantly, Wen Zhenheng's description of screens in his chapter on furniture does not even mention screens with pictorial subjects in any medium, all his examples being wooden frames inlaid with stone panels in various rare minerals.[34] His prescriptions about the hanging and viewing of painting are strict in insisting that too many paintings at the same time is the most vulgar kind of solecism:

Paintings must be hung high. In a studio position one hanging scroll up high, but the hanging of two scrolls facing one another on the left and right walls is extremely vulgar.[35]

This is precisely the arrangement depicted in an illustration to the 'Pictorial Compendium of the Three Powers' (illus. 87), where the only type of building in its section on dwellings and structures to be shown containing pictorial representation is the studio, or *zhai*, a strictly élite male space. For the illustrator, as for Wen Zhenheng, pictures of a certain kind (the

87 Woodblock print showing the ideal male studio (*zhai*), from the encyclopaedia *The Pictorial Compendium of the Three Powers*, 1607.

woodblock shows a landscape) used in a certain way (involving limitation and restriction) make the élite space. In his chapter on 'Utensils' Wen is sometimes more explicit in his disavowal of pictorial decoration on objects of daily life. When he writes about lanterns, he notes the extensive types of varieties then on the market; the range of materials involved includes precious minerals such as agate and coral as well as painted sheepskin, and he specifically allows the products of one maker of the latter type, an otherwise unknown artisan named Zhao Hu. But he names only to dismiss many more types, including those decorated with floral subjects, birds and beasts, and he is distinctly wary of 'human figures, towers and belvederes' (*ren wu lou ge*), the usual generic term in the Ming for the kind of figurative decoration seen on things like illus. 18 and 26.[36] His discussion of 'perfume tubes' (*xiang tong*), hollow cylinders of bamboo used to contain aromatics and placed in chests to perfume both men's and women's clothes or else carried on the person, is even more explicit, as well as bringing out the gender-specific nature of figurative decoration in the mind of such an arbiter:

Among old perfume cylinders the ones made by Li Wenfu and carved with flowers and birds, bamboos and rocks are rather valued for their antique simplicity. But if they approach an effeminate intricacy [literally, 'if they stray into rouge and powder'], or are carved with stories and people (*gu shi ren wu*), then they are vulgar items, and must not be placed in the bosom or the sleeve.[37]

As a final example, his discussion of 'incense boxes' (*xiang he*) lays out a triple hierarchy of decorative motifs, for which Wen typically claims the sanction of antiquity, when he says, 'In incense boxes, those of Song dynasty carved lacquer with a colour like coral are the best, and of old there is the saying that first come 'sword rings', second come flowers and grasses, third come people...'.[38] Three lacquer incense boxes of Ming or earlier date serve to illustrate his distinction; one is decorated with 'sword rings', the swirling design named after the pommel decorations of Ming broadswords (illus. 88), while another (illus. 89) shows a box carved with lichees (a symbol of fertility, and as such guaranteeing this is a box destined for a woman), and a third (illus. 90) shows the eighth-century poet Li Bai in the middle of one of his many drinking bouts, as he 'raises his cup to toast the bright moon'. There can be few better known topoi in Chinese poetry, and few literary figures with a higher reputation, but that does not mean that an incense box decorated with such a scene was guaranteed a warm welcome, at least from Wen Zhenheng.

Of course, the box was welcomed by somebody, just as were all the other numerous Ming luxury objects covered in figurative decoration. The museums of the world are full of Ming ceramics, lacquer, textiles, metalwork and other craft objects decorated with such scenes, which all the

88 *Top left* Lacquer box, carved with a pattern of 'sword pommel' scrolling, 15th–16th century, Victoria and Albert Museum, London.

89 *Top right* Lacquer box, carved with a design of lichees, late 16th–early 17th century, Metropolitan Museum of Art.

90 *Below* Lacquer box, carved on one side with a design of the Tang dynasty poet Li Bai toasting the moon, 15th century, Victoria and Albert Museum, London.

written evidence insists were likely to be read as vulgar by the educated. They are also full of paintings which do not fit in with the master narrative of Ming art as dominated by a trend away from the mimetic (see illus. 28). There is a severe disjunction here between Ming artistic theory, at least in its canonical form, and Ming artistic practice, which only becomes more acute when one investigates further the question of the role of 'stories' in Ming painting.

Stories were clearly what many customers wanted. In his section on 'Jokes', the sixteenth-century writer Lang Ying tells two stories about the unbounded ignorance and crassness of some viewers of painting:

At the beginning of the Jiajing reign (1522–66), the eunuch Gao Long was Grand Commandant of Nanjing, and someone presented him with a famous painting.

Gao said, 'It's good, but there's too much blank silk at the top, it would be nicer to add the "Three Battles of Lü Bu" at the top.' People passed this round as a joke. I say that that's eunuchs for you. I have heard that Shen Zhou sent the Commandant of Suzhou a picture of 'Five Horses Ushering in Spring', at which the Commandant got angry and said, 'How come I'm painted without a single follower?' Shen got to know of this, separately sketched the followers and offered them to him, whereupon the Commandant was delighted. Shen subsequently made fun of him, saying, 'It's a shame the silk is short, otherwise I would have painted three attendants at the front as well'. The Commandant said, 'Indeed, indeed.'[39]

Yet again the crass miss the point of what pictures are meant to do in the élite understanding. But the persistence with which they do so (note that once again the long-suffering Shen Zhou is the man having to put up with such idiocies) makes one think that perhaps the crass were more numerous than the received wisdom about Ming painting would like to assume. The place of 'stories' in art has yet to be fully disentangled.

To take just one example of the kind of filtering going on in the art-historical record, let us look again at 'Master Gu's Pictorial Album', and the manner in which it chooses to reduce the style of ancient and contemporary painters to a single memorable image which will encapsulate their entire output. Almost none of these, and certainly none involving contemporary painters, are of the type which might be recognized today as involving a narrative component. It might well be thought that the contemporary European discursive category of *istoria*, derived from Aristotle and so prominent in the aesthetic theorizing of certain contemporaries of the Ming (the Florentine Leon Battista Alberti comes to mind as one of them) had no place in Ming art. And indeed in the theoretical positions that were most widely promoted such concerns were quite radically de-emphasized. 'Telling a story' was not what painting did. There is certainly no *istoria* either in the actual painting by Wen Zhengming (illus. 77) or in the single image of his oeuvre found in 'Master Gu's Pictorial Album' (illus. 75). However, early catalogues, and the revisionist research of Richard Barnhart, make it plain that, along with other narrative and historical themes, he did produce more than one picture on the theme of 'Yuan An Sleeping through the Snow', a subject showing the self-abnegatory behaviour of a Later Han Dynasty (25–220 CE) worthy. Barnhart has demonstrated how numerous Ming versions of this picture, with its precise literary reference, have been submerged into a body of generic 'Winter scenes'. Perhaps significantly, the Wen Zhengming version of the subject is now lost.[40] The physical loss of the picture seems almost symbolic of the oblivion into which this sort of picture has fallen over the last few centuries, paralleling their decline in critical esteem. A Wen Zhengming with a

story is not a 'proper' Wen Zhengming. Many more such acts of connoisseurial recuperation are currently being undertaken in the field of Chinese painting studies.[41]

In Chinese terms, 'Yuan An Sleeps through the Snow' is a *dian gu* (Waikam Ho's *yue ding su cheng*, 'established by consensus and perfected by tradition'), which means something like 'canonical incident', and as the author of the Preface to a modern dictionary of them points out it is a term with a very broad semantic spread.[42] In modern usage, a *dian gu* is essentially a verbal phrase with historical or literary referents, used in speech or writing to evoke a known episode in a way that has a relevance to the current situation; a 'Phyrric victory' or 'Caesar's wife' approach the concept in English. These 'canonical incidents' can supply the matter for painting, but significantly the term is not one used in painting criticism. 'Xie An at East Mountain' (illus. 29) is a *dian gu*, and so are illus. 10 and 11 (Lin Bu), 13, 14, 34 (Su Dongpo's return), 18 (the Five Sons of Yanshan), and the separate scenes on the lacquer wedding boxes (illus. 36 and 65). I want to argue that as the Ming Dynasty progressed, the engagement of élite painters with this kind of subject-matter changed, as they distanced themselves increasingly from anything that smacked of the narrative in their art. Undoubtedly élite artists of the fifteenth–early sixteenth centuries, like Shen Zhou and Wen Zhengming, did produce such pictures. By 1600 they were very much rarer in the output of anyone with pretensions to élite status as a painter. It is doubtful whether a single one would be found in the work of the paradigmatic figure of the later Ming, Dong Qichang.

At this point an objection might be raised with regard to the distinctive and protean figure of Chen Hongshou, artist of 'Xuanwenjun Giving Instruction in the Classics' of 1638 (illus. 35), a picture with a clear reference made explicit through inscription to a set of historical circumstances. Such pictures are not unique in his output. However, recent work on this extremely complex picture demonstrates that, while historically based, this is a very particular type of *dian gu*, one not fully within a domain of public intelligibility, and restricted to this single and singular image – there are no other treatments of the subject in Chinese painting.[43] And there are certainly no known lacquer boxes, ceramics or textiles with such a subject, to parallel the way that in the fifteenth century something like the Lin Bu or Su Dongpo stories had straddled different types of picture-bearing medium, from scroll to screen panel.

Part of the problem in pursuing this sort of question further lies with the survival of evidence from the Ming period, and it is as well to be explicit about this. Objects in ceramic, metal and lacquer survive in some quantities. So do paintings by named artists. The most severe loss is in the area of

paintings produced as commodities for immediate sale by professional workshops (and here I do not mean the small number of 'famous' professionals like Qiu Ying), who might well have been responsible for work involving *dian gu*, most of which have a moralizing point making them suitable as gifts to convey a specific meaning. (For example, the point of the Yuan An story makes it an ideal gift to flatter anyone involved in local government office.) The scenes shown on the early seventeenth-century lacquer wedding boxes (illus. 36, 65), which are certainly unknown in the work of any painter of reputation at the period, may well also have once existed in painted form, produced by workshops who neither sought nor received notice by élite theorists.

A second problem is a historiographical one, related to the way 'Chinese painting' has been constructed as an object of study in the (principally) American and (to a much lesser extent) European academy. For a mixture of reasons involving language competencies, the privileging of painting over the 'decorative arts' and the movement of specific academics from the field of German *Kunstgeschichte* to the United States, the study of the field has arguably never gone through a 'Warburgian' or iconological phase, in which subject-matter was the object of detailed and intensive scrutiny.[44] Aby Warburg's ideas may have depended on notions of the value of 'low' art for the study of (his ultimate project) 'high art'. He may, in Francis Haskell's words, have believed that 'it was perfectly possible for that very art which incarnated humanity's noblest aspirations to draw for its own ends on the resources that were sometimes offered by the second-rate, the naive and the superstitious'.[45] However the empirical effect of such formulations was to legitimize within art-historical study a search for inter-relationships between representations in very different media. Such a project has only very recently attempted to strike roots in the study of representations in China.

This is in a way ironic given earlier European views of the East as the site of *excess* meaning, where not only every picture but also every decorative element on a ceramic, textile or lacquer 'tells a story'. Vernacular views of Chinese art sustain such an approach to this day. Experience of working in a museum, proffering opinions to the public on objects they own, has taught me that the question most generally asked after the date of a thing is 'what does the decoration *mean*?' (and conversations with colleagues across Europe and America suggest this is not a British peculiarity). This concern has a considerable history to it, broadly associated with the notion of 'the language of flowers'. The idea of the East as site of secret, hieroglyphic forms of communication using flowers as conveyors of meaning is, as Jack Goody has shown, essentially an orientalist confection of the early nineteenth century, though it is one which has proved surprisingly

resilient and long-lived.[46] This is not to say that in Ming China such one-to-one correspondences of decoration and meaning were never made. Lang Ying, in a discussion of a painting he once owned entitled 'Birthday Congratulations in the Deshou Palace of the Song Dynasty', by Zhao Boju (d. *c*.1162), mentions the prominent role of coral in the scene, and points out that coral (*shan hu*) is homophonous with 'imperial acclamation' (also *shan hu*, written with different characters).[47] This kind of rebus was clearly at work on numerous Ming objects as well as in paintings. The meaning of decoration on archaic objects was also a live issue for Ming commentators. The formalized mask or face widely seen on archaic bronze vessels and known in Ming Chinese (as today) as a *taotie*, was particularly the subject of learned comment. Whatever the current state of scholarly debate between formalists and structuralists about the meaning (and indeed, whether there is a meaning) of this motif, no such doubts assailed those Ming writers who touched upon it. Chen Quanzhi is quite confident that the decoration of tripods with a *taotie* motif is a warning against gluttony (*taotie* means something like 'glutton'), while vessels of other forms are decorated with the tortoise, which 'means' moderation.[48] Such correspondences of signifier and signified would in general have seemed incongruously flat and obvious to theorists of the visual aesthetic, in the context of the particular artefacts of paintings. Paintings could mean, but in other ways.

But there may be a deeper epistemological problem here. The Western tradition of viewing and understanding, at least until very recently, seeks to ground the meaning *in* the objects viewed, to see it as a container for the meaning poured into it at the time of manufacture. If as I have argued, following David Hall and Roger T. Ames among other scholars currently engaged with this problem, the Chinese epistemology grounds knowing in the knower, seeing in the person who sees, connoisseurship in the connoisseur, than attempts to deal with the essence of Ming Chinese painting, no matter how subtle, cannot but be misreadings of the manner in which they were created and brought to view. Such a misreading has perhaps a long European history behind it.

7 Conclusion

In late sixteenth- and seventeenth-century China, historical circumstances did exist to juxtapose pictures of a range of types manufactured locally with some imported from Europe and European-colonized parts of the globe such as the Americas. These were the circumstances surrounding the Jesuit mission to China, and the work of its great founder, the Italian Matteo Ricci (1552–1610). A restricted group of the primary sources on Ricci's mission, and in particular the material they contain on Jesuit picturing in China and Chinese reactions to it, have been extensively worked and reworked by both European and Chinese scholars – they were one of the key tropes of classical sinology – but it is a body of work which needs to be treated with caution, full of elisions and dubiously founded assumptions.[1] Most versions to a greater or lesser extent draw attention to the same passages within the writings of Ricci and his contemporaries, attesting to the avid Chinese desire for European pictures, and to Chinese astonishment at their realism and three-dimensionality. Such an interpretation rests to a degree on the testimony of the Jesuits themselves. Requests for illustrated books back to their superiors in Europe are frequent; Michele Ruggieri appealed for such works in 1580 and 1583, Nicolo Longobardi in 1598, and Ricci wrote to Pope Clement VIII for an illustrated Bible in 1600.[2] Ricci had also asked in 1588 for illustrated works on the antiquities of Rome, and there is reliable evidence for the deployment by the Jesuits as gifts of important illustrated works like the 1597 Ortelius *Teatrum Orbis Terrarum*, and the six-volume Braun and Hogenberg collection of topographical city views, *Civitates Orbis Terrarum*. The degree of appropriation (if any) of these European conventions of topography by Chinese painters has been a lively topic of scholarly debate for several decades.[3] So has the importance of Jesuit cartography in the Chinese context. Traditional accounts, including Ricci's own, stress the tremendous success of the maps he owned and composed, and their impact upon a Chinese élite forced for the first time to confront the non-centrality of the 'Middle Kingdom'. Certainly they were widely circulated through reproduction in Chinese illustrated encyclopaedias. Ricci's (lost)

first world map of 1584 is known only through its inclusion in such an encyclopaedia of 1613, the *Tu shu bian* compiled by Zhang Huang, who had met Ricci in 1595. Wang Qi put Ricci's second edition of his map into the *San cai tu hui* 'Pictorial Compendium of the Three Powers' of 1607, and Cheng Boer included Ricci's two-hemisphere map of 1601 into his 1612 text, *Fang yu sheng lüe*.[4] However as Cordell D.K. Yee argues in his revisionist account of the history of cartography, wide dissemination in such sources is not the same as influence. To go further, what the majority of European writers (with the signal exception of Paul Pelliot back in 1921) has failed to take into account is the 'culture of curiosity' in the China of the Ming period, a widespread interest in the novel, the curious and above all the foreign and imported, which provided Ming consumers with a conceptual framework into which new forms of representation and new forms of script could be comfortably accommodated without serious epistemological disturbance. Christian icons of the Virgin and maps of the world were far from being the only imported curiosities familiar to the Ming upper classes, who might also acquire through the luxury market religious texts written in Tibetan (a language none of them could read) and hang on their walls swords from Japan.[5] A guide-book to Beijing published in 1635 includes 'images of Jesus (*Yesu*) from the Western Ocean' in among Tibetan Buddhas, Indian banners, Japanese fans and bowls from somewhere called Gebala, as part of a list of exotica available at one of the city's markets.[6] In the same text, the main Beijing Jesuit church is included as one of the sights of the city, and there is described the furnishing of the church, with its painted image of Christ 'like a statue ... which the painting of China could not achieve'. The basic outline given here of sacred history and of the chief tenets of Christianity is generally accurate, suggesting that by the 1630s a consciousness of them was available to educated people in the same way that the material culture of Christianity was available in the marketplace independently of any religious commitment.[7] It is this same 'culture of curiosity' that must explain one of the best-studied pieces of Christian imagery circulating in Ming China, the image of the Virgin included in *Cheng shi mo yuan*, 'Master Cheng's Garden of Inkcakes', published by Cheng Dayue in 1606.[8] The entrepreneur Cheng Dayue (1541–c.1616), locked in a bitter commercial rivalry with another manufacturer named Fang Yulu, had met Ricci in Beijing in January 1606, and received from him four pages of samples of Latin script (Chinese texts romanized), as well as four pictorial prints, being three from Gieronimo Nadal's illustrations to the Bible, and the fourth (illus. 91) being a version of the miraculous Nuestra Señora de Antigua in Seville Cathedral, produced at Arima in Japan under Jesuit auspices in 1597.[9] Chen thus capped the achievement of his great competitor Fang Yulu,

91 Woodblock print, from Cheng Dayue, *Master Cheng's Garden of In-cakes (Cheng shi mo yuan)*, 1606, University of California, Berkeley, East Asiatic Library. An example of the Ming taste for exotic imported visual imagery.

who had included a number of foreign or obscure scripts in his *Fang shi mo pu*, 'Master Fang's Album of Ink Cakes' of 1588. No insuperable obstacles of comprehension stood in the way of this appropriation, which made of Christianity a marketing edge in the ruthless world of late Ming luxury consumerism.

The accounts sent back to Europe by Jesuits were designed to enlist support for the mission in difficult conditions, and to assure possible patrons of the successes which were already being achieved. Pictures played a major role in Jesuit accounts of their success. In the 1615 Latin version of Ricci's life edited by Nicolas Trigault, the one most widely circulated in Europe, the Chinese are constantly being amazed by the lifelikeness of Christian images. Of the Virgin on the high altar of the church in Zhao-qing, Guangdong Province, he writes, 'They [the Chinese] never ceased to admire the beauty and elegance of this painting: the coloring, the very natural lines and the lifelike posture of the figure', while at Shaozhou, 'These people are delighted and amazed when you show them books containing descriptive maps, or specimens of building architecture illustrated in diagrams or maps'.[10] One of the great set pieces of the book is the climactic encounter of the Wanli emperor with a set of European sculpted religious images:

When the king saw the crucifix, he stood in astonishment and said aloud, 'here is the Living God'. Despite the fact that this is a stock phrase with the Chinese, he spoke the truth without knowing it. This name is applied to the crucifix, even to this day, in China, and from that time on, the fathers were called the men who brought the living God to the King. From wonderment the sovereign seemed to pass into fear at the sight of the statues, and not being able to meet their gaze, he sent the statue of the Blessed Virgin to his mother. She also, who was devoted to the images of her lifeless gods, was embarrassed at the sight of the living God. She was frightened at the lifelike posture of the images and she gave orders to have them placed in her treasure vault, where they were occasionally shown to some of the Magistrates, by the eunuchs.[11]

The baroque analogy between 'lifeless' representations (*sensa nessuna vivezza* is Ricci's Italian original) and lifeless gods is an important one, for it underpins both Jesuit propaganda towards potential sources of funding (who might send them more 'living' images to use in the Ming gift economy), and their own understanding of the Chinese as proponents of failed, incomplete representations. They needed more: the Jesuits would provide it for them.

The Jesuit texts, at the same time that they stress Chinese admiration for 'living' pictures, stress also Chinese incomprehension of them. Indeed they go to lengths to police the boundary between what they see as two different systems of representation. Ricci records how the emperor cannot 'read' the conventions of the Western prints he is given, 'he could not appreciate the fine traits of a small figure, nor the variation in shading, which the Chinese ignore, so he ordered his royal artists to paint a copy of it, larger and with more colouring'.[12] Even more telling is an incident that occurred in 1600 as Ricci was on his way to the capital, towards his hoped-for imperial audience, bearing his gifts, which included oil paintings of Christ and the Virgin, an illustrated Bible, a cross inlaid with pearls, two clocks, a clavichord, and the 1597 edition of *Teatrum Orbis Terrarum*. In Jinan, the capital of Shandong Province, the wife of the governor saw and admired the image of the Virgin, and wished to send in a painter to make a copy of it. However the fathers 'feared that a painter would not be able to do it well', and Ricci gave her a copy already to hand, executed by a Chinese Christian convert (illus. 92). Note that the governor's wife had no doubts that a painter she hired would be able to copy the image effectively.[13] Here the Jesuits acted to keep representation in a Western style out of Chinese hands (converts were in this sense honorary Europeans, and their acceptance of images of Christ or the Virgin plays an important part in narratives of individual conversions[14]), to see them as two different and incompatible systems of representation. Keeping 'Chinese' and 'Western' pictures apart starts here, but it continues to the present. The Chinese

92 Anon, *Virgin and Child,* 17th century, ink and colour on paper. Field Museum of Natural History, Chicago. A Chinese version of the miraculous image of the Virgin in S. Maria Maggiore, Rome, a particular object of Jesuit devotion.

evidence does not entirely support such a cleavage between incompatible visualities.

This evidence consists of a vary small group of texts that have been extensively cited. The earliest is by a man named Gu Qiyuan, writing in a book published in 1618, after Ricci's death, but quite plausibly based on an actual encounter between them;

Li Madou [Ricci's Chinese name] is a man from the Western Ocean country of Ouluoba. He has a fair skin, a curly beard, and deep eyes with yellow pupils like those of a cat. He knows the Chinese speech. He came to Nanjing and lived in a barrack west of the Zhengyang Gate. He himself said that his nation worships the Lord of Heaven, and that this Lord of Heaven is the creator of Heaven and Earth and the myriad things. This Lord of Heaven is painted as a small boy, held by a woman called 'Heavenly Mother'. He is painted on a copper panel, with the five colours spread on top. The face is as if living, the body, arms and hands seem to protrude from the panel, the concave and convex parts of the face are no different from those of a living person to look at. When asked how the painting could achieve this, he replied, 'Chinese painting only paints the light (*yang*), it does not paint the shadow (*yin*). Thus to look at, people's faces are completely

flat, with no concave or convex physiognomy. My country's painting combines the *yin* and the *yang* in drawing, so that faces have higher and lower parts, and arms are round. When anyone's face is towards the light (*yang*), then it is entirely bright and white, but if it is turned then the side which is towards the light will be white and that which is not towards the light, the eye, ear, nose mouth and concave places will have a dark appearance. The portrait painters of my country understand this principle, and by using it are able to ensure that the painted effigy is no different from the living person...'. He brought with him a great number of books printed in his country, all printed on both sides of white sheets of paper, with characters in horizontal lines. The paper is like Yunnan rag paper of today, thick and robust, with type and ink both very fine. In these books are illustrations painting people and buildings, done in lines as fine as a hair. The bindings of the books is done in the folded style of Chinese editions of the Song Dynasty, protected on the outside by a covering of lacquered leather, with little clasps of gold or silver or bronze on the outside to fasten them together. These books are ornamented top and bottom with gilding, so that when you open them each page is as new, and when you shut them the effect is of a single panel of gold.[15]

Gu goes on to discuss the clocks given by Ricci to the emperor, his writings and his calendrical skills, and the subsequent presence in Nanjing of another father, Luo Ruwang, whose instruments and paintings were 'rather the same', an attitude of 'seen that' which rather undermines Jesuit claims of Chinese élite enthusiasm. What is more important to note is that we glimpse Ricci in this passage once again both insisting on and explaining total difference.

Much more removed from the actual presence of a European explication (although it still invokes Ricci's name) is the brief notice of 'Painting of the Western Regions' in the 'History of Poems without Words' (*Wu sheng shi shi*) of *c.*1640:

Li Madou brought from the Western Regions an image of the Lord of Heaven, being a woman holding a small boy. The eyebrows and eyes, and the lines of the clothing are like reflections in a mirror, about to make a slight movement. Their dignity and elegance are such that a Chinese artisan painter could not set their hand to it.[16]

Significant here is the siting of the picture within the realm of purely technical skill. It is the artisan painter (*hua gong*) who could not achieve this. The majority of the figures described in this book of artistic biographies would not even wish to. A Chinese élite view of European painting as belonging to an utterly different tradition from that which now enjoyed canonical status is found in a text of 1643, the *Shan hu wang hu lu* by Wang Keyu, who writes of the works brought by Ricci as 'a different tradition, a separate school from that of the Six Laws', referring to the canonical Six Laws of Painting by the sixth-century theorist Xie He.[17] However, he

continues by assimilating this 'Western' work into the Chinese canon by means of comparisons with the work of the Tang Dynasty artist Wu Daozi, in a deeply enigmatic reference to a westerner now producing Buddhist images in oils, paintings which deserve to be 'supreme in America (*Yamolijia*)'.

None of this adds up to extreme enthusiasm for or even stupefaction at Western pictures in late Ming China. The most extensive of the writers, Gu Qiyuan, merely repeats Ricci's explanation without comment. What has perhaps not been sufficiently interrogated is the precise uses being made of pictures by the Jesuits, and how these images might be differentially appropriated by different audiences. We need to cast on this question not exactly a jaundiced eye, but one that does not pre-suppose some great significance for every trace of Jesuit activity, and which does not presume an innate Chinese hostility to the novel or the foreign in the realms of representation or material culture.

The actual practices of picture-using that the Jesuits deployed need to be taken into consideration here. Books have already been mentioned, but these were by no means the only sort of picture-bearing artefact which they used in the process of conversion and consolidation of a nascent Christian community. Despite the great prestige of wall-painting as a summit of the painter's art in the Italy from which most of the missionaries had come, there is relatively little evidence that they decorated their churches extensively in this manner. A line of verse by the intellectual convert Wu Li (1632–1708), from his poem sequence 'Singing of the Course and Source of Holy Church', does include the line, 'On painted walls, year after year, we contemplate their images'.[18] However, such references are very much rarer than those to imported oil paintings. In 1581 the church in Macao received from Italy a copy of the miraculous image of the Virgin from S. Maria Maggiore in Rome, a painting piously ascribed to the hand of St Luke who was the focus of a particular Jesuit cult under the initial patronage of St Francis Borgia.[19] (The original of this sixth-century Byzantine picture might not have struck Gu Qiyuan in the same manner as did the one of its many late sixteenth-century copies which he saw; illus. 92.) We do not know if this was on canvas or on a wooden panel. We lack the same sorts of information about the three panel retable representing the miraculous Spanish image from Seville which Ricci received in 1598 (an image particularly rich in associations of triumph over the heathen). This may have been the picture, with its two wings depicting the Four Evangelists, that a Chinese Jew saw on the altar in Peking and, in Ricci's version, mis-identified as Rebecca with Jacob and Esau.[20] The Jesuits made strenuous efforts to acquire pictures of quality direct from Europe. Trigault spent much of his time on a fund-raising tour of Europe in 1614–

18 wheedling presents for the Chinese emperor out of Catholic monarchs (he met Rubens in Antwerp in 1617, but the painter seems to have got more out of the encounter in the way of authentic settings and costumes for his work).[21] Prints were imported too, as well as pictorial curiosities like the 'western lantern', decorated with 'scenes of Rome', which appears in another of Wu Li's poems.[22] When the supply of imports was insufficient, as when Trigault's lavish array of presents was lost at sea, more local resources had to be resorted to. These could be imports from Mexico or from the larger mission in Japan, or they could be the work of Chinese converts with artistic training in the Western manner, as we have seen. The two best-documented of these men were both active in a number of mission sites, and both were trained in Japan. You Wenhui (1575–1633) is credited with a much-reproduced posthumous portrait of Ricci, now in the Gesù in Rome, and died as an ordained priest in Hangzhou, while Ni Yicheng joined Ricci in Peking in 1602 having been trained by Jesuits at Arima in Japan. Nine separate paintings made by him are recorded, in both Macao and Peking, images of the Holy Family and of Christ. At least one was presented to a prominent convert.

Ni Yicheng, known to the Jesuit sources as Niicem or Jacopo Niva, was also active as a maker of prints. In 1608–10 he was in Nanchang, where he is recorded as making coloured woodcuts of 'Salvator Mundi' and of the Name of Jesus for distribution to Christians as equivalents of door gods. Such distributions of sacred pictures were important part of Jesuit practice:

It was customary to distribute holy pictures and medals, on the day of a baptism, but the mission supply of such things, that had been brought in through many countries and over many seas, was not very great and was soon exhausted. In order to meet the demand, the fathers had native sculptors carve a wooden stamp, from which pictures could be printed, because the Chinese knew nothing about the art of carving on copper. On the pictures, there was printed an explanation of the fact that the God of Heaven having no material form, took upon himself the form of a man, and brought with him the Holy Law from heaven, when he came to earth. It was quite necessary to add this explanation, because when the Chinese became Christians, they stripped the rooms of their homes of the statuette idols with which they were adorned, and when there was nothing to replace them, their pagan friends said the Christian religion was empty and bare because it had no God.[23]

This glimpse of a possible critique of an aniconic Christianity is not a glimpse of élite attitudes to the pictorial, but of attitudes held by those at less well documented positions in society who took a very different view of the utility of representation and of presence. The Jesuits might refer constantly to their Buddhist opponents as proponents of the 'cult of images',

聖母往顧依撒伯爾

甲聖母因天神之報
知依撒伯爾年老家
恩懷孕思往顧之
乙聖母同若瑟速行
三日路程之郊德
丙聖嘉禮亞居室
丁聖母一見依撒伯
戊依撒伯爾開聖所
覺胎中子踴躍母
己雜嘉禮亞若慈
相接供諸手全
庚依撒伯誕生大聖
若翰
辛聖母同居三閒月
後歸本鄉
見行紀卷一四章

93 Woodblock print showing one of a number of scenes from the life of Christ, from *Tian zhu jiang sheng chu xiang jing jie*, printed in Jinjiang under Jesuit supervision in 1637, Bibliothèque nationale de France, Paris.

but they were unable to dispense with pictures in their own public devotional practices. A bare altar was not an option. Here the Jesuit strategy of seeking to make converts among the élite was clearly at odds with one of the principal means by which they sought to achieve their aim. This is very clear if one looks at an example of the kind of pictures they were producing for a wide distribution, in the form of illustrated books in Chinese. The first illustrated Christian publication produced in China is the *Song nian zhu gui cheng*, 'Method of Reciting the Rosary', of 1608, followed by Father Rudomina's *Shi ba fu xin tu*, 'Eighteen Images of the Heart', of 1632, and the widely distributed *Tian zhu jiang sheng yan xing ji lüe*, 'Brief Account of the Deeds of the Incarnated Lord of Heaven', of 1635, followed two years later by *Tian zhi jiang sheng chu xiang jing jie*, 'Illustrated Explanation of the Incarnation of the Lord of Heaven' (illus. 93), both supervised by Giulio Aleni (1582–1649) at the mission in Jinjiang in Fujian province.[24] There is no doubt this is an 'iconotext' in Peter Wagner's sense of an indissoluble melding of text and image, the scene of the Virgin's meeting with St Anne being keyed by individual characters (used like 'A, B, C...')

within the picture to explanatory text below, so that we are told which character is which, for example. But is it a relationship of text and image very different from that understood as normative by the explicit tenets of Ming art theory. The problem a Ming upper class viewer might have with this picture is not its conventions of representation, or its (rather clumsy) fixed-point perspective. It is the fact of using a picture to 'tell a story', the utterly ostensive relationship of word and image, which makes this not an unreadable picture but a bad picture, or at the most charitable a picture, a *tu*, instead of a painting, *hua*. Intellectual converts to Christianity, for there were a few, had to engage head-on with this problem of picturing the ineffable, for it was not a trivial one. The Jesuits had partly created the problem for themselves by their appropriation of the classical concept of 'Heaven', *tian*, the one of the Three Powers which was both 'shapeless and soundless'. Yet the 'Lord of Heaven' (*Tian zhu*) was represented in human form in the pictures the missionaries placed on their altars and distributed to the faithful and occasionally to the curious. Yang Tingyun, one of these converts, argued that the Deity of the Old Testament was indeed unrepresentable, and unrepresented, but that since the Incarnation of Christ he did have the shape which allowed Him to be pictured.[25] Hence His presence in the form of Madonna and Child pictures, images of the Trinity, the Crucifixion, and Christ as Salvator Mundi, all of which the Jesuits employed in their teaching.

Just how hard this argument was to accept is shown in the very different type of images produced by a man who was deeply involved with the Christian project in seventeenth-century China, the poet, painter and Catholic priest Wu Li (1632–1718) (illus. 94). An argument has been made that at least one of this artist's pictures bears an inscription indicating Wu's absorption into his pictorial practice of ideas derived, via his European contacts, from Aristotle and St Augustine.[26] The case is ingenious but I do not find it convincing, and most Chinese viewers of his (much-admired) work since his own lifetime have had no difficulty siting his painting within the 'orthodox' tradition of landscape art. Wu Li's inability or unwillingness to paint a significant body of 'Christian' pictures must be set against his astonishing achievement in forging single handed a corpus of explicitly Christian devotional poetry, most notably in the 'Singing of the Course and Source of Holy Church' sequence. Here he tackles sacred history, and an entire new metaphysic and eschatology, generating the language he needs for the purposes he has. He chose not to do this visually, because for a man of his training and class paintings did not signify in that crass and unilinear manner, even if pictures did. In the China of the late seventeenth century, Christian pictures abounded in a range of media (illus. 95), just as pictures of all sorts continued to appear on all sorts of

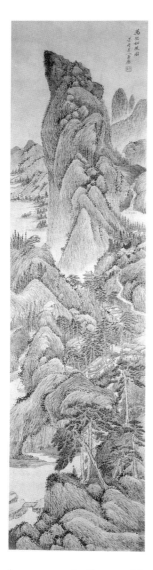

94 Wu Li (1632–1718), *Pine Wind from Myriad Valleys,* late 17th century, ink and light colour on paper. Cleveland Museum of Art.

luxury goods. Some of these goods even began to ape in their appearance the manner of paintings, as ceramics for example were decorated for the first time with landscape scenes in schematized versions of distinctive élite regional styles of painting (illus. 96). The prestige of painting was such that pictures increasingly sought to appropriate it, leading the makers of paintings to draw and re-draw new boundaries in different places and on different terms in succeding centuries. The categories could not be fixed as to their content, but the terms of the argument were now clear, and the site of the struggle over the discourse of pictures was set to move forward into a new phase.

95 Embroidered satin hanging, 'St Anthony of Padua', late 17th century. Victoria and Albert Museum, London. Probably made for a Christian community in China.

96 Brushpot or censer, porcelain painted in underglaze blue, *c.*1670. Private collection.

Painting and pictures

'Painting' in Ming and Qing China was above all a discursive object, not a solidly bounded category of picture-making practices. Its composition was a site of continuous contest, re-affirmation and denial, a set of propositions designed to emphasize its difference from the things it constantly risked resembling, mere 'pictures'. This difference was at root a social one, about painting and viewing subjects (educated, socially privileged and usually male) as much as it ever was about objects. It is crystallized in a passage that, whatever the authenticity of the text's attribution to the painter Gong Xian (1619–89), reflects accurately a widespread division of pictorial labour which was already firmly part of the élite imaginary in the seventeenth century:

In ancient times there were pictures (*tu*) but no paintings (*hua*). Pictures depict objects, portray people, or transcribe events. As for paintings, the same isn't necessarily true for them. . . . [To do a painting], one uses a good brush and antique ink, and executes it on a piece of old paper. As for the things [in a painting], they are cloudy hills and misty groves, precipitous boulders and cold waterfalls, plank bridges and rustic houses. There may be figures [in the painting] or no figures. To insist on a specific subject or the representation of some event is very low class.[27]

The translation is by James Cahill, who goes on to point up some of the problems in mapping the *tu/hua* binary onto a simple professional/amateur one, as if the status of the painter totally determined the nature of

the representation. The empirical weakness of such a correlation (which nevertheless remains alive in popular accounts of Chinese art, and has not lost all of its force for critics working in China) has been the subject of a sustained critique by Cahill and other scholars over recent years. However, this critique should not be allowed to reduce the force of this construction of 'painting' as a discursive object, or to diminish the power which, expanding since its first adumbration in the eleventh century, was consolidated and accepted as ultimately hegemonic in the sixteenth to seventeenth. However it must be helpful to see 'paintings' and 'pictures' by this time, not as mutually exclusive opposites, but rather as, in Cahill's words, 'an issue, not properly a distinction'.[28] After all, each individual painting of the period contained *tu* in its title, a title physically inscribed in most cases on the outside wrapper of the scroll, if not on the pictorial surface itself. Every *hua* was in some sense also a *tu*, even if not every *tu* was a *hua*. It might be better to see them as a 'complementary bipolarity' (the phrase coined by the literary critic Andrew Plaks), 'a paired concept treated as a continuum along which the qualities of experience are plotted in a ceaseless alternation, with the implication of presence within absence of the hypothetical poles'.[29] They existed as copper and silver did in the bimetallic Ming monetary system, not as opposites but as possibilities of mutual transmutation. The imagined binary, if not sustained in practice, was nevertheless very important as a way of understanding representation, even if not of always successfully transcending it.

Practices in the seventeenth and eighteenth centuries do exist to police this division. One such is visible in the enormous imperially sponsored collection of inscriptions on paintings, the *Yu ding li dai ti hua shi lei* of 1707. Yee has drawn attention to the way in which its prefatory matter makes a distinction, reflected in its cataloguing practices, between *dili tu*, 'pictures of the principles of the earth' or broadly 'maps', and *shanshui*, 'mountains and water' or 'landscape painting'. In his translation of the introductory notes by Chen Bangyan the latter 'is a picture in which one creates a scene out of nothing "to portray one's impressions", or a picture in which one "embellishes [reality] as one wishes without identifying names so as to make any mountain or river whatever" '.[30] In sheer numerical terms, the balance within this enormous catalogue is in favour of *shanshui*, of 'any mountain or river whatever'. This seemed by 1707, at least to the curators of the imperial collections, a clear and sensible division of the pictorial field. It meant in effect that almost any landscape painting with a place name in its title was a 'picture of the principles of the earth', and liable to the strictures of being bound by mimesis, not by the more valued aspect of 'portraying impressions'. Poems by important Ming artists do appear in this category, including work by Shen Zhou, Wen

Zhengming and other iconic figures of the 'scholar-ideal'.[31] But they are seen as distinctly a minor part of their output of verse on the landscape subject.

The triumph of painting as self-expression over painting as topographical record might seem secure from the vantage point of 1707. But it was a triumph at the level of the discursive. The importance of representation of place to the major figures of Yuan Dynasty landscape painting, figures whose canonical status was by the seventeenth century practically unassailable, was first argued coherently in a crucial article published in 1982 by Richard Vinograd, and work done since has tended to strengthen rather than weaken his conclusions about the 'landscape of property'.[32] Patronage of the topographical landscape in the fifteenth and early sixteenth centuries (and beyond into the succeding Qing Dynasty) was certainly more widespread and more intense than the scattering of poems in the eighteenth-century imperial compilation would suggest. Here, as in so many other cases, we are looking at the Ming through a later filter, reading back on to the period patterns whose full force was only invoked in the centuries of the Qing Dynasty (and significantly here, with the full authority of the imperial state). This historical dimension is what desperately needs to be brought into play against the numerous invocations of the essence of Chinese painting which, from tentative engagements in the nineteenth century down to the present, have existed principally to act as Bhabha's 'horizon of difference', making 'painting' [= 'not Chinese' painting] available as an object of art-historical study.

A better awareness of the presence of 'pictures' should not weaken the importance of 'painting' as a source of cultural power in Ming and Qing China. I am not seeking a sort of revisionism that requires attention to be removed from 'scholar painting' and turned instead to the pictures in books, or to maps, or to porcelain painting and lacquer carving, as if these were somehow more 'authentic'. Such a shift of attention would merely reinstall the horizon of difference at another point of the compass. The Chinese élite's critique of mimesis, a critique which is in itself a representation, has to be taken instead as a social fact. For the leading theorists of that élite, the failure of pictorial representation lay in its inferior status to poetry, to the written and spoken sign. Sima Guang in the Song period was only one of many writers to suggest that the depicted scene is less effective than the poetic, and that painting was held within bounds that language had the possibility of transcending. Several of his contemporaries (among them Ouyang Xiu and Wang Anshi) put on record the view that poetry could express things painting could not: 'Leisure, peace, solemnity, and quietude'). Wai-kam Ho has pointed out that this in some ways prefigures post-modern notions of the visual as 'a realm of experi-

ence that is inseparable from the verbal'.[33] John Hay has shown how in the Yuan period inscriptions draw attention to the surface which is increasingly the focus of connoisseurly attention, as representation itself rather than what is represented becomes a valid subject for painting.[34] By the late Ming, this imbrication of the visual and verbal sign had reached the point where the texts of business contracts were written out on paper printed with pictorial designs (illus. 71).

This imbrication of the pictorial and the textual sign has of course often been cited as a distinctive feature of Chinese art. In the present volume at least illus. 3, 5–7, 9, 11, 12, 15, 16, 18, 20, 32, 35, 38, 40, 41, 43–7, 49, 60, 62, 64, 70, 77, 78, 81 (and arguably several others) are objects where words are present within the pictorial field. Some of these (illus. 3 and 78) are definitely 'paintings', *hua*, by Gong Xian's standards, while others (illus. 12 and 16) are equally definitely 'pictures', *tu*. Some (illus. 35 and 59) might escape his strictures, while indubitably containing 'the representation of some event', deemed to be 'very low-class'. The word/picture association thus cuts across the *tu/hua* binary divide. Here it may be helpful to invoke the notion of the 'iconotext', a word deployed (but not invented) by Wagner in a recent study of word and image relations in eighteenth-century Europe.[35] Such interpenetrations of text and image are relatively rare in those parts of the European pictorial tradition validated as 'art', being instead concentrated in media like print-making. Relatively few 'paintings' of the European canon have writing on them. Although apparently unaware of the analogies with China, Wagner's insistence that, in the objects he studies, picture and text are 'dialogical, at times even polylogical and contradictory, in themselves', and his use of 'intermediality' seems potentially fruitful. He is insisting on an account of art not as sign (which he claims would run aground because of the weaknesses of the linguistic model on which it is based), but as 'intermedial fabric established by allusions'.

The semiotic model of art as sign is still valid for Margaret Iversen in her discussion of the vicissitudes of the visual sign within European cultural history, where she sees an oscillating relationship between the terms word/image or discourse/figure, the former dominating during the Enlightenment and the latter under the modern movement.[36] In her gloss on Norman Bryson's *Word and Image*, she sees textuality and power within the European tradition as close allies in the early modern period. By contrast, a similar reading of the Chinese material might lend itself to the interpretation that power in China adhered from an early period to the autonomous painterly signifier, long before Roger de Piles and theorists in Europe like him began to deal with painting as painting, and not primarily as text, in a set of proposals which 'liberate painting from the dominance of

literary assumptions'.[37] Martin Jay has staged some of the same argument, in the claim that:

The progressive, if by no means uniformly accepted, disentanglement of the figural from its textual task – the denarrativisation of the ocular we might call it – was an important element in that larger shift from reading the world as an intelligible text (the 'book of nature') to looking at it as an observable but meaningless object, which Foucault and others have argued was the emblem of the modern epistemological order.[38]

He goes on to argue that this 'full denarrativisation was a long way off, only to be achieved in painting with the emergence of abstract art in the twentieth century'. Yet the Chinese élite challenge to the validity of representing 'one particular thing' is very much more ancient than that. Is the effect of this to make Chinese élite painters of the Ming into good modernists *avant la lettre* (a view certainly flirted with in some twentieth-century scholarship)? Or is it rather to mount a challenge to the heroic, teleological narrative of Western 'modernism' itself, in which it is the 'liberation' of the image from the discursive which is the motor driving forward both picturing in history and the picturing of history? Jay also notes how the work of Svetlana Alpers, in her seminal *The Art of Describing*, 'has successfully reopened the question of the multiplicity of visual cultures in modernity'.[39] *All* attempts to understand these modernities, and all explanations, from the invention of pornography through the diffusion of the printing press to the plethora of luxury goods in the Renaissance, which refuse to engage with the Chinese material, are equally doomed to reductionism and ultimate failure. All attempts to first reduce 'Chinese painting' to manageable proportions by substituting essentialism for getting to grips with the enormous range of pictures operating in that culture at any given historical moment, are doomed too. Perhaps this makes any attempt to understand what Chinese painting is 'really all about' impossible. Perhaps then the history of pictures can begin.

References

1 *Introduction*

 1 'Introduction' in *Visual Culture: Images and Interpretations*, eds Norman Bryson, Michael Ann Holly and Keith Moxey (Hannover, 1994), pp. xv–xxix (p. xv).

 2 Ivan Gaskell, 'History of Images' in *New Perspectives on Historical Writing*, ed. Peter Burke (Cambridge, 1991), pp. 168–92.

 3 Hal Foster, *Vision and Visuality* (Seattle, 1988), p. ix.

 4 Gaskell, 'History of Images', p. 182.

 5 Michael Sullivan, 'Sandrart on Chinese Painting', *Oriental Art*, n.s., 1 (1948), pp. 159–61.

 6 Johannes Bettray S.V.D., *Die Akkomodationsmethode des P. Matteo Ricci S.I. in China*. Analecta Gregoriana 76 Series Facultatis Missiologicae, sectio B.1 (Rome, 1955), p. 55; John Barrow, *Travels in China* (London, 1804), p. 323.

 7 Kenneth Clark, *Landscape into Art* (Harmondsworth, repr. 1966), examples on pp. 63, 66, 76.

 8 John Onians, 'Chinese Painting in the Twentieth Century and in the Context of World Art Studies' in *Ershi shiji Zhongguo hua: 'Chuantong de yanxu yu yanjin'/Chinese Painting in the Twentieth Century: Creativity in the Aftermath of Tradition*, eds Cao Yiqiang and Fan Jingzhong (Hangzhou, 1997), pp. 497–508 (pp. 502–3).

 9 Norman Bryson, *Vision and Painting: The Logic of the Gaze* (New Haven, 1983), pp. 89–92.

 10 Homi Bhabha, *The Location of Culture* (London, 1994), p. 31.

 11 Bryson, *Vision and Painting*, p. 181, nn. 4, 5.

 12 Philip Sohm, *Pittoresco: Marco Boschini, his Critics, and their Critiques of Painterly Brushwork in Seventeenth- and Eighteenth-Century Italy* (Cambridge, 1991), pp. 12, 68.

 13 James Cahill, *The Painter's Practice: How Artists Lived and Worked in Traditional China* (New York, 1994); Richard Barnhart, *Painters of the Great Ming: The Imperial Court and the Zhe School* (Dallas, 1993).

 14 There are ironies here, in that the most flamboyantly performative of brushwork was in sixteenth-century China often associated with professional painters who enjoyed a particularly low esteem in the eyes of élite theorists of the image.

 15 Bryson, *Vision and Painting*, p. 140.

 16 Ibid., p. 85.

 17 Ibid., p. 89.

 18 Susan Bush and Hsio-yen Shih, *Early Chinese Texts on Painting* (Cambridge, MA and London, 1985), p. 224.

 19 This is the position espoused in the magisterial survey by Wen C. Fong, *Beyond Representation: Chinese Painting and Calligraphy 8th–14th Century*. Princeton Monographs in Art and Archaeology 48 (New York, 1992).

20 Yang Shen, *Hua pin*, in *Yishu congbian 1 ji, 12 ce, Mingren huaxue lunzhu*, 1, ed. Yang Jialuo (Taibei, 1975), p. 1. On Yang Shen as an aesthetic theorist, see Adam Schorr, 'Connoisseurship and the Defence against Vulgarity: Yang Shen (1488–1559) and his Work', *Monumenta Serica*, XLI (1993), pp. 89–128.

21 Lang Ying, *Qi xiu lei gao*. Du shu zha ji dier ji, Shijie shuju edn, 2 vols (Taibei, 1984), I, p. 219.

22 Wang Keyu, *Wang shi shan hu wang hua ji*, in *Yishu congbian 1 ji, 12 ce, Mingren huaxue lunzhu*, 11, ed. Yang Jialuo (Taibei, 1975), p. 137.

23 Wai-kam Ho, 'The Literary Concepts of "Picture-Like" (*Ju-hua*) and "Picture-Idea" (*Hua-I*) in the Relationship Between Poetry and Painting' in *Words and Images: Chinese Poetry, Painting and Calligraphy*, eds Alfreda Murck and Wen C. Fong (New York, 1991) pp. 353–404. To be pedantic, and for reasons which will become clear later, it obfuscates a central issue in my argument to translate *ru hua* as 'like a picture' rather than 'like a painting'. The term *ru tu*, which might mean 'like a picture', does not appear to be common in Ming texts.

24 Donald Preziosi, *Rethinking Art History: Meditations on a Coy Science* (New Haven and London, 1989), pp. 42–3.

2 *Positions of the Pictorial*

1 Richard Edwards, 'Shen Chou' in *Dictionary of Ming Biography 1368–1644*, eds. Carrington, Goodrich and Chaoying Fang (New York and London, 1976) pp. 1173–7 (p. 1174). The story retains its force in accounts of Shen's career such as that in James Cahill, *Parting at the Shore: Chinese Painting of the Early and Middle Ming Dynasty, 1368–1580* (Tokyo, 1978), pp. 82–3.

2 Jiang Shaoshu, *Wu sheng shi shi*. Hua shi congshu edn, 5 vols (Shanghai, 1982), III, *juan* 2, p. 26b.

3 The complexities of the actual as opposed to the ideal are the subject of James Cahill, *The Painter's Practice: How Artists Lived and Worked in Traditional China* (New York, 1994).

4 Richard Barnhart, *Painters of the Great Ming: The Imperial Court and the Zhe School* (Dallas, 1993), pp. 128–9.

5 Jonathan Chaves, *Singing of the Source: Nature and God in the Poetry of the Chinese Painter Wu Li*. SHARPS Library of Translations (Honolulu, 1993), p. 111.

6 For the view that wall painting had ceased to be of interest to major canonical artists as early as the eleventh century, see Richard Barnhart, 'Survivals, Revivals, and the Classical Tradition of Chinese Figure Painting' in *Proceedings of the International Symposium on Chinese Painting: National Palace Museum Republic of China 18th–24th June 1970* (Taipei, 1972), pp. 143–210.

7 Quoted in Kathlyn Maurean Liscomb, *Learning from Mount Hua: A Chinese Physician's Illustrated Travel Record and Painting Theory*. Res Monographs on Anthropology and Aesthetics (Cambridge, 1993), p. 48.

8 Richard Barnhart, 'The "Wild and Heterodox School" of Ming Painting' in *Theories of the Arts in China*, eds Susan Bush and Christian Murck (Princeton, 1983), pp. 365–96 (pp. 389–90).

9 Romeyn Taylor, 'Official and Popular Religion and the Political Organisation of Chinese Society in the Ming' in *Orthodoxy in Late Imperial China*, ed. Kwang-ching Liu (Berkeley and Los Angeles, 1990), pp. 126–57 (p. 150).

10 Marsha Weidner, 'Buddhist Pictorial Art of the Ming Dynasty (1368–1644): Patronage, Regionalism and Internationalism' in *Latter Days of the Law: Images of Chinese Buddhism 850–1850*, ed. Marsha Weidner (Lawrence and Honolulu, 1994), pp. 51–87 (pp. 55–6). Yang Boxian, *Beijing Fahai si* (Beijing, 1994), p. 52, lists the two 'painting officials' and some of the fifteen painters who executed the project.

11 Judith M. Boltz, *A Survey of Taoist Literature: Tenth to Seventeenth Centuries*.

University of California Berkeley Center for Chinese Studies Research Monographs, 32 (Berkeley, 1987), p. 197.

12 He Liangjun, *Si you zhai cong shuo*. Yuan Ming biji shiliao congkan edn (Beijing, 1983), p. 266.

13 For a typical provincial scheme of temple decoration, preserved almost in its entirety by the remoteness of the site, see Mu Xueyong, ed., *Jian'ge Jueyuansi Mingdai Fo zhuan bihua* (Beijing, 1933).

14 Wen Zhenheng, *Zhang wu zhi jiao zhu* (Nanjing, 1984), p. 36, quoted in Wai-yee Li, 'The Collector, the Connoisseur and Late-Ming Sensibility', *T'oung Pao*, LXXXI (1995), pp. 269–302 (p. 281).

15 Timothy Brook, *Praying for Power: Buddhism and the Formation of Gentry Society in Late Ming China*. Harvard–Yenching Institute Monograph Series, 38 (Cambridge, MA and London, 1993). A personal communication from Professor Brook confirms the rarity of reference to new temple murals in the areas he has studied, which range from Shandong to the more wealthy and fashionable Ningbo.

16 Judith Zeitlin, *Historian of the Strange: Pu Songling and the Classical Chinese Tale* (Stanford, 1993), pp. 183–99. Zeitlin sensitively illustrates her discussion with the murals of the Fahai Temple itself, although as she points out there is no evidence Pu Songling ever saw these actual paintings.

17 Paul Katz, 'The Function of Temple Murals in Imperial China: The Case of the Yung-lo Kung', *Journal of Chinese Religions*, XXI (Fall 1993), pp. 45–68.

18 Zheng Zhenduo, 'Chatu zhi hua' in *Zheng Zhenduo yishu kaogu wenji*, ed. Zheng Erkang (Beijing, 1988), pp. 3–22. The piece was originally published in *Xiaoshuo yuebao*, XVIII/1 (1927). Zheng formalized this canon in his monumental *Zhongguo banhua shi tulu* (Shanghai, 1940–7).

19 Convenient compilations include Fu Xihua, ed., *Zhongguo gudian wenxue banhua xuanji*, 2 vols (Shanghai, 1981); and Zhou Wu, ed., *Zhongguo guben xiqu chatu xuan* (Tianjin, 1985). Recent additions to the secondary literature in Western languages include Sören Edgren, *Chinese Rare Books in American Collections* (New York: China Institute, 1985); Frances Wood, *Chinese Illustration* (London, 1985); Frederick Mote and Hung-lam Chu, *Calligraphy and the East Asian Book*, ed. Howard Goodman (Boston and Shaftesbury, 1989); and Monique Cohen and Nathalie Monnet, *Impressions de Chine* (Paris: Bibliothèque nationale, 1992).

20 Reproduced in Craig Clunas, *Fruitful Sites: Garden Culture in Ming Dynasty China* (London, 1996), illus. 47, 48.

21 Ch'ien Chung-shu, 'China in the English Literature of the Seventeenth Century', *Quarterly Journal of Chinese Bibliography*, I (1940), pp. 351–84 (p. 361). This is pointed out apppositely in Frederick Mote and Hung-lam Chu, *Calligraphy and the East Asian Book*, ed. Howard Goodman (Boston and Shaftesbury, 1989), p. 10.

22 Elizabeth L. Eisenstein, *The Printing Revolution in Early Modern Europe* (Cambridge, 1983), p. xiii.

23 Ibid., pp. 21, 23, 44.

24 Martin Jay, *Downcast Eyes: The Denigration of Vision in Twentieth-Century French Thought* (Berkeley and Los Angeles, 1994), pp. 66–9.

25 Quoted in Susan Stewart, *Crimes of Writing: Problems in the Containment of Representation* (Durham and London, 1994), p. 4.

26 Joseph Needham, *Science and Civilisation in China*, V. *Chemistry and Chemical Technology*, part I. *Paper and Printing*, by Tsien Tsuen-hsuin (Cambridge, 1985), p. 255.

27 Lang Ying, *Qi xiu lei gao*, II, p. 664.

28 *Shui dong ri ji*, by Ye Sheng (1420–74), cited in Wang Shaochuan, *Yuan Ming Qing san dai jinhui xiaoshuo xiqu shiliao* (Beijing, 1958), p. 170. The quotation is discussed further in Wu Hung, *The Double Screen: Medium and Representation in Traditional Chinese Painting* (London, 1997), p. 245, quoting Li Zhizhong, *Lidai keshu kaoshu* (Chengdu, 1990).

29 Wen Zhenheng, *Zhang wu zhi jiao zhu*, p. 219.

30 The notion of a 'golden age' is invoked in Zhou Wu, *Zhongguo guben xiqu*, p. 13. Zhang Yuanfen, 'Xin faxian de "Jin Ping Mei" yanjiu ziliao chu tan' in *Lun Jin Ping Mei*, eds Hu Weishan and Zhang Qingshan (Beijing, 1984), pp. 331–8, attempts to argue that the man identified in 1609 as the first owner of a complete text of the libertine (and heavily illustrated) novel *Jin Ping Mei*, and possibly its first publisher, got that text from Wen Zhenheng himself, which would be piquant if true. Unfortunately it is a red herring, based on a misreading of the colophon on a famous work of calligraphy, and can be totally discounted.

31 Quoted in Xie Guozhen, ed., *Mingdai shehui jingji shiliao zuanbian*, 3 vols (Fuzhou, 1980), I, p. 322.

32 Du Xinfu, *Mingdai banke zonglu*, 8 vols (Yangzhou, 1983). The estimate is in the Preface by Zhou Caiquan, and is of editions rather than titles. I have not counted the number of separate titles listed.

33 Sören Edgren (personal communication March 1996) points out that 'Du Xinfu follows the accepted convention of recording the title from the "caption" (i.e. the first page of the text proper) whereas mention of being illustrated may only occur on the *fengmian* leaf (your advertisement title?) most specimens of which are now lost. I am of the opinion that *fengmianye* (sometimes mistakenly referred to as a title page) most nearly functioned like the dust jacket of modern books, including the occasional use of illustration . . .'.

34 A convenient collection of such catalogues is Feng Huimin and Li Wanjian, eds, *Mingdai shumu tiba congkan*, 2 vols (Beijing, 1994).

35 Gao Ru, *Baichuan shu zhi*. Gudian wenxue chubanshe edn (Beijing, 1957).

36 Ibid., p. 72.

37 Ibid., p. 74.

38 Ibid., p. 119.

39 Ibid., pp. 131, 153.

40 Wu Hung, *The Double Screen*, p. 245.

41 Anne E. McLaren, 'Ming Audiences and Vernacular Hermeneutics: the Uses of the *Romance of the Three Kingdoms*', T'oung Pao, LXXXI (1995), pp. 51–80 (p. 55).

42 Tsien Tsuen-hsuin, *Paper and Printing*, p. 263. The illustrations are reproduced *in toto* in Fang Zhimin, ed., *Ming kan Xi xiang ji quan tu* (Shanghai, 1983). See also Dajuin Yao, 'The Pleasure of Reading Drama: Illustrations to the Hongzhi Edition of *The Story of the Western Wing*' in Wang Shifu, *The Moon and the Zither: The Story of the Western Wing*, eds and trans. Stephen H. West and Wilt L. Idema (Berkeley, 1991), pp. 437–68.

43 Victor H. Mair, *Painting and Performance: Chinese Picture Recitation and its Indian Genesis* (Honolulu, 1988), pp. 3, 7–8.

44 Wood, *Chinese Illustration*, pl. 19. On this edition, see Liu Ts'un-yan, *Chinese Popular Fiction in Two London Libraries* (Hong Kong, 1967), pp. 25–6.

45 Zhou Wu, *Zhongguo guben xiqu*, pp. 175–6. The publisher is Hangzhou's Qifengguan; see Du Xinfu, *Mingdai banke zonglu*, IV, p. 12a.

46 Anne E. McLaren, 'Chantefables and the Textual Evolution of the San-kuo-chih yen-i', T'oung Pao, LXXI (1985), pp. 159–227 (p. 187).

47 This is not to slight the important work done on literacy, including Evelyn Rawski, *Education and Popular Literacy in Ch'ing China* (Ann Arbor, 1979); and Joanna F. Handlin, 'Lü Kun's New Audience: the Influence of Women's Literacy on Sixteenth-Century Thought' in *Women in Chinese Society*, eds Margery Wolf and Roxane Witke (Stanford, 1975), pp. 13–38.

48 Eamon Duffy, *The Stripping of the Altars: Traditional Religion in England 1400–1580* (New Haven, 1992), pp. 214, 224–5.

49 Timothy Brook, 'Edifying Knowledge: the Building of School Libraries in the Ming', *Late Imperial China*, XVII/I (1996), pp. 88–114.

50 *Tian shui bing shan lu*, in *Ming Wuzong waiji*. Zhongguo lishi yanjiu ziliao congshu edn, reprint of 1951 Shenzhou Guoguangshe edn, Shanghai shudian (Shanghai, 1982). The itemized volumes are on pp. 136–8, and the unitemized (distributed to Confucian schools and monasteries) are on p. 159.

51 Wang Jinming, 'Taicang Nanzhuancun Ming mu chutu guji', *Wenwu*, no. 3 (1987), pp. 19–22.

52 Zhao Jingshen, 'Tan Ming Chenghua kanben "Shuo chang ci hua" ', *Wenwu*, no. 3 (1972), pp. 19–22. The fact that none of the editions, which date from 1471 to 1478 and are now in the Shanghai Museum, appear in any bibliography is a salutary reminder of how much Ming printed matter is irrevocably lost. They are discussed with illustrations in Chu-tsing Li and James C.Y. Watt, eds, *Art from the Scholar's Studio: Artistic Life in the Late Ming Period* (New York, 1987), no. 25, pp. 159–60. See also Anne E. McLaren, 'The Discovery of Chinese Chantefable Narratives from the Fifteenth Century: a Reassessment of their Likely Audience', *Ming Studies*, XXIX (1990), pp. 1–29.

53 Victor H. Mair, 'Language and Ideology in the Written Popularisations of the *Sacred Edict*' in *Popular Culture in Late Imperial China*, eds David Johnson, Andrew J. Nathan and Evelyn S. Rawski (Berkeley, 1985), pp. 325–59 (p. 327).

54 Katherine Carlitz, 'The Social Uses of Female Virtue in Late Ming Editions of "Lienü zhuan" ', *Late Imperial China*, XII/2 (1991), pp. 117–52 (p. 117). Carlitz is to my knowledge the first scholar to apply Chartier's work to Chinese material.

55 Song Ying-hsing, *T'ien-kung K'ai-wu: Chinese Technology in the Seventeenth Century*, trans. E-tu Zen-sun and Shiou-chuan Sun (University Park and London, 1966), pp. xiii–xiv.

56 Tsien Tsuen-hsuin, *Paper and Printing*, p. 265; Hiromitsu Kobayashi and Samantha Sabin, 'The Great Age of Anhui Printing' in *Shadows of Mt Huang: Chinese Painting and Printing of the Anhui School*, ed. James Cahill (Berkeley, 1981), pp. 25–33 (pp. 26–8).

57 Facsimile edition published as *Ming Chen Hongshou Shui hu yezi*. Shanghai renmin meishu chubanshe (Shanghai, 1979). Chen's activities as a designer of book illustration are discussed in Tsien Tsuen-hsuin, *Paper and Printing*, pp. 264–5; and Zhou Wu, *Zhongguo guben xiqu*, pp. 9–10. For examples of Chen's designs, see Zhou Wu, *Wulin chatu xuanji* (Hangzhou, 1984), pp. 127–44.

58 Tsien Tsuen-hsuin, *Paper and Printing*, p. 265. See also the classic article by Wu Kuang-tsing, 'Ming Printing and Printers', *Harvard Journal of Asiatic Studies*, VII (1942) pp. 203–60. On signatures generally, see Clunas, *Superfluous Things*, pp. 60–8.

59 Anne Burkus-Chasson, 'Elegant or Common? Chen Hongshou's Birthday Presentation Pictures and his Professional Status', *Art Bulletin*, XXVI/2 (1994), pp. 279–300.

60 Roger Chartier, *The Cultural Uses of Print in Early Modern France*, trans. Lydia G. Cochrane (Princeton, 1987), pp. 3, 6–7. See also *idem*, *Cultural History: Between Practices and Representations*, trans. Lydia G. Cochrane (Cambridge, 1988).

61 Carlitz, 'Social Uses of Female Virtue'.

62 *Chinese and Associated Lacquer from the Garner Collection* (London: British Museum, 1973), p. 37, no. 123.

63 The box and the cult of Lin Bu in the Ming are discussed in more detail in Craig Clunas, 'Human Figures in the Decoration of Ming Lacquer', *Oriental Art*, n.s., XXXII (1986), pp. 177–88 (pp. 177–80).

64 Stephen Little, 'Dimensions of a Portrait: Du Jin's *The Poet Lin Bu Walking in the Moonlight*', *Bulletin of the Cleveland Museum of Art*, LXXV/9 (1988), pp. 331–51.

65 Cahill, *Parting at the Shore*, pp. 129–32; Barnhart, 'The "Wild and Heterodox" School'.

66 Fu Xihua, *Zhongguo gudian wenxue banhua xuang ji*, pp. 250–3. The text is not listed under this title in Du Xinfu.

67 Wai-kam Ho, 'The Literary Concepts of "Picture-like" ', p. 366.

68 Elizabeth Scheicher, 'Die Kunstkammer in Schloss Ambras' in *Europa und die Kaiser von China 1240–1816*, ed. Lothar Ledderose (Berlin, 1985), pp. 58–61; Roderick Whitfield, 'Chinese Paintings from the Collection of Archduke Ferdinand II', *Oriental Art*, n.s., XXII (1976), pp. 406–16.

69 Carlo Ginzburg, 'Titian, Ovid and Sixteenth-Century Codes for Erotic Illustration' in *Myths, Emblems, Clues*, ed. Carlo Ginzburg (London, 1990), pp. 77–95 (p. 79). Ginzburg cites Peter Burke, *Culture and Society in Renaissance Italy* (London, 1972) as the source of the distinction.

70 Richard Barnhart, 'Rediscovering an Old Theme in Ming Painting', *Orientations*, XXVI/8 (1995), pp. 52–61.

71 Julia K. Murray, 'The Temple of Confucius and Pictorial Biographies of the Sage', *Journal of Asian Studies*, LV/2 (1996), pp. 269–300.

72 Katz, 'Yung-lo-kung', p. 48.

73 Murray, 'The Temple of Confucius', p. 278.

74 Barnhart, 'Rediscovering an Old Theme', p. 54.

75 The London version is V & A Museum FE. 21–1982. The Osaka version is illustrated in *Chūgoku no raden/Exhibition of Mother-of-Pearl Inlay in Chinese Lacquer Art* (Tokyo: National Museum, 1979), p. 33.

76 See the examples reproduced in Qin Lingyun, *Minjian huagong shiliao* (Beijing, 1958), pp. 27–30.

77 Edgren, *Chinese Rare Books*, no. 34.

78 Craig Clunas, *Chinese Furniture*. V & A Far Eastern Series (London, 1988), p. 71.

79 The piece is illustrated in colour in Rose Kerr, ed., *Chinese Art and Design* (London, 1991), p. 25.

80 Clunas, *Superfluous Things*, pp. 18–28.

81 I have looked at *Chong xi Xinzhai Wang xian sheng quan ji*, 8 *juan*, published at Taizhou by Wang Binglian in 1631, and available in the microfilm collection *Guoli zhongyang tushuguan cang shanben*. This is presumably a reprint of the edition in 3 *juan* of 1606, cited by Du Xinfu, *Mingdai banke zonglu*, IV, p. 9b, as published by Geng Dingli and entitled *Xinzhai Wang xiansheng quan ji*.

82 Craig Clunas, 'The West Chamber: a Literary Theme in Chinese Porcelain Decoration', *Transactions of the Oriental Ceramic Society*, XLVI (1981–2), pp. 69–86.

83 Dawn Ho Delbanco, 'The Romance of the West Chamber: Min Qiji's Album in Cologne', *Orientations*, XIV/6 (1983), pp. 12–23.

84 Wu Hung, *The Double Screen*, pp. 246–59.

85 Mary H. Fong, 'Wu Daozi's Legacy in the Popular Door Gods (*Menshen*) Qin Shubao and Yuchi Gong', *Archives of Asian Art*, XLII (1989), pp. 6–24 (p. 17).

86 Robert H. van Gulik, *Chinese Pictorial Art*. Serie Orientale 19 (Rome, 1958), pp. 4–6. The Chinese text is Wen Zhenheng, *Zhang wu zhi jiao zhu*, p. 221.

87 Barnhart, 'The "Wild and Heterodox" School', p. 384.

88 Wen Zhenheng, *Zhang wu zhi jiao zhu*, p. 221, preferring the punctuation of this edition to that in van Gulik.

89 For an example, see He Liangjun, *Si you zhai cong shuo*, p. 269.

90 For a discussion of this literature in the Ming context, see Clunas, *Fruitful Sites*, p. 163.

91 Cahill, *Three Alternative Histories*, p. 38.

92 Ellen Johnston Laing, 'Ch'iu Ying's Three Patrons', *Ming Studies*, VIII (1979), pp. 51–2.

93 Ellen Johnston Laing, 'Sixteenth-Century Patterns of Art Patronage: Qiu Ying and the Xiang Family', *Journal of the American Oriental Society*, CXI/1 (1991), pp. 1–7. On the Peach Blossom Spring as a birthday theme, see Jerome Silbergeld, 'Chinese Concepts of Old Age and Their Role in Chinese Painting, Painting Theory and

Criticism', *Art Journal*, XLVI/2 (1987), pp. 103–14, where he provides an excellent list of birthday themes.

94 Zhang Dafu, *Mei hua cao tang bi tan*. Gudi'an cang Ming Qing zhanggu congkan, Shanghai guji chubanshe edn, 3 vols (Shanghai, 1986), III, p. 716; Gui Youguang, *Zhenchuan xiansheng ji*. Zhongguo gudian wenxue congshu, Shanghai guji chubanshe edn, 2 vols (Shanghai, 1981), I, p. 44.

95 Mary H. Fong, 'The Iconography of the Popular gods of Happiness, Emolument and Longevity (*Fu Lu Shou*)', *Artibus Asiae*, XLIV (1983), pp. 159–98.

96 Wang Shixiang, *Xiu shi lu jie shuo* (Beijing, 1983), p. 135.

97 Clunas, *Fruitful Sites*, p. 57.

98 He Liangjun, *Si you shui cong shuo*, p. 103.

99 *Jin ping mei cihua*. Zengnizhi wenhua shiye gongsi edn, 3 vols (Taibei, 1980–1), II, p. 107 (the closing of chapter 41); French translation in Andre Lévy, *Fleur en fiole d'or (Jin ping mei cihua)*, 2 vols (Paris, 1985), I, p. 871. Additionally, *Jin ping mei*, I, p. 121 (*The Plum in the Golden Vase, or Chin P'ing Mei*, 1. *The Gathering*, trans. David Tod Roy, 5 vols [Princeton, 1993–], p. 128; Lévy, p. 130) specifically mentions sending the boxes back empty; *Jin ping mei*, I, p. 125 (Roy, p. 137; Lévy, p. 139) is a gift of cakes; *Jin ping mei*, I, p. 162 (Roy, p. 197; Lévy, p. 194) is a gift of flowers, in both cases in 'boxes' (*her*).

100 Clunas, 'Human Figures', pp. 182–5.

101 See Clunas, 'Books and Things', p. 142, n. 5, for details of nine comparable examples. *Jin ping mei*, I, p. 124 (Roy, p. 136; Lévy, *Fleur en fiole*, p. 136) mentions the delivery of betrothal presents in a 'retangular box' (*fang he*), which may be an important bit of precision.

102 *Chu Hsi's* Family Rituals, trans., Annotation and Introduction Patricia Buckley Ebrey. Princeton Library of Asian Translations (Princeton, 1991), p. 58.

103 Fu Xihua, *Zhongguo*, p. 648; Du Xinfu, *Mingdai banke zonglu*, II, pp. 8b–9a. On such encyclopedias generally, see Tadao Sakai, 'Confucianism and Popular Educational Works' in *Self and Society in Ming Thought*, ed. Wm Theodore de Bary. Columbia Studies in Oriental Culture 4 (New York, 1970), pp. 331–66.

104 On Songjiang, see John Meskill, *Gentlemanly Interests and Wealth on the Yangtze Delta*. Association for Asian Studies Monograph and Occasional Paper Series, no. 49 (Ann Arbor, 1994), p. 106.

3 *Representing the Triad*

1 Deborah A. Sommer, 'Images into Words: Ming Confucian Iconoclasm', *National Palace Museum Bulletin*, XXIX/1–2 (1994), pp. 1–24 (p. 8).

2 On geomancy in the Ming and on the landscape of number generally, see Craig Clunas, *Fruitful Sites*, pp. 177–97.

3 Discussed in J. B. Harley and David Woodward, eds, *The History of Cartography*, II, bk 2. *Cartography in the Traditional East and Southeast Asian Societies* (Chicago, 1994), pl. 1.

4 Matteo Ricci, *China in the Sixteenth Century: The Journals of Matteo Ricci: 1583–1610*, trans. Louis J. Gallagher S. J. (New York, 1953), pp. 165, 536–7.

5 Gui Youguang, *Zhenchuan xiansheng ji*, II, pp. 75, 105.

6 Ibid., pp. 46, 419.

7 Cordell D. K. Yee, 'Chinese Cartography Among the Arts: Objectivity, Subjectivity, Representation' in Harley and Woodward, *The History of Cartography*, pp. 128–69 (pp. 137, 167).

8 J.V. Mills, 'Chinese Coastal Maps', *Imago Mundi*, XI (1954), pp. 151–68 (pp. 156–7).

9 Peter H. Lee, *A Korean Storyteller's Miscellany: The 'P'aegwan chapki' of Ö Sukkwŏn* (Princeton, 1989), pp. 74–6.

10 Clunas, *Fruitful Sites*, p. 165.

11 He Liangjun, *Si you zhai cong shuo*, pp. 257, 113, 121; Susan Bush and Hsio-yen Shih, *Early Chinese Texts on Painting* (Cambridge, MA and London), pp. 36–8.

12 Kathlyn Maureen Liscomb, *Learning from Mount Hua*; Richard Vinograd, 'Family Properties: Personal Context and Cultural Pattern in Wang Meng's *Pien Mountains of 1366*', *Ars Orientalis*, XIII (1982), pp. 1–29; Clunas, *Fruitful Sites*, pp. 156–8.

13 For example, James Cahill, *Three Alternative Histories of Chinese Painting. The Franklin D. Murphy Lectures* IX (Lawrence, 1988), pp. 51–7.

14 Richard Strassberg, *Inscribed Landscapes: Travel Writing from Imperial China* (Berkeley, 1994); Susan Stewart, *On Longing: Narratives of the Miniature, the Gigantic, the Souvenir, the Collection* (Durham, NC and London, 1993), p. 138.

15 Du Xinfu, *Mingdai banke zonglu*, 8 vols (Yangzhou, 1983), VI, p. 43a; Frederick Mote and Hung-lam Chu, *Calligraphy and the East Asian Book*, p. 142.

16 On this, see Wang Zhongmin, *Zhongguo shanben shu tiyao* (Shanghai, 1983), p. 203.

17 Monique Cohen and Nathalie Monnet, *Impressions de Chine* (Paris: Bibliothèque nationale, 1992), pp. 152–3, date the work to 1621–7 on the grounds of its technical proximity to another dated work printed in colour in Hangzhou in those years. They associate it too with the colour printing of *Jian xia ji*; illus. 24.

18 James Cahill, *Parting at the Shore, p. 191*.

19 Lynn A. Struve, *Voices from the Ming-Qing Cataclysm: China in Tigers' Jaws* (New Haven and London, 1993), p. 205.

20 Livia Kohn, 'A Textbook of Physiognomy: the Tradition of the *Shenxiang quanbian*', *Asian Folklore Studies*, XLV/2 (1986), pp. 227–58.

21 See the excellent discussion in Mette Siggstedt, 'Forms of Fate: an Investigation of the Relationship Between Formal Portraiture, Especially Ancestral Portraits, and Physiognomy (*xiangshu*) in China' in *Proceedings of the International Colloquium on Chinese Art History, 1991: Painting and Calligraphy*, ed. Wang Yaoting, 2 vols (Taipei, 1992), II, pp. 713–48. The major starting point for any investigation of Ming portraiture is now Richard Vinograd, *Boundaries of the Self: Chinese Portraits 1600–1900* (Cambridge, 1992). Another useful short survey is Vishaka N. Desai and Denise Patry Leidy, *Faces of Asia: Portraits from the Permanent Collection* (Boston: Boston Museum of Fine Arts, 1989).

22 Siggstedt, 'Forms of Fate', p. 721.

23 Ladislav Kesner Jr, 'Memory, Likeness and Identity in Chinese Ancestor Portraits', *Bulletin of the National Gallery in Prague*, III–IV (1993–4), pp. 4–15, discusses the boundaries of the category very well. There is a description of the process of making these portraits in Qin Lingyun, *Minjian huagong shiliao* (Beijing, 1958), pp. 59–62, but the terminology he uses is not born out by usages in Ming fiction.

24 Ebrey, p. 78.

25 Sommer, p. 10.

26 *Jin ping mei cihua*, Zengnizhi wenhua gongsi edn, 3 vols. (Taibei, 1980–1), II, pp. 468–9. Levy, pp. 332–4. Abridged English translation is Kesner, pp. 9–10.

27 Xi Zhou sheng, *Xing shi yin yuan zhuan*, Zhongguo gudian xiaoshuo yanjiu ziliao congshu, 3 vols (Shanghai, 1980), pp. 266–7.

28 Lang Ying, II, p. 689.

29 Discussed in Vinograd, p. 2.

30 e.g. Machida City Museum of Graphic Arts, *Chūgoku kōdai hanga-ten* (Machida, 1988), p. 100 illustrates a genealogy of the Yan family dated 1499.

31 Siggstedt, p. 722. The portrait is discussed in Vinograd, pp. 28–9.

32 Gui Youguang, p. 657; Lang Ying, II, p. 451.

33 Yang Shen, p. 12.

34 Gui Youguang, p. 105.

35 Zhang Dafu, III, pp. 647–54.

36 Lang Ying, p. 400.

37 Ibid., p. 601.

38 He Liangjun, p. 158 (smelly feet), p. 157 (lunch), p. 69 (Ye Sheng).

39 *Chūgoku kōdai hanga-ten*, p. 101.

40 Vinograd, p. 46.

41 For examples see Wen C. Fong and James C. Y. Watt, *Possessing the Past: Treasures from the National Palace Museum, Taipei* (New York, 1996), pp. 327–33. For a discussion of one particular Ming imperial procession scroll, and its purposes in inner-court propaganda, see Craig Clunas, *Art in China* (Oxford, 1997), p. 71.

42 Vinograd, pp. 40–3. Huang Cunwu is unrecorded, and the suspicion remains that Zeng Jing is the lone portrait painter, like the lone jade worker or lacquer artisan, necessary to incorporate new types of object into the Ming system of artistic value.

43 Lang Ying, *Qi xiu lei gao*, 11, pp. 635, 646.

44 Ibid., 11, p. 836.

45 Ibid., 1, p. 121.

46 Deborah A. Sommer, 'Images into Words: Ming Confucian Iconoclasm', *National Palace Museum Bulletin*, XXIX/2 (1994), pp. 1–24 (p. 5). This important article and other work in progress by Sommer is the chief source for my understanding of state attitudes to images.

4 *Practices of Vision*

1 Willard J. Peterson, 'Making Connections: "Commentary on the Attached Verbalizations" of the *Book of Change*', *Harvard Journal of Asiatic Studies*, XLII/1 (1982), pp. 67–116.

2 On the role of this text in Ming culture, see Howard L. Goodman and Anthony Grafton, 'Ricci, the Chinese and the Toolkits of the Textualists', *Asia Major*, 3rd series, 11/2 (1990–1), pp. 95–148, especially pp. 123–40.

3 Peterson, 'Making Connections', p. 112.

4 Ibid., pp. 80–1.

5 Ibid., p. 99.

6 See, for example, the fifteenth-century writer Du Qiong (1397–1474), quoted in Yu Jianhua, *Zhongguo hualun leibian*, 2 vols (Beijing, 1986), 1, p. 103. For a discussion of their earlier impact on aesthetic theory, see Min Ze, 'Lun Jin Wei zhi Tang guanyu yishi yingxiang de renshi' in *Xingxiang, yixiang, qinggan*, ed. Min Ze (Shijiazhuang, 1987), pp. 29–53.

7 Lang Ying, *Qi xiu lei gao*, 1, pp. 29, 39, 221, 264.

8 Ibid., p. 296. On 'gesture' and 'attitude', see Martin J. Powers, 'Character (*Ch'i*) and Gesture (*Shih*) in Early Chinese Painting Criticism' in *Procedings of the International Colloquium on Chinese Art History, 1991: Painting and Calligraphy*, ed. Wang Yaoting, 2 vols (Taipei, 1992), 11, pp. 909–31.

9 Lang Ying, *Qi xiu lei gao*, 1, p. 74.

10 Gui Youguang, *Zhenchuan xiansheng ji*, 2 vols (Shanghai, 1981), 11, p. 691.

11 Richard Vinograd, *Boundaries of the Self*, pp. 5–6.

12 Cordell D.K. Yee, 'Chinese Maps in Political Culture', pp. 71–95 (p. 72, no. 9, which discusses the etymology of the term as it appears in the earliest dictionaries thoroughly).

13 Lai Zhide, *Yi jing Lai zhu tu jie*, ed. Zheng Can, Ba shu shu she edn (Chengdu, 1988), p. 484. This reproduces a second edition, that published by Gao Xuejun at some point in the late Ming, on the basis of the original 1602 Guo Qingluo edition. On Lai, see Goodman and Grafton, 'Ricci', pp. 95–148 (pp. 134–6). I have not had access to Larry Schulz, 'Lai Chih-te (1525–1604) and the Phenomenology of the Classic of Change', PhD disertation, Princeton University, 1982.

14 Goodman and Grafton, 'Ricci', pp. 126–8.

15 Michael Lackner, 'Die "Verplanung" des Denkens am Beispiel der *T'u*' in *Lebenswelt und Weltanschauung im Fruhneuzeitlichen China*, ed. Helwig Schmidt-

Glintzer (Stuttgart, 1990), pp. 133–56; *idem*, 'Argumentation par diagrammes: une architecture à base de mots. Le *Ximing* (*l'Inscription Occidentale*) depuis Zhang Zai jusqu'au *Yanjitu*', *Extrême-Orient – Extrême Occident*, XIV (1992), pp. 131–68. For a Ming example of argumentation by diagrams, see Li Xu, p. 346, the *Quan xiao tu*, 'Diagram of total filiality'.

16 Ssu-yu Teng and Knight Biggerstaff, *An Annotated Bibliography of Selected Chinese Reference Works*. Harvard–Yenching Monographs 2 (Cambridge, MA, 1950), p. 125.

17 *Yuan jian lei han*, VIII, *juan* 197, p. 15a. The full text of the commentary, in Peterson, 'Making Connections', p. 108, reads, 'The Diagram was produced from the Yellow River and the Writing was produced from the Lo River and sages modelled [the *Change* in part] on them'.

18 John B. Henderson, 'Chinese Cosmographical Thought: the High Intellectual Tradition', in J.B. Harley and David Woodward, eds, *The History of Cartography*, II, bk 2. *Cartography in the Traditional East and Southeast Asian Studies* (Chicago, 1994), pp. 203–27 (p. 214).

19 Michael Saso, 'What Is the *Ho-t'u*?', *History of Religions*, XVII/2 (1977), pp. 399–416 (p. 404); Richard J. Smith, *Fortune Tellers and Philosophers: Divination in Traditional Chinese Society* (Boulder, 1991), pp. 59–62.

20 Gui Youguang, *Zhenchuan xiansheng ji*, I, pp. 1–6 contains his three-part 'Discussion on the Diagrams in the "Change" ' (*Yi tu lun*).

21 Kidder Smith Jr, Peter K. Bol, Joseph A. Adler and Don J. Wyatt, *Sung Dynasty Uses of the* I Ching (Princeton, 1990), pp. 120–2.

22 Benjamin A. Elman, *From Philosophy to Philology: Intellectual and Social Aspects of Change in Late Imperial China*. Harvard East Asian Monographs 10 (Cambridge, MA, 1984), pp. 29–30, 117; R. Kent Guy, *The Emperor's Four Treasuries: Scholars and the State in the Late Ch'ien-lung Era*. Harvard East Asian Monographs 129 (Cambridge, MA, 1987), p. 41.

23 Li Xu, p. 310.

24 Confusingly, most early texts give Shihuang and Cangjie as alternative names for the same mythical culture hero, associated primarily with the invention of writing, which he copied from the tracks of birds.

25 Cited in Yu Jianhua, I, p. 95. Sommer, p. 5, remarks on Song Lian's hostility to images in Confucian temples, while at the same time he was prepared to praise Buddhist images.

26 He Liangjun, *Si you zhai cong shuo* (Beijing, 1983), p. 255.

27 For example, ibid., p. 257.

28 *Yuan jian lei han, juan* 327, XIII, p. 1a.

29 Ibid., pp. 1b–4a.

30 Du Xinfu, *Mingdai banke zonglu*, I, p. 40a. The Shiquge was active from 1593 to the Kangxi period, with over ten surviving editions identified.

31 Peng Dayi, *Shan Tang si kao*, 25 vols. Leishu huibian 23, Yiwen yinshuguan edn (Taibei, 1973), *zheng ji, juan* 22, pp. 22a, 25a.

32 *15th-Century Illustrated Chinese Primer, Hsin-pien tui-hsiang ssu-yen*, facsimile reproduction with Introduction and Notes L. Carrington Goodrich (Hong Kong, n.d.).

33 Peter Wagner, *Reading Iconotexts: From Swift to the French Revolution* (London, 1995), p. 171.

34 Zhang Dafu, *Mei hua cao tang bi tan*, 3 vols (Shanghei, 1986), I, p. 72.

35 He Liangjun, *Si you zhai cong shuo*, p. 237.

36 Clunas, *Superfluous Things*, p. 86.

37 For example, in the writing of Zhao Xigu (active *c*.1195–1242); Susan Bush and Hsio-yen Shih, *Early Chinese Texts on Painting*, pp. 237–9.

38 Mao Yixiang, *Hui miao*, I *juan* in *Yishu congbian* I *ji*, 12 *ce*, *Mingren huaxue lunzhu*, ed. Yang Jialuo (Taibei, 1975), II, p. 9. These 'rules' (*fa*) are reminiscent of the 'Rules for reading' (*Du fa*), which begin to appear in the texts of novels in the late Ming

39 Mao Yixiang, *Hui miao*, p. 12.

40 Wai-yee Li, 'The Collector, the Connoisseur and Late-Ming Sensibility', pp. 277–8 for an example.

41 Wen Zhenheng, *Zhang wu zhi jiao zhu*, p. 147.

42 Wang Keyu, *Wang shi shan hu wang hua ji*, p. 139. For the original context of Tang Hou's words (and an alternative translation), see Bush and Shih, *Early Chinese Texts on Painting*, p. 261.

43 Wang Keyu, *Wang shi shan hu wang hua ji*, pp. 135–6.

44 Ibid., p. 137.

45 *Jin ping mei cihua*, 3 vols (Taibei, 1980–1), II, p. 468.

46 Wang Keyu, *Wang shi shan hu wang hua ji*, p. 141.

47 Isabelle Robinet, 'Taoist Insight Meditation: the Tang Practice of *Neiguan*' in *Taoist Meditation and Longevity Techniques*, ed. Livia Kohn (Ann Arbor, 1989), pp. 159–91 (p. 195).

48 Isabelle Robinet, 'Visualisation and Ecstatic Flight in Shangqing Taoism' in *ibid.*, pp. 159–91 (p. 162). On the links to artistic creation, see Lothar Ledderose, 'Some Taoist Elements in the Calligraphy of the Six Dynasties', *T'oung Pao*, LXX (1984), pp. 247–78; *idem*, 'The Earthly Paradise: Religious Elements in Chinese Landscape Art' in *Theories of the Arts in China*, eds Susan Bush and Christian Murck (Princeton, 1983), pp. 164–83; and Audrey Spiro, 'New Light on Gu Kaizhi', *Journal of Chinese Religions*, XVI (1988), pp. 1-17.

49 Robinet, 'Taoist Insight Meditation', p. 196. Isabelle Robinet, *Taoist Meditation: The Mao-shan Tradition of Great Purity*, trans. Julian F. Pas and Norman J. Girardot, Foreword Norman J. Girardot, New Afterword Isabelle Robinet. SUNY Series in Chinese Philosophy and Culture (Albany, 1993), pp. 60, p. 29.

50 Kotatsu Fujita (trans. Kenneth K. Tanaka), 'The Textual Origins of the *Kuan Wu-liang shou ching*: a Canonical Scripture of Pure Land Buddhism' in *Chinese Buddhist Apocrypha*, ed. Robert E. Buswell Jr (Honolulu, 1990), pp. 149–73. For a translation, see *The Sutra of Contemplation on the Buddha of Immeasurable Life, as Expounded by Sakyamuni Buddha*, trans. and Annotated Ryokoku University Translation Center under the direction of Meiji Yamada (Kyoto, 1984).

51 Ch'un-fang Yü, *The Renewal of Buddhism in China: Chu-hung and the Late Ming Synthesis* (New York, 1981), pp. 199, 221.

52 Gao Lian, *Yan nian que bing jian* (Chengdu, 1985), p. 36.

53 Ibid., pp. 33–4. On the *Zhen gao* as visualization text, see Michel Strickmann, 'On the Alchemy of T'ao Hung-ching' in *Facets of Taoism: Essays in Chinese Religion*, eds Holmes Welch and Anna Seidel (New Haven and London, 1979), pp. 123–92 (p. 128). On the pervasiveness of Daoist practices in the Ming élite, see Liu Ts'un-yan, 'The Penetration of Taoism into the Ming Neo-Confucian Elite', *T'oung Pao*, LVII (1971), pp. 31–102.

54 Shigehisa Kuriyama, 'Visual Knowledge in Clasical Chinese Medicine' in *Knowledge and the Scholarly Medical Traditions*, ed. Don Bates (Cambridge, 1995), pp. 205–34 (p. 218).

55 Chen Naiqian, *Shiming biehao suoyin*, enlarged and revised edn (Beijing, 1982).

56 Robinet, *Taoist Meditation*, p. 164.

57 Kuriyama, 'Visual Knowledge', pp. 205–34 (p. 208). The following discussion depends entirely on this extremely important and suggestive article.

58 Chen Quanzhi, *Lian chuang ri lu*, 8 *juan*. Shanghai shudian facsimile of Jiajing period edn, 2 vols (Shanghai, 1985), II, *juan* 5, p. 9b.

59 Vinograd, *Boundaries of the Self*, p. 15, citing Jiang Ji's *Secrets of Portraiture* (*c*.1700).

60 *Yuan jian lei han, juan* 259, p. 4a. On the 'five colours', see Kuriyama, 'Visual Knowledge', pp. 210–12.

period, and the connection between them merits further study within the field of hermeneutics. David L. Rolston, *How to Read the Chinese Novel* (Princeton, 1990).

61 Joseph Needham with the collaboration of Wang Ling, and the special co-operation of Kenneth Girdwood Robinson, *Science and Civilization in China*, IV. *Physics and Physical Technology*, part I. *Physics* (Cambridge, 1962), p. 3.

62 Ibid., IV.I, p. 117.

63 A.C. Graham and Nathan Sivin, 'A Systematic Approach to the Mohist Optics (ca. 300 B.C.)' in *Chinese Science: Explorations of an Ancient Tradition*, eds Shigeru Nakayama and Nathan Sivin (Cambridge, MA and London, 1973), pp. 105–52.

64 Anne Burkus-Chasson, ' "Clouds and Mists that Emanate and Sink Away". Shitao's *Waterfall on Mount Lu* and practices of observation in the seventeenth century', *Art History*, XIX/2 (1996), pp. 168–90.

65 Ibid., p. 171.

66 Quoted in ibid., p. 184.

67 Translation in Herbert A. Giles, *Strange Tales from a Chinese Studio* (New York, 1969), pp. 3–5; Chinese text in Pu Songling, *[Quanben xin zhu] Liao zhai zhi yi*. Renmin wenxue chubanshe edn, 2 vols (Beijing, 1989), I, pp. 11–12.

68 George Steiner, *After Babel: Aspects of Language and Translation* (Oxford, 1972), p. 102, cites evidence for the connection between the pupil of the eye and a small child in Latin (*pupilla*), Chinese (*tong*), Swahili, Lapp and Samoan.

69 Wang Jinguang and Hong Zhenhuan, *Zhongguo guangxue shi* (Changsha, 1986), pp. 157–9.

70 Lang Ying, *Qixiu lei gao*, II, p. 836; Needham, *Science and Civilization in China*, IV.I, pp. 119–21, discusses the likelihood of transmission from the Islamic world, as well as the possible use of magnifying lenses in China at an earlier date.

71 Otto Durham Rasmussen, *Chinese Eyesight and Spectacles*, 4th revision (Tonbridge Wells, 1949), pp. 34–5. The scholarly credentials of this rare work are not beyond reproach, and it abounds with 'explanations' for the prevalence of myopia in China which depend on racial sterotypes.

72 Wang Jinguang and Hong Zhenhuan, p. 159.

73 Joseph Needham with the collaboration of Wang Ling, *Science and Civilization in China*, III. *Mathematics and the Sciences of the Heavens and the Earth* (Cambridge, 1959), pp. 443–4.

74 Burkus-Chasson, 'Clouds and Mist', p. 185.

75 Wang Jinguang and Hong Zhenhuan, p. 168, Needham, *Science and Civilization in China*, IV.I, pp. 123–4.

76 Don Bates, 'Scholarly ways of Knowing: an Introduction' in *Knowledge and the Scholarly Medical Traditions*, ed. Don Bates (Cambridge, 1995), pp. 1–22 (p. 1).

77 Roger T. Ames, 'Meaning as Imaging: Prologomena to a Confucian Epistemology' in *Culture and Modernity*, ed. Eliot Deutsch (Honolulu, 1990), pp. 227–44.

78 Ibid., p. 239.

79 Farquhar argues intriguingly for an understanding of the contemporary Chinese medical practitioner as connoisseur in Bates, 'Scholarly ways of Knowing', p. 19, n. 44, and develops these ideas together with James L. Hevia in 'Culture and Postwar American Historiography of China', *positions: east asia cultures critique*, I/2 (1993), pp. 486–525.

5 *The Work of Art in the Age of Woodblock Reproduction*

1 Susan Bush and Hsio-yen Shih, *Early Chinese Texts on Painting*, pp. 62–3; Yu Feian, *Chinese Painting Colours*, trans. Jerome Silbergeld and Amy McNair (Hong, Kong, 1988).

2 Kuriyama, 'Visual Knowledge', pp. 205–34 (p. 210).

3 Lang Ying, *Qi xiu lei gao*, I, p. 225.

4 What follows depends on Kuriyama, 'Visual Knowledge', pp. 214–17.

5 James Cahill, *The Painter's Practice*, p. 107.

6 See Bush and Shih, *Early Chinese Texts on Painting*, pp. 272–88, for translations of some of the Yuan Dynasty texts on these two subjects. The latter is now the subject of an important monograph by Maggie Bickford, *Ink Plum: The Making of a Chinese Scholar-Painting Genre* (Cambridge, 1996).

7 Maggie Bickford, 'Stirring the Pot of State: the Sung Picture-Book *Mei-Hua Hsi-Shen P'u* and its implications for Yuan Scholar-Painting', *Asia Major*, 3rd series, VI/2 (1993), pp. 169–225.

8 Ibid., p. 225; *Luofu huan zhi* is reproduced in Yang Jialuo, *Yishu congbian* (Taibei, 1975), I, along with the other *Yi men guang du* manuals by the same author: *Jiu wan yi rong* (epidendrum), *Qi yuan xiao ying* (bamboo), *Chun gu ying xiang* (birds and insects) and *Tian xing dao mao* (human figures). On *Yi men guang du*, see Du Xinfu, *Mingdai banke zonglu*, IV, p. 10a.

9 Du Xinfu, *Mingdai banke zonglu*, I, p. 11a; II, p. 10a. I do not pretend to have unravelled the question of the relationship between these two editions. See also Xia Wei, 'The Huizhou Style of Woodcut Illustration', *Orientations*, XXV/1 (1994), pp. 61–6 (p. 63). For the catalogue of a major exhibition of these texts, see *Kinsei Nihon kaiga to gafu; etehon-ten*, 2 vols (Machida: City Museum of Graphic Arts, 1990).

10 On this text, see Tadao Sakai, 'Confucianism and Popular Educational Works', pp. 332, 334.

11 The only extensive study of the text is Michela Bussotti, 'The *Gushi huapu*, a Ming Dinasty [*sic*] Wood-Block Printing Masterpiece in the Naples National Library' in *Ming Qing yanjiu*, ed. Paolo Santangelo (Naples and Rome, 1995), pp. 11–44. I am grateful to Jonathan Hay for drawing my attention to this piece.

12 See Gu Bing, *Gu shi hua pu*. Wenwu chubanshe edn (Beijing, 1983), which reproduces the copy in the library of Beijing University. The text also circulates as *Lidai minggong huapu*, given according to Bussotti to the second Ming edition of 1613 (or possibly 1619).

13 Jiang Shaoshu, *Wu sheng shi shi*, p. 57.

14 Bussotti, 'The *Gushi huapu*', p. 25.

15 Du Xinfu, *Mingdai barke zonglu*, VII, p. 20.

16 Bussotti, 'The *Gushi huapu*', p. 25. Zhu Zhifan has a biography in Jiang Shaoshu, *Wu sheng shi shi, juan* 4, p. 65, where it is remarked upon that he was the only Ming *zhuangyuan*, or highest-placed *jinshi* graduate, to paint. His other claim to fame is the huge fortune he acquired on a diplomatic mission to Korea in 1605, by trading his own brushwork for lucrative furs and ginseng. Zhou Lasheng, *Mingdai zhuangyuan qi tan: Mingdai zhuangyuan pu* (Beijing, 1993), p. 226.

17 Deborah Del Gais Muller, 'Hsia Wen-yen and His *T'u-hui pao-chien (Precious Mirror of Painting)*', Ars Orientalis, XVIII (1988), pp. 131–50.

18 Richard Vinograd, 'Private Art and Public Knowledge in Later Chinese Painting' in *Images of Memory, on Remembering and Representation*, eds Susan Küchler and Walter Melion (London and Washington, 1991), pp. 176–202.

19 Wen Zhenheng, *Zhang wu zhi jiao zhu*, p. 141, set against the admission on p. 151 that, 'The ancient works of remote antiquity, I am unable to discuss comprehensively . . .'.

20 Zheng Yinshu, *Xiang Yuanbian zhi shuhua shoucang yu yishu*. Yishu congkan 3 (Taibei, 1984), pp. 140–1.

21 Joan Stanley-Baker, 'Forgeries in Chinese Painting', *Oriental Art*, n.s., XXXII (1986), 54–66 (p. 57).

22 Craig Clunas, 'An Authentic Fake Chinese Painting', *Apollo*, CXXXI (1990), 177–8.

23 Both pictures are reproduced in Craig Clunas, *Art in China* (Oxford, 1997), pls 76, 98. Bussotti, 'The *Gushi huapu*', p. 29, gives another example.

24 Li Kaixian, *Zhong yue hua pin* in *Mingren huaxue lunzhu*, ed. Yang Jialuo. Yishu congbian, *juan* 1, p. 48; *juan* 5, p. 57.

25 Based on Wen Zhenheng, *Zhang wu zhi jiao zhu*, pp. 152–3, the section entitled 'Famous artists' (*Ming jia*).

26 Ibid., p. 142. The modern editors make the assumption that this refers to sixteenth-century professionals such as Jiang Song and Zhang Lu, but the attack could equally be on the 'Songjiang School' of Mo Shilong, Dong Qichang *et al.* who had displaced the artistic hegemony of Suzhou and of the lineage represented by Wen's famous ancestors.

27 Susan Stewart, *On Longing*, p. 151.

28 Wai-kam Ho, *The Century of Tung Ch'i-ch'ang 1555–1636*, 2 vols (Kansas City, 1992), II, pp. 183–5.

29 Walter Benjamin, 'The Work of Art in the Age of Mechanical Reproduction' in Walter Benjamin, *Illuminations*, Introduction Hanna Arendt (London, 1992), pp. 211–35 (p. 215).

30 Craig Clunas, 'Luxury Knowledge: the *Xiushilu* ("Records of Lacquering") of 1595', *Techniques et cultures* (forthcoming).

6 *Fears of the Image*

1 Ch'un-fang Yü, *The Renewal of Buddhism in China: Chu-hung and the Late Ming Synthesis* (New York, 1981), p. 249.

2 Matteo Ricci, *China in the Sixteenth Century: The Journals of Matteo Ricci 1583–1610*, trans. Louis J. Gallagher S.J. (New York, 1953), p. 103.

3 Quoted in Wang Shaochuan, *Yuan Ming Qing san dai jinhui xiaoshuo xiqu shiliao*, p. 153.

4 Quoted in ibid., p. 178. Cynthia Brokaw, *The Ledgers of Merit and Demerit: Social Change and Moral Order in Late Imperial China* (Princeton, 1991), is the standard account of these texts, and of Yuan Huang.

5 He Liangjun, *Si you zhai cong shuo*, p. 258. For examples of erotic representation in ceramic tiles of the Han period, see Jessica Rawson, ed., *Mysteries of Ancient China* (London, 1996), pp. 201–3.

6 Lang Ying, *Qi xiu lei gao*, I, p. 381.

7 Shen Defu, *Wanli ye huo bian*. Yuan Ming shiliao biji congkan edn, 3 vols (Beijing, 1980), III, p. 659.

8 Li Xu, *Jiean lao ren man bi*. Yuan Ming shiliao biji congkan edn (Beijing, 1982), p. 39.

9 Ricci, *China in the Sixteenth Century*, p. 421.

10 Elizabeth Wichmann, *Listening to the Theatre: The Aural Dimensions of Beijing Opera* (Honolulu, 1991).

11 Quoted in Wang Shaochuan, *Yuan Ming Qing*, p. 175. The modern Chinese word for 'audience' is *guanzhong*.

12 Charlotte Furth, 'Rethinking Van Gulik: Sexuality and Reproduction in Traditional Chinese Medicine' in *Engendering China: Women, Culture and the State*, eds Christina K. Gilmartin, Gail Hershatter, Lisa Rofel and Tyrene White. Harvard Contemporary China Series 10 (Cambridge, MA and London, 1994), pp. 125–46 (p. 135).

13 Reproduced and discussed in Wen C. Fong and James C.Y. Watt, *Possessing the Past: Treasures from the National Palace Museum, Taipei* (New York, 1996), pp. 399–401.

14 Giovanni Vitiello, 'The Fantastic Journey of an Ugly Boy: Homosexuality and Salvation in Late Ming Pornography', *positions: east asia cultures critique*, IV/2 (1996), pp. 291–320 (p. 295).

15 Quoted in Yang Xin, 'Mingdai nü huajia yu chungonghua zhouyi', *Gugong bowuyuan yuankan*, no. 3 (1995), pp. 1–5 (p. 4).

16 Li Yu, *The Before Midnight Scholar*, trans. Richard Martin from the German by Franz Kuhn (London, 1974), p. 265.

17 Robert Darnton, *The Forbidden Best-Sellers of Pre-Revolutionary France* (New York, 1996), p. 88.

18 They are not with van Gulik's books in the Library of the Sinological Institute of Leiden University. On their acquisition, see Robert H. van Gulik, *Erotic Colour Prints of the Ming Dynasty. With an Essay on Chinese Sex Life from the Han to the Ch'ing Dynasty, B.C. 206–A.D.1644* (Tokyo, 1951), p. 1. This work, originally published as a private edition of fifty copies and in three volumes, has been reprinted in a single paperback volume without place or publisher. See also R.H. van Gulik, *Sexual Life in Ancient China: A Preliminary Survey of Chinese Sex and Society from ca. 1500 B.C. till 1644 A.D.* (Leiden, 1961); and *The Fragrant Flower: Chinese Classic Erotica in Art and Poetry, Hua Ying Jin Zhen*, trans. N.S. Wang and B.L. Wang (Buffalo, 1990), which reproduce all the pictures and translate the poems. The suggestion that van Gulik drew the pictures himself as a scholarly joke does not seem to me convincing; they are very different from the illustrations to his *Judge Dee* novels, and include scenes (notably the homoerotic) which he would have seen as 'perverse'. If they are modern fakes they are extraordinarily close in style to genuine Ming book illustrations.

19 *The Plum in the Golden Vase*, trans. David Tod Roy, pp. 271–2; *Jin Ping Mei cihua*, p. 208.

20 Roy, p. 516, n. 23; van Gulik, *Erotic Colour Prints*, pp. 177–185.

21 Li Yu, *The Before Midnight Scholar*, pp. 44–5.

22 Ibid., p. 54.

23 The growing literature includes Marsha Weidner, Ellen Johnston Laing, Irving Yucheng Lo, Christina Chu and James Robinson, *Views from Jade Terrace: Chinese Women Artists 1300–1912* (Indianapolis, 1988); Marsha Weidner, ed., *Flowering in the Shadows: Women in the History of Chinese and Japanese Art* (Honolulu, 1990); Tseng Yuho, 'Women Painters of the Ming Dynasty', *Artibis Asiae*, LIII (1993), pp. 249–60; and Yang Xin, 'Mingdai nü huajia'.

24 Translation by Irving Lo in Weidner *et al.*, *Views from Jade Terrace*, p. 76. The assertion there that Xue Mingyi was the son-in-law of the major Suzhou cultural landmark, Wen Zhengming (1470–1559) seems problematic given the disparity in their dates.

25 Roy, p. 26; *Jin Ping Mei cihua*, p. 49.

26 Dorothy Ko, *Teachers of the Inner Chambers: Women and Culture in 17th-Century China* (Stanford, 1994), pp. 172–6; for an example of 'Gu embroidery', see Craig Clunas, *Art in China*, pl. 100.

27 Roy, p. 132; *Jin Ping Mei cihua*, I, p. 123. Interestingly the illustrator did not follow the text to the letter, since it is clearly stated that the deity Guanyin is in the form of the 'Water Moon Guanyin' and is shown with her attendant Sudhana. That is not what the print shows.

28 Lévy, *Fleur en fiole d'or*, II, p. 211; *Jin Ping Mei cihua*, II, p. 384 (brothel): Lévy, *Fleur*, II, p. 893; *Jin Ping Mei cihua*, III, p. 249 (Jinlian's apartments).

29 Lévy, *Fleur*, II, p. 642; *Jin Ping Mei cihua*, III, p. 80.

30 Weidner *et al.*, *Views from Jade Terrace*, pp. 70–3.

31 Liu Ts'un-yan, *Chinese Popular Fiction in Two London Libraries* (Hong Kong, 1967), pp. 31, 168.

32 Martin Jay, *Downcast Eyes*, pp. 590–2.

33 Wu Hung, *The Double Screen*, p. 183.

34 Wen Zhenheng, *Zhang wu zhi jiao zhu*, pp. 243–4.

35 Ibid., p. 351.

36 Ibid., p. 272.

37 Ibid., p. 255.

38 Ibid., p. 249.

39 Lang Ying, *Qi xiu lei gao*, II, p. 740.

40 Richard Barnhart, 'Rediscovering an Old Theme in Ming Painting', fig 15 reproduces it from an old publication.

41 An important part of this project is the unpublished PhD dissertation by Scarlett Ju-yu Jang, 'Issues of Public Service in the Themes of Chinese Court Painting', University of California at Berkeley, 1989, which sheds much light on the subject matter of Ming painting at and beyond the court.

42 Zheng Yimei, 'Xu yan' in *Changyong diangu cidian*, eds Xu Chengzhi, Wang Guanghan and Yu Shi (Shanghai, 1985).

43 Anne Burkus-Chasson, 'Elegant or Common?', pp. 287–92.

44 For an interesting piece of prosopography, see Warren I. Cohen, *East Asian Art and American Culture* (New York, 1992), pp. 158–99.

45 Francis Haskell, *History and its Images: Art and the Interpretation of the Past* (New Haven and London, 1993), p. 387.

46 Jack Goody, *The Culture of Flowers* (Cambridge, 1993), pp. 232–53.

47 Lang Ying, *Qi xiu lei gao*, 11, p. 681.

48 Chen Quanzhi, *Lian chuang ri lu*, 11, *juan* 5, p. 4a.

7 Conclusion

1 A brief bibliography on the topic would have to include Paul Pelliot, 'La peinture et la gravure europeènnes en Chine au temps du Mathieu Ricci', *T'oung Pao*, xx (1921), pp. 1–18; Hsiang Ta, 'European Influences on Chinese Art in the Later Ming and Early Ch'ing Period' in *The Translation of Art: Essays on Chinese Painting and Poetry: Renditions No. 6*, ed. James C.Y. Watt (Hong Kong, 1976), pp. 152–78 (originally published in Chinese in 1930); Berthold Laufer, *Christian Art in China* (Peking, 1939); John E. McCall, 'Early Jesuit Art in the far East IV: In China and Macao Before 1635', *Artibus Asiae*, xi (1948), pp. 45–69; Johannes Bettray S.V.D., *Die Akkomodationsmethode des P. Matteo Ricci S.I. in China* (Rome, 1955); Michael Sullivan, 'Some Possible Sources of European Influence on Late Ming and Early Ch'ing Painting' in *Proceedings of the International Symposium on Chinese Painting: National Palace Museum Republic of China 18th–24th June 1970* (Taipei, 1972), pp. 595–625; and Harrie Vanderstappen S.V.D., 'Chinese Art and the Jesuits in Peking' in *East Meets West: The Jesuits in China, 1582–1773*, eds Charles E. Ronan S.J. and Bonnie B.C. Oh (Chicago, 1988), pp. 103–26. Much relevant material remains unpublished in Roman, Filipino and Iberian archives.

2 Sullivan, 'Some Possible Sources', p. 604.

3 In addition to Sullivan, see James Cahill, 'Late Ming Landscape Albums and European Printed Books' in *The Early Illustrated Book: Essays in Honor of Lessing J. Rosenwald*, ed. Sandra Hindman (Washington, 1982), pp. 150–71. The issue is also sensitively discussed in Howard L. Goodman and Anthony Grafton, 'Ricci', pp. 143–4.

4 Cordell D.K. Yee, 'Traditional Chinese Cartography and the Myth of Westernisation' in *The History of Cartography*, 11, bk 2. *Cartography in the Traditional East and Southeast Asian Societies*, eds J.B. Harley and David Woodward (Chicago, 1994), pp. 170–202 (pp. 174–5).

5 Craig Clunas, *Superfluous Things*, pp. 58–60.

6 Liu Tong and Yu Yizheng, *Di jing jing wu lüe*. Beijing guji chubanshe edn (Beijing, 1980), p. 166.

7 Ibid., pp. 152–4.

8 Edgren, *Chinese Rare Books in American Collection*, pp. 104–5.

9 The fullest account of the transaction is in Jonathan Spence, *The Memory Palace of Matteo Ricci* (London, 1985).

10 Ricci, pp. 155, 201.

11 Ibid., p. 372.

12 Ibid., pp. 375–6.

13 Quoted in Pelliot, 'La peinture et la gravure', pp. 9–10.

14 Goodman and Grafton, 'Ricci', p. 116.
15 Gu Qiyuan, *Ke zuo zhui yu*. Yuan Ming shiliao biji congkan edn (Beijing, 1987), pp. 193–4.
16 Jiang Shaoshu, *Wu sheng shi shi*, p. 133.
17 Wang Keyu, *Shan hu wang hua lu, juan* 42, pp. 42a–b.
18 Chaves, *Singing of the Source*, p. 71.
19 Bettray, *Die Akkomodationsmethode*, p. 53.
20 Ricci, pp. 107–8.
21 Sullivan, 'Some Possible Sources', p. 603.
22 Chaves, *Singing of the Source*, p. 134.
23 Ricci, pp. 459–60.
24 See Monique Cohen and Natalie Monnet, *Impressions de Chine*, p. 112, for the publishing details.
25 Nicholas Standaert, *Yang Tingyun, Confucian and Christian in Late Ming China: His Life and Thought* (Leiden, 1988), p. 123.
26 Lin Xiaoping, 'Wu Li's Religious Beliefs and *A Lake in Spring*', Archives of Asian Art, XL (1987), pp. 24–35. The picture is in the Shanghai Museum.
27 James Cahill, 'Types of Artist–Patron Transactions in Chinese Painting' in *Artists and Patrons: Some Social and Economic Aspects of Chinese Painting*, ed. Chu-tsing Li (Lawrence, 1989), pp. 7–20 (p. 8). In his note 1 (p. 19) Cahill draws attention to the unresolved question of the authorship of this text, contained in the anonymous manuscript *Shibaizhai shu hua* (*c*.1800), but stresses that it is the content not the authorship which is important to him. See Hin-cheung Lovell, *An Annotated Bibliography of Chinese Painting Catalogues and Related Texts*. Michigan Papers on Chinese Studies XVI (Ann Arbor, 1973), pp. 64–5, for a discussion of the text's history.
28 James Cahill, *Three Alternative Histories of Chinese Painting*.
29 Andrew H. Plaks, 'Allegory in *Hsi-yu chi* and *Hung-lou meng*' in *Chinese Narrative: Critical and Theoretical Essays*, ed. Andrew H. Plaks (Princeton, 1977), pp. 163–202 (p. 169). Plaks first developed these terms in *Archetype and Allegory in the Dream of the Red Chamber* (1976).
30 Yee, 'Traditional Chinese Cartography', p. 153.
31 For example, Shen Zhou's inscription on his 'Ten Thousand Miles along the Yangtze River' in *Yu ding li dai ti hua shi lei*, 120 *juan*, ed. Chen Bangyan. *Qin ding si ku quan shu* edn, reprinted *Taiwan shangwu yinshuguan*, 1435–6 *ce* (Taibei, 1983), *juan* 6 *mulu*, p. 2b.
32 Richard Vinograd, 'Family Properties', pp. 1–29.
33 Wai-kam Ho, 'The Literary Concepts', p. 361.
34 John Hay, 'Boundaries and Surfaces of Self and Desire in Yuan Painting' in *Boundaries in China*, ed. John Hay (London, 1994), pp. 124–70.
35 Peter Wagner, *Reading Iconotexts: From Swift to the French Revolution* (London, 1995).
36 Margaret Iversen, 'Vicissitudes of the visual sign', *Word & Image*, VI/4 (1990), pp. 212–16.
37 Svetlana Alpers, *The Making of Rubens* (New Haven and London, 1995), p. 76.
38 Martin Jay, *Downcast Eyes*, p. 51.
39 Ibid., p. 62.

Bibliography

15th-Century Illustrated Chinese Primer, Hsin-pien tui-hsiang ssu-yen, facsimile reproduction with Introduction and Notes L. Carrington Goodrich (Hong Kong, n.d.).

Svetlana Alpers, *The Making of Rubens* (New Haven and London, 1995).

Roger T. Ames, 'Meaning as Imaging: Prologomena to a Confucian Epistemology' in *Culture and Modernity*, ed. Eliot Deutsch (Honolulu, 1990), pp. 227–44.

Anon., *The Fragrant Flower: Chinese Classic Erotica in Art and Poetry, Hua Ying Jin Zhen*, trans. N.S. Wang and B.L. Wang (Buffalo, 1990).

Richard Barnhart, 'Survivals, Revivals, and the Classical Tradition of Chinese Figure Painting' in *Proceedings of the International Symposium on Chinese Painting: National Palace Museum Republic of China 18th–24th June 1970* (Taipei, 1972), pp. 143–210.

——— 'The "Wild and Heterodox School" of Ming Painting' in *Theories of the Arts in China*, eds Susan Bush and Christian Murck (Princeton, 1983), pp. 365–96.

——— *Painters of the Great Ming: The Imperial Court and the Zhe School* (Dallas, 1993).

——— 'Rediscovering an Old Theme in Ming Painting', *Orientations*, XXVI/8 (1995), pp. 52–61.

John Barrow, *Travels in China* (London, 1804).

Don Bates, 'Scholarly Ways of Knowing: An Introduction' in *Knowledge and the Scholarly Medical Traditions*, ed. Don Bates (Cambridge, 1995), pp. 1–22.

Walter Benjamin, 'The Work of Art in the Age of Mechanical Reproduction' in Walter Benjamin, *Illuminations*, Introduction Hanna Arendt (London, 1992), pp. 211–35.

Johannes Bettray S.V.D., *Die Akkomodationsmethode des P. Matteo Ricci S.I. in China*. Analecta Gregoriana 76 Series Facultatis Missiologicae, sectio B.1 (Rome, 1955).

Homi Bhabha, *The Location of Culture* (London, 1994).

Maggie Bickford, 'Stirring the Pot of State: the Sung Picture-Book *Mei-Hua Hsi-Shen P'u* and its Implications for Yuan Scholar-Painting', *Asia Major*, 3rd series, VI/2 (1993), pp. 169–225.

——— *Ink Plum: The Making of a Chinese Scholar-Painting Genre* (Cambridge, 1996).

Judith M. Boltz, *A Survey of Taoist Literature: Tenth to Seventeenth Centuries*. University of California Berkeley Center for Chinese Studies Research Monographs, 32 (Berkeley, 1987).

Cynthia Brokaw, *The Ledgers of Merit and Demerit: Social Change and Moral Order in Late Imperial China* (Princeton, 1991).

Timothy Brook, *Praying for Power: Buddhism and the Formation of Gentry Society in Late Ming China*. Harvard–Yenching Institute Monograph Series, 38 (Cambridge, MA and London, 1993).

——— 'Edifying Knowledge: the Building of School Libraries in the Ming', *Late Imperial China*, XVII/1 (1996), pp. 88–114.

Norman Bryson, *Vision and Painting: The Logic of the Gaze* (New Haven, 1983).

Norman Bryson, Michael Ann Holly and Keith Moxey, eds, *Visual Culture: Images and Interpretations* (Hannover, 1994), pp. xv–xxix (p. xv).

Anne Burkus-Chasson, 'Elegant or Common? Chen Hongshou's Birthday Presentation Pictures and his Professional Status', *Art Bulletin*, XXVI/2 (1994), pp. 279–300.

—— ' "Clouds and Mists that Emanate and Sink Away": Shitao's *Waterfall on Mount Lu* and Practices of Observation in the Seventeenth Century', *Art History*, XIX/2 (1996), pp. 168–90.

Susan Bush and Hsio-yen Shih, *Early Chinese Texts on Painting* (Cambridge, MA and London, 1985).

Michela Bussotti, 'The *Gushi huapu*, a Ming Dinasty [sic] Wood-Block Printing Masterpiece in the Naples National Library' in *Ming Qing yanjiu*, ed. Paolo Santangelo (Naples and Rome, 1995), pp. 11–44.

James Cahill, *The Restless Landscape: Chinese Painting of the Late Ming Period* (Berkeley, 1971).

—— *Parting at the Shore: Chinese Painting of the Early and Middle Ming Dynasty, 1368–1580* (Tokyo, 1978).

—— 'Late Ming Landscape Albums and European Printed Books' in *The Early Illustrated Book: Essays in Honor of Lessing J. Rosenwald*, ed. Sandra Hindman (Washington, 1982), pp. 150–71.

—— *Three Alternative Histories of Chinese Painting*. The Franklin D. Murphy Lectures IX (Lawrence, 1988).

—— 'Types of Artist–Patron Transactions in Chinese Painting' in *Artists and Patrons: Some Social and Economic Aspects of Chinese Painting*, ed. Chu-tsing Li (Lawrence, 1989), pp. 7–20.

—— *The Painter's Practice: How Artists Lived and Worked in Traditional China* (New York, 1994).

Katherine Carlitz, 'The Social Uses of Female Virtue in Late Ming Editions of "Lienü zhuan" ', *Late Imperial China,* XII/2 (1991), pp. 117–52.

Roger Chartier, *The Cultural Uses of Print in Early Modern France*, trans. Lydia G. Cochrane (Princeton, 1987), p. 3, 6–7.

—— *Cultural History: Between Practices and Representations,* trans. Lydia G. Cochrane (Cambridge, 1988).

Jonathan Chaves, *Singing of the Source: Nature and God in the Poetry of the Chinese Painter Wu Li*. SHARPS Library of Translations (Honolulu, 1993).

Chen Bangyan, ed., *Yu ding li dai ti hua shi lei*, 120 *juan*, *Qin ding si ku quan shu* edn, reprinted Taiwan shangwu yinshuguan, 1435–6 ce (Taibei, 1983).

Chen Naiquan, *Shiming biehao suoyin*, enlarged and revised edn (Beijing, 1982).

Chen Quanzhi, *Lian chuang ri lu*, 8 *juan*. Shanghai shudian facsimile edn, 2 vols (Shanghai, 1985).

Ch'ien Chung-shu, 'China in the English Literature of the Seventeenth Century', *Quarterly Journal of Chinese Bibliography* (1940), I, pp. 351–84.

Chinese and Associated Lacquer from the Garner Collection (London: British Museum, 1973).

Chu Hsi's Family Rituals, trans., Annotation and Introduction Patricia Buckley Ebrey. Princeton Library of Asian Translations (Princeton, 1991), p. 58.

Chūgoku kōdai hanga-ten (Machida: Machida City Museum of Graphic Arts, 1988).

Chūgoku no raden/Exhibition of Mother-of-Pearl Inlay in Chinese Lacquer Art (Tokyo: Tokyo National Museum, 1979).

Kenneth Clark, *Landscape into Art* (Harmondsworth, repr. 1966).

Craig Clunas, 'The West Chamber: A Literary Theme in Chinese Porcelain Decoration', *Transactions of the Oriental Ceramic Society*, XLVI (1981–2), pp. 69–86.

—— 'Human Figures in the Decoration of Ming Lacquer', *Oriental Art*, n.s., XXXII (1986), pp. 177–88.

—— 'Books and Things: Ming Literary Culture and Material Culture' in *Chinese Studies*, ed. Frances Wood. British Library Occasional Papers 10 (London, 1988), pp. 136–43.

—— *Chinese Furniture*. V&A Far Eastern Series (London, 1988).
—— 'An Authentic Fake Chinese Painting', *Apollo*, CXXXI (1990), pp. 177–8.
—— *Superfluous Things: Material Culture and Social Status in Early Modern China* (Cambridge, 1991).
—— *Fruitful Sites: Garden Culture in Ming Dynasty China* (London, 1996).
—— *Art in China* (Oxford, 1997).
—— 'Luxury Knowledge: the *Xiushilu* ("Records of Lacquering") of 1595', *Techniques et Cultures* (forthcoming).
Monique Cohen and Nathalie Monnet, *Impressions de Chine* (Paris: Bibliothèque nationale, 1992).
Warren I. Cohen, *East Asian Art and American Culture* (New York, 1992).
Robert Darnton, *The Forbidden Best-Sellers of Pre-Revolutionary France* (New York, 1996).
Deborah Del Gais Muller, 'Hsia Wen-yen and His *T'u-hui pao-chien* (*Precious Mirror of Painting*)', *Ars Orientalis*, XVIII (1988), pp. 131–50.
Vishaka N. Desai and Denise Patry Leidy, *Faces of Asia: Portraits from the Permanent Collection* (Boston: Boston Museum of Fine Arts, 1989).
Du Xinfu, *Mingdai banke zonglu*, 8 vols (Yangzhou, 1983).
Eamon Duffy, *The Stripping of the Altars: Traditional Religion in England 1400–1580* (New Haven, 1992).
Sören Edgren, *Chinese Rare Books in American Collections* (New York: China Institute, 1985).
Richard Edwards, 'Shen Chou' in *Dictionary of Ming Biography 1368–1644*, eds L. Carrington Goodrich and Chaoying Fang (New York and London, 1976), pp. 1173–7.
Elizabeth L. Eisenstein, *The Printing Revolution in Early Modern Europe* (Cambridge, 1983).
Benjamin A. Elman, *From Philosophy to Philology: Intellectual and Social Aspects of Change in Late Imperial China*. Harvard East Asian Monographs 10 (Cambridge MA, 1984).
Fang Zhimin, ed., *Ming kan Xi xiang ji quan tu* (Shanghai, 1983).
Judith B. Farquhar and James L. Hevia, 'Culture and Postwar American Historiography of China', *positions: east asia cultures critique*, 1/2 (1993), pp. 486–525.
Feng Huimin and Li Wanjian, eds, *Mingdai shumu tiba congkan*, 2 vols (Beijing, 1994).
Mary H. Fong, 'The Iconography of the Popular Gods of Happiness, Emolument and Longevity (*Fu Lu Shou*)', *Artibus Asiae*, XLIV (1983), pp. 159–98.
—— 'Wu Daozi's Legacy in the Popular Door Gods (*Menshen*) Qin Shubao and Yuchi Gong', *Archives of Asian Art*, XVII (1989), pp. 6–24.
Wen C. Fong, *Beyond Representation: Chinese Painting and Calligraphy 8th–14th Century*. Princeton Monographs in Art and Archaeology 48 (New York, 1992).
Wen C. Fong and James C. Y. Watt, *Possessing the Past: Treasures from the National Palace Museum, Taipei* (New York, 1996).
Hal Foster, *Vision and Visuality* (Seattle, 1988).
Fu Xihua, ed., *Zhongguo gudian wenxue banhua xuanji*, 2 vols (Shanghai, 1981).
Charlotte Furth, 'Rethinking Van Gulik: Sexuality and Reproduction in Traditional Chinese Medicine' in *Engendering China: Women, Culture and the State*, eds Christina K. Gilmartin, Gail Hershatter, Lisa Rofel and Tyrene White. Harvard Contemporary China Series 10 (Cambridge, MA and London, 1994), pp. 125–46.
Gao Lian, *Yan nian que bing jian* (Chengdu, 1985).
Gao Ru, *Baichuan shu zhi*. Gudian wenxue chubanshe edn (Beijing, 1957).
Ivan Gaskell, 'History of Images' in *New Perspectives on Historical Writing*, ed. Peter Burke (Cambridge, 1991), pp. 168–92.
Carlo Ginzburg, 'Titian, Ovid and Sixteenth-Century Codes for Erotic Illustration' in *Myths, Emblems, Clues*, ed. Carlo Ginzburg (London, 1990).
Howard L. Goodman and Anthony Grafton, 'Ricci, the Chinese and the Toolkits of the Textualists', *Asia Major*, 3rd series, II/2 (1990–1), pp. 95–148.
Gu Bing, *Gu shi hua pu*. Wenwu chubanshe edn (Beijing, 1983).

Gu Qiyuan, *Ke zuo zhui yu*. Yuan Ming shiliao biji congkan edn (Beijing, 1987).

Gui Youguang, *Zhenchuan xiansheng ji*. Zhongguo gudian wenxue congshu, Shanghai guji chubanshe edn, 2 vols (Shanghai, 1981).

R. Kent Guy, *The Emperor's Four Treasuries: Scholars and the State in the Late Ch'ien-lung Era*. Harvard East Asian Monographs 129 (Cambridge, MA, 1987).

Joanna F. Handlin, 'Lü Kun's New Audience: the Influence of Women's Literacy on Sixteenth-Century Thought' in *Women in Chinese Society*, eds Margery Wolf and Roxane Witke (Stanford, 1975), pp. 13–38.

J. B. Harley and David Woodward, eds, *The History of Cartography*, II, bk 2. *Cartography in the Traditional East and Southeast Asian Societies* (Chicago, 1994).

Francis Haskell, *History and its Images: Art and the Interpretation of the Past* (New Haven and London, 1993).

John Hay, 'Boundaries and Surfaces of Self and Desire in Yuan Painting' in *Boundaries in China*, ed. John Hay (London, 1994), pp. 124–70.

He Liangjun, *Si you zhai cong shuo*. Yuan Ming biji shiliao congkan edn (Beijing, 1983).

John B. Henderson, 'Chinese Cosmographical Thought: the High Intellectual Tradition' in *The History of Cartography*, II, bk 2. *Cartography in the Traditional East and Southeast Asian Societies*, eds J. B. Harley and D. Woodward (Chicago, 1994), pp. 203–27.

Wai-kam Ho, 'The Literary Concepts of "Picture-Like" (*Ju-hua*) and "Picture-Idea" (*Hua-I*) in the Relationship Between Poetry and Painting' in *Words and Images: Chinese Poetry, Painting and Calligraphy*, eds Alfreda Murck and Wen C. Fong (New York, 1991), pp. 353–404.

—— *The Century of Tung Ch'i-ch'ang (1555–1636)*, 2 vols (Kansas City, 1992).

Dawn Ho Delbanco, 'The Romance of the West Chamber: Min Qiji's Album in Cologne', *Orientations*, XIV/6 (1983), pp. 12–23.

Hsiang Ta, 'European Influences on Chinese Art in the Later Ming and Early Ch'ing Period' in *The Translation of Art: Essays on Chinese Painting and Poetry: Renditions No. 6*, ed. James C. Y. Watt (Hong Kong, 1976), pp. 152–78.

Margaret Iversen, 'Vicissitudes of the visual sign', *Word & Image*, VI/4 (1990), pp. 212–16.

Scarlett Ju-yu Jang, 'Issues of Public Service in the Themes of Chinese Court Painting', unpublished PhD dissertation, University of California at Berkeley, 1989.

Martin Jay, *Downcast Eyes: The Denigration of Vision in Twentieth-Century French Thought* (Berkeley and Los Angeles, 1994).

Jiang Shaoshu, *Wu sheng shi shi*. Hua shi congshu edn (Shanghai, 1982).

Jin ping mei cihua. Zengnizhi wenhua shiye gongsi edn (Taibei, 1980–1).

Paul Katz, 'The Function of Temple Murals in Imperial China: the Case of the Yung-lo Kung', *Journal of Chinese Religions*, XXI (Fall 1993), pp. 45–68.

Ladislav Kesner Jr, 'Memory, Likeness and Identity in Chinese Ancestor Portraits', *Bulletin of the National Gallery in Prague*, III–IV (1993–4), pp. 4–15.

Kinsei Nihon kaiga to gafu; etehon-ten, 2 vols (Machida: Machida City Museum of Graphic Arts, 1990).

Dorothy Ko, *Teachers of the Inner Chambers: Women and Culture in 17th-Century China* (Stanford, 1994).

Hiromitsu Kobayashi and Samantha Sabin, 'The Great Age of Anhui Printing' in *Shadows of Mt Huang: Chinese Painting and Printing of the Anhui School*, ed. James Cahill (Berkeley, 1981), pp. 25–33 (pp. 26–8).

Livia Kohn, 'A Textbook of Physiognomy: the Tradition of the *Shenxiang quanbian*', *Asian Folklore Studies*, XLV/2 (1986), pp. 227–58.

Kotatsu Fujita (trans. Kenneth K. Tanaka), 'The Textual Origins of the *Kuan Wu-liang shou ching*: a Canonical Scripture of Pure Land Buddhism' in *Chinese Buddhist Apocrypha*, ed. Robert E. Buswell Jr (Honolulu, 1990), pp. 149–73.

Shigehisa Kuriyama, 'Visual Knowledge in Classical Chinese Medicine' in *Knowledge and the Scholarly Medical Traditions*, ed. Don Bates (Cambridge, 1995), pp. 205–34.

Michael Lackner, 'Die "Verplanung" des Denkens am Beispiel der *T'u*' in *Lebenswelt und*

Weltanschauung im Fruhneuzeitlichen China, ed. Helwig Schmidt-Glintzer (Stuttgart, 1990), pp. 133–56.

—— 'Argumentation par diagrammes: une architecture a base de mots. Le *Ximing* (l'*Inscription Occidentale*) depuis Zhang Zai jusqu'au *Yanjitu*', *Extrême-Orient–Extrême Occident*, XIV (1992), pp. 131–68.

Lai Zhide, *Yi jing Lai zhu tu jie*, ed. Zheng Can. Ba shu shu she edn (Chengdu, 1988).

Ellen Johnston Laing, 'Ch'iu Ying's Three Patrons', *Ming Studies*, VIII (1979), pp. 51–2.

—— 'Sixteenth-Century Patterns of Art Patronage: Qiu Ying and the Xiang Family', *Journal of the American Oriental Society*, CXI/1 (1991), pp. 1–7.

Lang Ying, *Qi xiu lei gao*. Du shu zha ji dier ji, Shijie shuju edn, 2 vols (Taibei, 1984).

Berthold Laufer, *Christian Art in China* (Peking, 1939).

Lothar Ledderose, 'The Earthly Paradise: Religious Elements in early Chinese Landscape Art' in *Theories of the Arts in China*, eds Susan Bush and Christian Murck (Princeton, 1983), pp. 164–83.

—— 'Some Taoist Elements in the Calligraphy of the Six Dynasties', *T'oung Pao*, LXX (1984), pp. 247–78.

Peter H. Lee, *A Korean Storyteller's Miscellany: The 'P'aegwan chapki' of Ŏ Sukkwon* (Princeton, 1989).

André Lévy, *Fleur en fiole d'or (Jin ping mei cihua)*, 2 vols (Paris, 1985).

Chu-tsing Li and James C.Y. Watt, eds, *Art from the Scholar's Studio: Artistic Life in the Late Ming Period* (New York, 1987).

Li Kaixian, *Zhong yue hua pin*, in *Mingren huaxue lunzhu*, ed. Yang Jialuo. Yishu congbian 1:10 (Taibei, 1975).

Wai-yee Li, 'The Collector, the Connoisseur and Late-Ming Sensibility', *T'oung Pao*, LXXXI (1995), pp. 269–302.

Li Xu, *Jiean lao ren man bi*. Yuan Ming shiliao biji congkan edn (Beijing, 1982).

Li Yu, *The Before Midnight Scholar*, trans. Richard Martin from the German by Franz Kühn (London, 1974), p. 265.

Li Zhizhong, *Lidai keshu kaoshu* (Chengdu, 1990).

Lin Xiaoping, 'Wu Li's Religious Beliefs and *A Lake in Spring*', *Archives of Asian Art*, XL (1987), pp. 24–35.

Kathlyn Maurean Liscomb, *Learning from Mount Hua: A Chinese Physician's Illustrated Travel Record and Painting Theory*. Res Monographs on Anthropology and Aesthetics (Cambridge, 1993).

Stephen Little, 'Dimensions of a Portrait: Du Jin's *The Poet Lin Bu Walking in the Moonlight*', *Bulletin of the Cleveland Museum of Art*, LXXV/9 (1988), pp. 331–51.

Liu Tong and Yu Yizheng, *Di jing jing wu lüe*. Beijing guji chubanshe edn (Beijing, 1980).

Liu Ts'un-yan, *Chinese Popular Fiction in Two London Libraries* (Hong Kong, 1967).

—— 'The Penetration of Taoism into the Ming Neo-Confucian Elite', *T'oung Pao*, LVII (1971), pp. 31–102.

John E. McCall, 'Early Jesuit Art in the Far East IV: In China and Macao Before 1635', *Artibus Asiae*, XI (1948), pp. 45–69.

Anne E. McLaren, 'Chantefables and the Textual Evolution of the San-kuo-chih yen-i', *T'oung Pao*, LXXI (1985), pp. 159–227.

—— 'The Discovery of Chinese Chantefable Narratives from the Fifteenth Century: a Reassessment of their Likely Audience', *Ming Studies*, XXIX (1990), pp. 1–29.

—— Ming Audiences and Vernacular Hermeneutics: the Uses of the *Romance of the Three Kingdoms*', *T'oung Pao*, LXXXI (1995), pp. 51–80.

Hin-cheung Lovell, *An Annotated Bibliography of Chinese Painting Catalogues and Related Texts*. Michigan Papers in Chinese Studies XVI (Ann Arbor, 1973).

Victor H. Mair, 'Language and Ideology in the Written Popularisations of the *Sacred Edict*' in *Popular Culture in Late Imperial China*, eds David Johnson, Andrew J. Nathan and Evelyn S. Rawski (Berkeley, 1985), pp. 325–59.

—— *Painting and Performance: Chinese Picture Recitation and its Indian Genesis* (Honolulu, 1988).

Mao Yixiang, *Hui miao*, 1 *juan*, in *Yishu congbian* 1 *ji*, 12 *ce*, *Mingren huaxue lunzhu*, ed. Yang Jialuo, 2 vols (Taibei, 1975).

John Meskill, *Gentlemanly Interests and Wealth on the Yangtze Delta*. Association for Asian Studies Monograph and Occasional Paper Series, no. 49 (Ann Arbor, 1994).

J. V. Mills, 'Chinese Coastal Maps', *Imago Mundi*, 11 (1954), pp. 151–68.

Min Ze, 'Lun Jin Wei zhi Tang guanyu yishi yingxiang de renshi' in *Xingxiang, yixiang, qinggan* (Shijiazhuang, 1987), pp. 29–53.

Frederick Mote and Hung-lam Chu, *Calligraphy and the East Asian Book*, ed. Howard Goodman (Boston and Shaftesbury, 1989).

Mu Xueyong, ed., *Jian'ge Jueyuansi Mingdai Fo zhuan bihua* (Beijing, 1993).

Julia K. Murray, 'The Temple of Confucius and Pictorial Biographies of the Sage', *Journal of Asian Studies*, LV /2 (1996), pp. 269–300.

Joseph Needham, with the collaboration of Wang Ling, *Science and Civilization in China*, III. *Mathematics and the Sciences of the Heavens and the Earth* (Cambridge, 1959).

—— with the collaboration of Wang Ling and the special co-operation of Kenneth Girdwood Robinson, *Science and Civilization in China*, IV. *Physics and Physical Technology*, part I. *Physics* (Cambridge, 1962).

—— *Science and Civilization in China*, V. *Chemistry and Chemical Technology*, part I. *Paper and Printing*, by Tsien Tsuen-hsuin (Cambridge, 1985).

John Onians, 'Chinese Painting in the Twentieth Century and in the Context of World Art Studies' in *Ershi shiji Zhongguo hua: 'Chuantong de yanxu yu yanjin'/Chinese Painting in the Twentieth Century: Creativity in the Aftermath of Tradition*, eds Cao Yiqiang and Fan Jingzhong (Hangzhou, 1997), pp. 497–508.

Paul Pelliot, 'La peinture et la gravure europeènnes en Chine au temps du Mathieu Ricci', *T'oung Pao*, XX (1921), pp. 1 -18.

Peng Dayi, *Shan tang si kao*. Leishu huibian 23, Yiwen yinshuguan edn, 25 vols (Taibei, 1973).

Willard J. Peterson, 'Making Connections: "Commentary on the Attached Verbalizations" of the *Book of Change*', *Harvard Journal of Asiatic Studies*, XLII/1 (1982), pp. 67–116.

Andrew H. Plaks, 'Allegory in *Hsi-yu chi* and *Hung-lou meng*' in *Chinese Narrative: Critical and Theoretical Essays*, ed. Andrew H. Plaks (Princeton, 1977).

Martin J. Powers, 'Character (*Ch'i*) and Gesture (*Shih*) in Early Chinese Painting Criticism' in *Proceedings of the International Colloquium on Chinese Art History, 1991: Painting and Calligraphy*, ed. Wang Yaoting, 2 vols (Taipei, 1992), II, pp. 909–31.

Donald Preziosi, *Rethinking Art History: Meditations on a Coy Science* (New Haven and London, 1989).

Qin Lingyun, *Minjian huagong shiliao* (Beijing, 1958).

Otto Durham Rasmussen, *Chinese Eyesight and Spectacles*, 4th revision (Tonbridge Wells, 1949).

Evelyn Rawski, *Education and Popular Literacy in Ch'ing China* (Ann Arbor, 1979).

Jessica Rawson, ed., *Mysteries of Ancient China* (London, 1996).

Matteo Ricci, *China in the Sixteenth Century: The Journals of Matteo Ricci 1583–1610*, trans. Louis J. Gallagher S.J. (New York, 1953).

Isabelle Robinet, 'Taoist Insight Meditation: the Tang Practice of *Neiguan*' and 'Visualisation and Ecstatic flight in Shangqing Taoism' in *Taoist Meditation and Longevity Techniques*, ed. Livia Kohn (Ann Arbor, 1989), pp. 193–224.

—— *Taoist Meditation: The Mao-shan Tradition of Great Purity*, trans. Julian F. Pas and Norman J. Girardot, Foreword Norman J. Girardot, New Afterword Isabelle Robinet. SUNY Series in Chinese Philosophy and Culture (Albany, 1993), pp. 159–91.

David L. Rolston, *How to Read the Chinese Novel*. Princeton Library of Asian Translations (Princeton, 1990).

Tadao Sakai, 'Confucianism and Popular Educational Works' in *Self and Society in Ming Thought*, ed. Wm Theodore de Bary. Columbia Studies in Oriental Culture 4 (New York, 1970), pp. 331–66.

Michael Saso, 'What Is the *Ho-t'u?*', *History of Religions*, XVII/2 (1977), pp. 399–416.

Elizabeth Scheicher, 'Die Kunstkammer in Schloss Ambras' in *Europa und die Kaiser von China 1240–1816*, ed. Lothar Ledderose (Berlin, 1985), pp. 58–61.

Adam Schorr, 'Connoisseurship and the Defence against Vulgarity: Yang Shen (1488–1559) and his Work', *Monumenta Serica*, XLI (1993), pp. 89–128.

Shen Defu, *Wanli ye huo bian*. Yuan Ming shiliao biji congkan edn, 3 vols (Beijing, 1980).

Mette Siggstedt, 'Forms of Fate: an Investigation of the Relationship Between Formal Portraiture, Especially Ancestral Portraits, and Physiognomy (*xiangshu*) in China' in *Proceedings of the International Colloquium on Chinese Art History, 1991: Painting and Calligraphy*, ed. Wang Yaoting, 2 vols (Taipei, 1992), II, pp. 713–48.

Jerome Silbergeld, 'Chinese Concepts of Old Age and Their Role in Chinese Painting, Painting Theory and Criticism', *Art Journal*, XLVI/2 (1987), pp. 103–14.

Kidder Smith Jr, Peter K. Bol, Joseph A. Adler and Don J. Wyatt, *Sung Dynasty Uses of the* I Ching (Princeton, 1990).

Richard J. Smith, *Fortune Tellers and Philosophers: Divination in Traditional Chinese Society* (Boulder, 1991).

Philip Sohm, *Pittoresco: Marco Boschini, his Critics, and their Critiques of Painterly Brushwork in Seventeenth- and Eighteenth-Century Italy* (Cambridge, 1991).

Deborah A. Sommer, 'Images into Words: Ming Confucian Iconoclasm', *National Palace Museum Bulletin*, XXIX/1–2 (1994), pp. 1–24.

Song Ying-hsing, *T'ien-kung K'ai-wu: Chinese Technology in the Seventeenth Century*, trans. E-tu Zen-sun and Shiou-chuan Sun (University Park and London, 1966).

Jonathan Spence, *The Memory Palace of Matteo Ricci* (London, 1985).

Audrey Spiro, 'New Light on Gu Kaizhi', *Journal of Chinese Religions*, XVI (1988), pp. 1–17.

Nicholas Standaert, *Yang Tingyun, Confucian and Christian in Late Ming China: His Life and Thought* (Leiden, 1988).

Joan Stanley-Baker, 'Forgeries in Chinese Painting', *Oriental Art*, n.s., XXXII (1986), pp. 54–66.

George Steiner, *After Babel: Aspects of Language and Translation* (Oxford, 1972).

Susan Stewart, *On Longing: Narratives of the Miniature, the Gigantic, the Souvenir, the Collection* (Durham, NC and London, 1993).

—— *Crimes of Writing: Problems in the Containment of Representation* (Durham, NC and London, 1994).

Richard Strassberg, *Inscribed Landscapes: Travel Writing from Imperial China* (Berkeley, 1994).

Michel Strickmann, 'On the Alchemy of T'ao Hung-ching' in *Facets of Taoism: Essays in Chinese Religion*, eds Holmes Welch and Anna Seidel (New Haven and London, 1979), pp. 123–92.

Lynn A. Struve, *Voices from the Ming-Qing Cataclysm: China in Tigers' Jaws* (New Haven and London, 1993).

Michael Sullivan, 'Sandrart on Chinese Painting', *Oriental Art*, n.s., I (1948), pp. 159–61.

—— 'Some Possible Sources of European Influence on Late Ming and Early Ch'ing Painting' in *Proceedings of the International Symposium on Chinese Painting: National Palace Museum Republic of China 18th–24th June 1970* (Taipei, 1972), pp. 595–625.

Romeyn Taylor, 'Official and Popular Religion and the Political Organisation of Chinese Society in the Ming' in *Orthodoxy in Late Imperial China*, ed. Kwang-ching Liu (Berkeley and Los Angeles, 1990), pp. 126–57 (p. 150).

Ssu-yu Teng and Knight Biggerstaff, *An Annotated Bibliography of Selected Chinese Reference Works*. Harvard–Yenching Monographs 2 (Cambridge, MA, 1950).

The Plum in the Golden Vase, or Chin P'ing Mei, I. *The Gathering*, trans. David Tod Roy, 5 vols (Princeton, 1993–).

Tian shui bing shan lu, in *Ming Wuzong waiji*. Zhongguo lishi yanjiu ziliao congshu edn, reprint of 1951 Shenzhou Guoguangshe edn, Shanghai shudian (Shanghai, 1982).

Tseng Yuho, 'Women Painters of the Ming Dynasty', *Artibus Asiae*, LIII (1993), pp. 249–60.

Harrie Vanderstappen S.V.D., 'Chinese art and the Jesuits in Peking' in *East Meets West: The Jesuits in China, 1582–1773*, eds Charles E. Ronan S.J. and Bonnie B.C. Oh (Chicago, 1988), pp. 103–26.

Robert H. van Gulik, *Erotic Colour Prints of the Ming Dynasty, With an Essay on Chinese Sex Life from the Han to the Ch'ing Dynasty, B.C.206–A.D.1644* (Tokyo, 1951).

—— *Chinese Pictorial Art*. Serie Orientale 19 (Rome, 1958).

—— *Sexual Life in Ancient China: A Preliminary Survey of Chinese Sex and Society from* ca. *1500 B.C. till 1644 A.D.* (Leiden, 1961).

Richard Vinograd, 'Family Properties: Personal Context and Cultural Pattern in Wang Meng's *Pien Mountains* of 1366', *Ars Orientalis*, XIII (1982), pp. 1–29.

—— 'Private Art and Public Knowledge in Later Chinese Painting' in *Images of Memory, on Remembering and Representation*, eds Susan Küchler and Walter Melion (London and Washington, 1991), pp. 176–202.

—— *Boundaries of the Self: Chinese Portraits 1600–1900* (Cambridge, 1992).

Giovanni Vitiello, 'The Fantastic Journey of an Ugly Boy: Homosexuality and Salvation in Late Ming Pornography', *positions: east asia cultures critique*, IV/2 (1996), pp. 291–320.

Peter Wagner, *Reading Iconotexts: From Swift to the French Revolution* (London, 1995).

Wang Gen, *Chong xi Xinzhai Wang xian sheng quan ji, 8 juan*, published at Taizhou by Wang Binglian in 1631, and available in the microfilm collection *Guoli zhongyang tushuguan cang shanben*.

Wang Jinguang and Hong Zhenhuan, *Zhongguo guangxue shi* (Changsha, 1986).

Wang Jinming, 'Taicang Nanzhuancun Ming mu chutu guji', *Wenwu*, no. 3 (1987), pp. 19–22.

Wang Keyu, *Wang shi shan hu wang hua ji*, in *Yishu congbian 1 ji*, 12 *ce*, *Mingren huaxue lunzhu*, 11, ed. Yang Jialuo (Taibei, 1975).

—— *Shan hu wang hua lu*,. Si ku yishu congshu edn, Shanghai guji chubanshe (Shanghai, 1991).

Wang Shaochuan, *Yuan Ming Qing san dai jinhui xiaoshuo xiqu shiliao* (Beijing, 1958).

Wang Shixiang, *Xiu shi lu jie shuo* (Beijing, 1983).

Marsha Weidner, *Flowering in the Shadows: Women in the History of Chinese and Japanese Art*, ed. Marsha Weidner (Honolulu, 1990).

—— ed., 'Buddhist Pictorial Art of the Ming Dynasty (1368–1644): Patronage, Regionalism and Internationalism' in *Latter Days of the Law: Images of Chinese Buddhism 850–1850* (Lawrence and Honolulu, 1994), pp. 51–87.

Marsha Weidner, Ellen Johnston Laing, Irving Yucheng Lo, Christina Chu and James Robinson, *Views from Jade Terrace: Chinese Women Artists 1300–1912* (Indianapolis, 1988).

Wen Zhenheng, *Zhang wu zhi jiao zhu* (Nanjing, 1984).

Roderick Whitfield, 'Chinese Paintings from the Collection of Archduke Ferdinand II', *Oriental Art*, n.s., XXII (1976), pp. 406–16.

Elizabeth Wichmann, *Listening to the Theatre: The Aural Dimensions of Beijing Opera* (Honolulu, 1991).

Frances Wood, *Chinese Illustration* (London, 1985).

Wu Hung, *The Double Screen: Medium and Representation in Traditional Chinese Painting* (London, 1996).

Wu Kuang-tsing, 'Ming Printing and Printers', *Harvard Journal of Asiatic Studies*, VII (1942), pp. 203–60.

Xi Zhou sheng, *Xing shi yin yuan zhuan*. Zhongguo gudian xiaoshuo yanjiu ziliao congshu, 3 vols (Shanghai, 1980).

Xia Wei, 'The Huizhou Style of Woodcut Illustration', *Orientations*, XXV/1 (1994), pp. 61–6.

Xie Guozhen, ed., *Mingdai shehui jingji shiliao xuanbian*, 3 vols (Fuzhou, 1980).

Xu Chengzhi, Wang Guanghan and Yu Shi, eds, *Changyong diangu cidian* (Shanghai, 1985).

Yang Boxian, *Beijing Fahai si* (Beijing, 1994).

Yang Shen, *Hua pin*, in *Yishu congbian* 1 *ji*, 12 *ce*, *Mingren huaxue lunzhu*, ed. Yang Jialuo, 2 vols (Taibei, 1975).

Yang Xin, 'Mingdai nü huajia yu chungonghua zhouyi', *Gugong bowuyuan yuankan*, no. 3 (1995), pp. 1–5.

Dajuin Yao, 'The Pleasure of Reading Drama: Illustrations to the Hongzhi Edition of *The Story of the Western Wing*' in Wang Shifu, *The Moon and the Zither: The Story of the Western Wing*, ed. and trans. Stephen H. West and Wilt L. Idema (Berkeley, 1991), pp. 437–68.

Cordell D. K. Yee, 'Chinese Cartography Among the Arts: Objectivity, Subjectivity, Representation' and 'Traditional Chinese Cartography and the Myth of Westernisation' in *The History of Cartography*, V, bk 2. *Cartography in the Traditional East and Southeast Asian Societies*, eds J.B. Harley and D. Woodward (Chicago, 1994), pp. 128–169, 170–202.

Yu Anjian, *Hua shi congshu*, 5 vols (Shanghai, 1982).

Ch'un-fang Yü, *The Renewal of Buddhism in China: Chu-hung and the Late Ming Synthesis* (New York, 1981).

Yu Feian, *Chinese Painting Colours*, trans. Jerome Silbergeld and Amy McNair (Hong Kong, 1988).

Yu Jianhua, *Zhongguo hualun leibian*, 2 vols (Beijing, 1986).

Yuan jian lei han, 450 *juan*, compiled under Imperial auspices by Zhang Ying *et al.* and presented to the throne in 1701. Zhongguo shudian edn, 18 vols (Beijing, 1985).

Judith Zeitlin, *Historian of the Strange: Pu Songling and the Classical Chinese Tale* (Stanford, 1993).

Zhang Dafu, *Mei hua cao tang bi tan*. Gudi'an cang Ming Qing zhanggu congkan, Shanghai guji chubanshe edn, 3 vols (Shanghai, 1986).

Zhang Yuanfen, 'Xin faxian de "Jin Ping Mei" yanjiu ziliao chu tan' in *Lun Jin Ping Mei*, eds Hu Weishan and Zhang Qingshan (Beijing, 1984), pp. 331–8.

Zhao Jingshen, 'Tan Ming Chenghua kanben "Shuo chang ci hua"', *Wenwu*, no. 3 (1972), pp. 19–22.

Zheng Yinshu, *Xiang Yuanbian zhi shuhua shoucang yu yishu*. Yishu congkan 3 (Taibei, 1984).

Zheng Zhenduo, *Zhongguo banhua shi tulu* (Shanghai, 1940–7).

—— 'Chatu zhi hua' in *Zheng Zhenduo yishu kaogu wenji*, ed. Zheng Erkang (Beijing, 1988), pp. 3–22.

Zhou Lasheng, *Mingdai zhuangyuan qi tan: Mingdai zhuangyuan pu* (Beijing, 1993).

Zhou Wu, *Wulin chatu xuanji* (Hangzhou, 1984).

—— ed., *Zhongguo guben xiqu chatu xuan* (Tianjin, 1985).

Picture Acknowledgements

The author and publishers wish to express their thanks to the following sources of illustrative material and/or permission to reproduce it (excluding those sources credited in the picture captions): Aberdeen Art Gallery and Museums Collections (James Cromar Watt Bequest): p. 60; Agence Photographique de la Réunion des Musées Nationaux: p. 19; Barlow Collection, University of Sussex: p. 54; Boston Museum of Fine Arts: pp. 28 (William Sturgis Bigelow Collection), 84 (Keith McLeod Fund), 161 (gift of Robert T. Paine, Jr.); © 1996 Art Institute of Chicago (Kate S. Buckingham Fund), p. 87 (bottom); Field Museum of Natural History, Chicago: pp. 50 (cat. no. 245254), 176 (cat. 116027); © 1997 Cleveland Museum of Art: pp. 72 (Mr & Mrs William H. Marlatt Fund), 87 (top) (John L. Severance Fund), 145 (left) (intended gift of Mr & Mrs Dean A. Perry), 182 (John A. Severance Fund); Dr Sören Edgren: p. 137; Jingyuanzhai Collection, on extended loan to the University Art Museum, Berkeley: p. 44 (bottom); Rheinisches Bildarchiv, Köln: p. 70 (top); British Library, London: p. 162 (bottom); © The Board of Trustees of the Victoria and Albert Museum, London: pp. 42 (left), 52, 56, 63, 64 (from the Salting Bequest), 68–9, 70 (bottom), 74, 122 (given by Mr A. E. Anderson), 127 (Sharples Bequest), 167 (top left and bottom), 183; Minneapolis Institute of Arts (gift of Ruth and Bruce Dayton): p. 101; Metropolitan Museum of Art, New York: pp. 159 (Edward Elliott Family Collection, Purchase, The Dillon Fund Gift), 167 (top left) (Collection of Mr & Mrs Herbert Irving); Kunsthistorisches Museum, Vienna: p. 71, and Wan-go Weng. p. 66.

Index

Numerals in italics refer to illustration numbers